watercolor
school

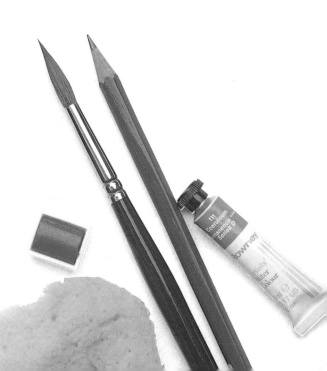

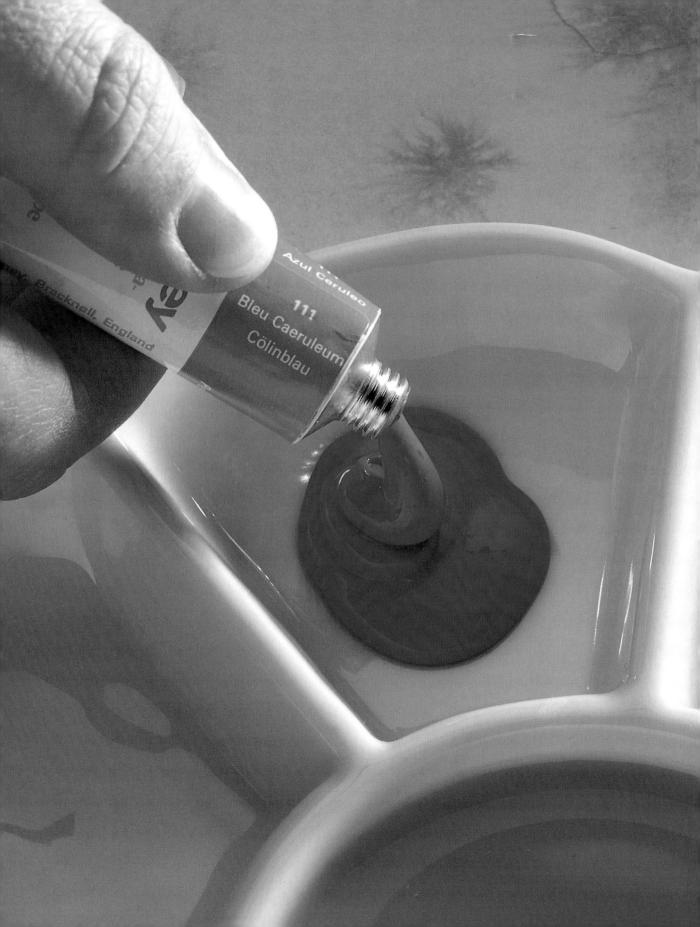

READER'S
Learn-As-You-Go Guide
DIGEST

watercolor
school

Hazel Harrison

THE READER'S DIGEST ASSOCIATION, INC.
Pleasantville, New York
Montreal

A READER'S DIGEST BOOK

Designed and edited by
Quarto Publishing plc

First published in North America in 1993

Senior Art Editor *Penny Cobb*
Designer *Clive Hayball*
Senior Editor *Sally MacEachern*
Editor *Mary Senechall*
Photographers *Paul Forrester and Chas Wilder*
Picture Researcher *Amanda Little*
Picture Manager *Rebecca Horsewood*
Publishing Director *Janet Slingsby*
Art Director *Moira Clinch*

Special thanks to Daler-Rowney for providing
art materials

The acknowledgments that appear on page 176
are hereby made a part of this copyright page.

Library of Congress Cataloging in Publication Data

Harrison, Hazel.
 Watercolor school / Hazel Harrison.
 p. cm. – (Reader's digest learn-as-you-go guides)
 Includes index.
 ISBN 0-89577-466-6
 1. Watercolor painting–Technique. I. Title. II. Series.
ND2420.H38 1993
751.42'2–dc20 92-39201

Printed in Singapore

Third Printing, October 1994

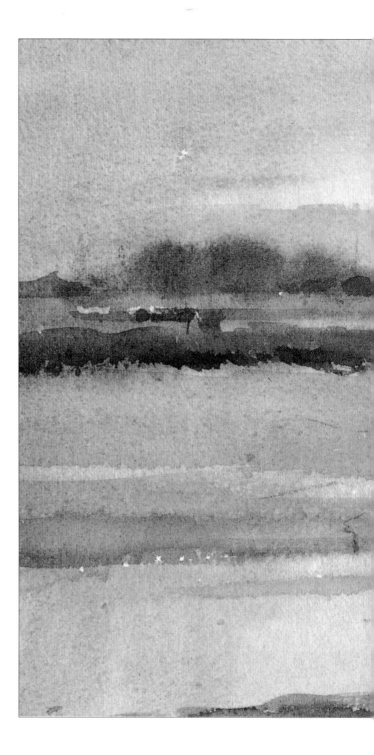

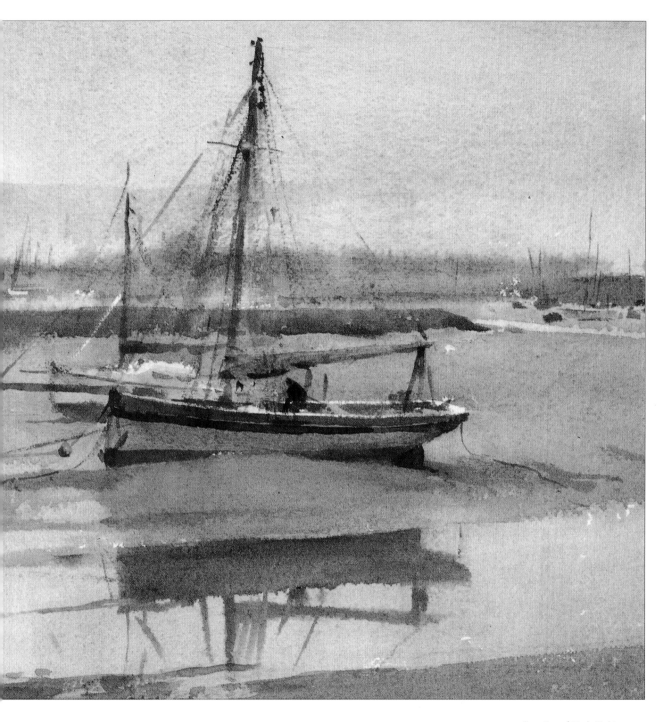

On a Sea of Mud, Malden
Trevor Chamberlain

This atmospheric painting expresses the quiet beauty of the scene as well as celebrating the unique qualities of watercolor.

Contents

Why watercolor?

Watercolor is the most popular painting medium today. Once regarded as the "poor relation" of oils, it has become the first choice of many modern artists.

A good watercolor has a compelling vitality and immediacy. Watercolorists are drawn by the medium's magical if sometimes elusive qualities, its unexpected effects – which can be exasperating but also exciting – and by its capacity to adapt to the visual responses of the individual artist. They like the way watercolor can capture a particular light or mood. And they like its practical advantages for working either indoors or on location.

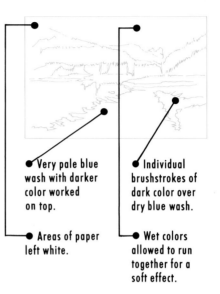

● Very pale blue wash with darker color worked on top.

● Areas of paper left white.

● Individual brushstrokes of dark color over dry blue wash.

● Wet colors allowed to run together for a soft effect.

▼ **Harrison Lagoon**
Tim Pond

Long before watercolor became popular, its value as a sketching medium was recognized by many eminent artists whose principal work was in oils. As this small painting shows, there is no better medium for recording quick impressions. The artist conveyed the quiet majesty of the landscape with broad washes and brushstrokes.

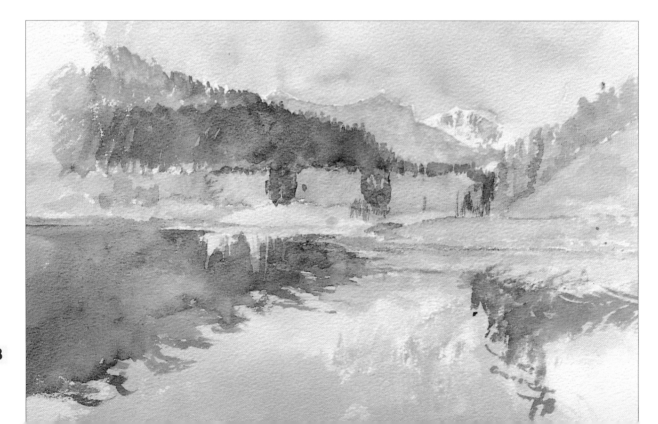

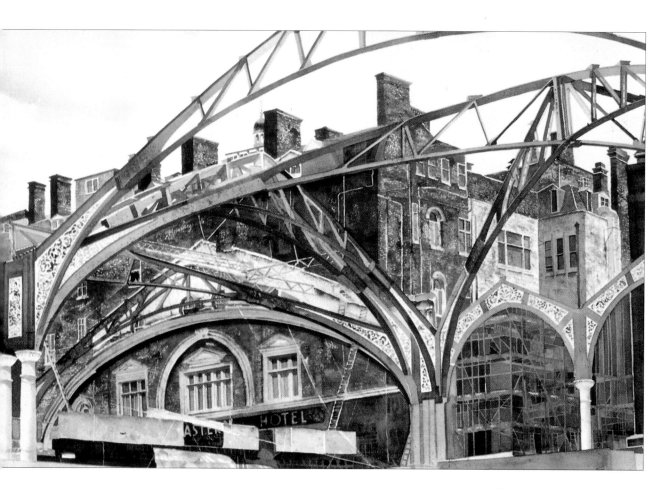

● **Patterns of ironwork picked out with dark paint and a very small brush.**

● **Darker grays painted over light gray wash for sky.**

● **Texture suggested by working rather dry paint over a background color.**

● **White areas reserved by painting carefully around them.**

▲ **Liverpool Street Station**
Sandra Walker

Watercolor is equally suited to detailed work, and is the chosen medium of many artists who specialize in elaborate botanical, zoological, and architectural subjects. Urban architecture is this artist's particular interest. She managed to paint each door, window, and chimney pot as well as every inch of decorative detail without the paint becoming overworked.

The fluidity and transparency of watercolor are unique, but these are the very qualities that have given the medium a reputation for being "difficult." Because the paint is transparent, you can't correct mistakes by overpainting, as you can with opaque paints. In fact, watercolor is no more difficult than any other medium; but like all painting, it takes practice and a willingness to experiment.

The fresh and spontaneous appearance of successful watercolors depends upon planning, technique, and a knowledge of the medium – all of which can be achieved in time.

Acquiring watercolor techniques is both a challenge and a delight. Using them successfully will not only be a source of great satisfaction but will free you to find and use your own artistic vision.

The bonus is that you can enjoy yourself while you learn. The most important task is to become familiar with the medium through

Continued on p.12 ▷

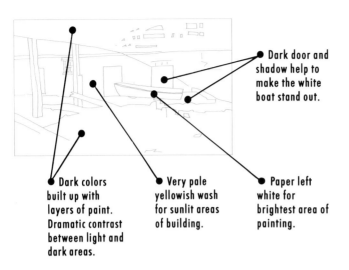

Dark door and shadow help to make the white boat stand out.

Dark colors built up with layers of paint. Dramatic contrast between light and dark areas.

Very pale yellowish wash for sunlit areas of building.

Paper left white for brightest area of painting.

▼ **The Farm, Much Wenlock, Shropshire – Peter Jones**

If you asked a non-painter for the words he or she associates with watercolor, it is likely that "pale" and "delicate" would be among them. But although watercolor can be subtle, it can also be strong. To create strong watercolors, choose vivid or dark colors and use less water and more color. Here the paint was applied almost "straight" in the foreground, and appears even darker because of the contrast with the sunlit building behind.

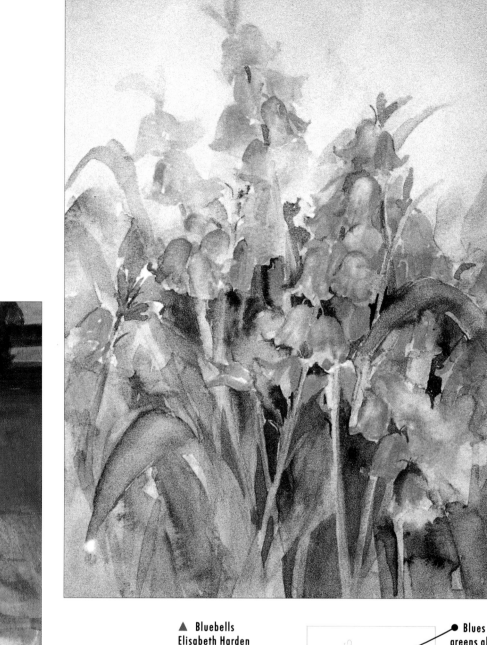

▲ **Bluebells**
Elisabeth Harden

This painting is delicate in the very best sense of the word. The artist matched her technique to the subject, letting the colors run together in places to achieve a gentle effect. This "wet on wet" method (see p.64) is perfect for floral subjects.

● Blues and greens allowed to run slightly into gray background.

● Crisper effects made by painting some leaves over dry background color.

● Colors running together. Crisper detail painted on top after these have dried.

● Light green stems reserved by painting around them with darker colors.

"hands on" experience. There are few more agreeable ways of spending your time than letting the brush glide over the paper as you lay washes, or observing the way colors merge as you work "wet on wet." By direct involvement with the materials, you will get to know their characteristics and learn how to make the most of both planned and unpredicted effects.

The second task – which may take longer and entail more trial and error – is learning to recognize your own pictorial interests and knowing what you want to "say" in paint. Watercolor is such a versatile mode of expression that once you have learned to use it, you'll find there is little it cannot convey. If you are interested in atmospheric landscape you can make rapid sketches, catching impressions with just a few broad washes and brushstrokes. If you like detail, you can build up intricate effects with a small brush; you can paint flowers in delicate colors, still lifes in vivid hues, or portraits in somber shades. Discovering what you enjoy painting is the first step toward developing your personal style, and it is the ability to instill something of yourself in your paintings that makes you an artist.

The paintings on these pages will show how wide your choices are. No two approaches are the same, even when the subject is similar, because each artist has a different way of looking at the world. If you attend watercolor exhibitions, you'll find that you respond to some paintings more than others. This will help you decide how and what to paint. Whatever their approach, the experience and experiments of other watercolorists can help to inspire and enhance your own artistic development. One of the best ways of learning is from other people, even when they don't know they are teaching you.

● **Hill painted** after sky colors have dried. Backrun formed intentionally.

● **Branches** painted over hill and sky after first colors have dried.

● **Contrast** between soft effect, where colors have run together, and crisp lines, painted over dry color.

● **Colors** encouraged to run together, but not allowed to creep over edge of hill.

▼ **Enchanted Rock**
Shirley Felts

One of the great joys of watercolor is the element of "happy accident." Colors may run together or blotches appear, and instead of spoiling the painting, they look attractive. Once you know why these accidents have happened, you can decide to avoid or exploit them in future work. In this atmospheric painting the artist allowed colors to "bleed" into one another and encouraged backruns (see p.86) that promote a spontaneous feeling.

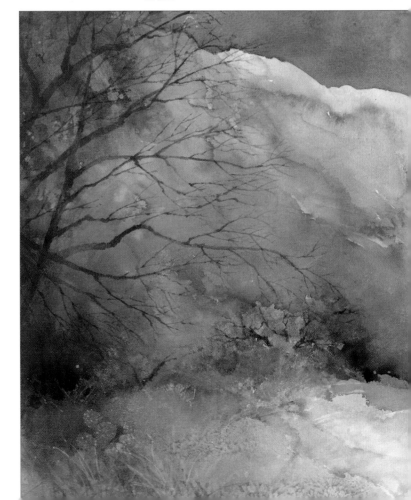

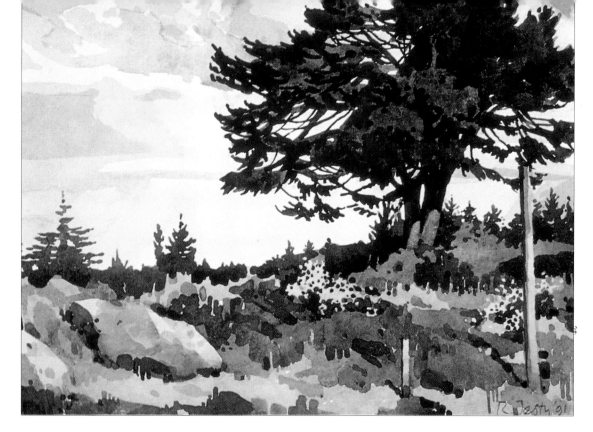

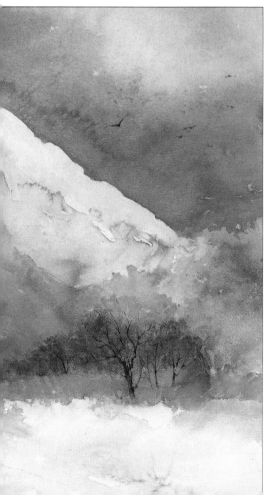

▲ Pine Tree
Ronald Jesty

*Although the subject
matter of these two
paintings is similar, the
results could not be
more diverse. Both
artists know exactly
how to control their
medium, but their
different pictorial
interests give rise to
contrasting styles. Jesty
likes crisp effects with
every shape clearly
defined. He builds his
paintings gradually,
laying one small area of
wash over another,
leaving the painting to
dry between stages so
that colors don't merge.*

● **Small, dark
brushstrokes
painted over
light gray of sky.**

● **Blue patches
and gray shapes
for clouds
painted
separately.**

● **Very dark
olive greens
allowed to dry,
and darker colors
applied on top.**

● **Foliage
suggested with
tiny dots of dark
green-black over
yellow.**

● Light blue applied with a large brush; areas of paper left white to suggest clouds.

● Same blue taken over parts of building, painted over light yellow-browns.

● Light pinkish-brown wash and separate brushstrokes of yellow-brown for brickwork pattern.

● Free, scribbly drawing with fine pen and black ink over dry paint.

▼ Street in Kiev – Ray Evans

This painting makes an interesting comparison with Liverpool Street Station (see p.8). The subject matter is similar but the style is quite different. While Walker built detail with paint alone, Evans used watercolor sparingly, reinforcing his light washes with lively pen lines. Line and wash (see p.84) is an excellent technique for architectural subjects; you can keep the color fresh and clean, and rely on pen or pencil for the fine detail.

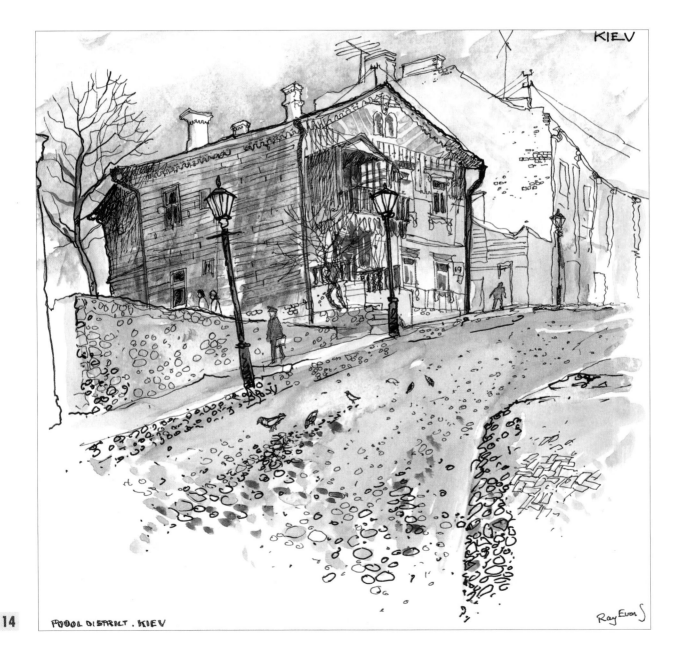

KIEV

PODOL DISTRICT . KIEV

Ray Evans

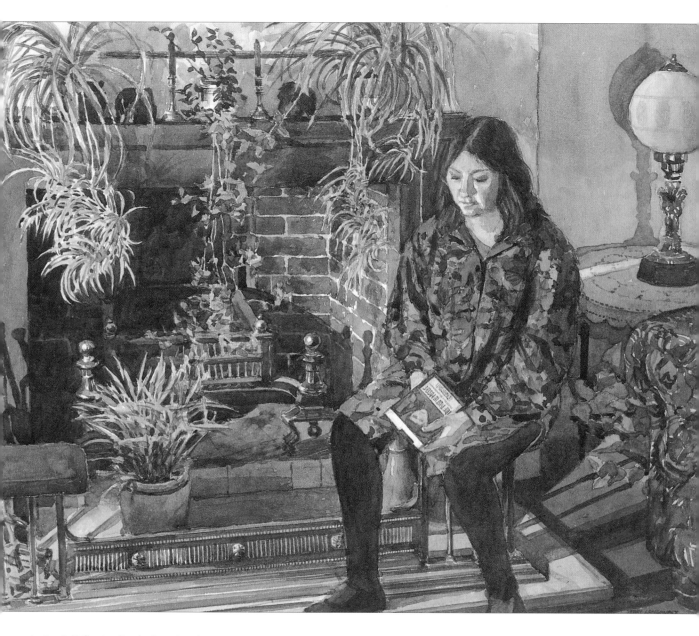

▲ **Dee in Reflective Mood – Terry Longhurst**

Just as there are countless possible styles and approaches in watercolor, there is no limit on subject matter either. The medium is perhaps most frequently used for landscape and flowers. But, as this painting shows, it also can be wonderfully expressive for portraits and figure work. This artist paints many portraits in watercolor, both commissioned and informal, and finds it the ideal medium for his work.

● Pale, spiky leaves reserved by painting on masking fluid (see p.47).

● Deep, brilliant colors enhanced by overpainting adjacent areas in near-black.

● Deliberately uneven gray wash gives variety to background and suggests play of light.

● Forms of face built up by laying darker colors over dry, light ones.

15

Before you start

Paint manufacturers produce a huge range of colors, but to begin you only need a small selection. The basic palette on page 23 contains 10 colors, which is quite a lot in watercolor terms; some artists use only five or six. You'll need to decide first between tubes and pans. Both have merits: Pans are easier to carry around, because you simply slot them into your paintbox; tubes have to be carried

BEFORE YOU START

Paints and brushes

separately, and the colors squeezed out as needed. Tubes are better, though, when you need to mix a lot of paint for washes (see p.28).

Whether you opt for tubes or pans, be sure to buy the best quality "artists'" paints. Don't be tempted by the inexpensiveness of special "sketching sets" or "students'" colors; they may be inferior paints that will not provide the vibrancy of true watercolors. A tube or pan of paint lasts a long time, so you can regard your initial outlay as a one-time expense – you'll sometimes need to replace an individual color but you'll never have to buy a whole set again.

You don't need a large selection of brushes either, and here you can save by not buying the best. The aristocrats among watercolor brushes are made from the hair of the sable (a member of the marten family). Less expensive brushes are made of squirrel and ox hair, and there are also many synthetic brushes and sable-and-synthetic mixtures. These are less springy and don't hold the paint as well as pure sables, but they are fine to start with.

▶ GOUACHE PAINTS

Gouache paints are an opaque version of watercolors, which can be used more thickly and sometimes in combination with the transparent colors. Gouache white, in particular, is a useful alternative to Chinese white for adding highlights or thickening paint for certain effects.

◀ PAN PAINTBOX

All watercolors contain gum arabic to keep them moist, so don't be put off pans because you think they may dry up. Pans are available in whole and half-sizes. Try a half-pan if you are unsure about a color. There is a wide range of paintboxes designed to hold pans and half-pans, which can be removed and replaced when used up.

◀ TUBE PAINTBOX

The choice of paintbox needs some thought. Avoid boxes prefitted with a selection of colors. First, you won't know whether they are good-quality paints, and second, you may find yourself stuck with colors you don't need. It is better to buy an empty box that can be filled with colors of your choice, either tubes, pans, or half-pans. The paintbox shown here is designed for tube paints, which you can squeeze into the small sections as needed.

◀ TUBES

Regular tubes of watercolor are quite small. Some manufacturers make larger sizes, but these are not necessary – it takes a long time to get through even a regular tube. Good-quality paints can be kept indefinitely as long as you screw the caps back after use. If you prefer tubes to pans, you may not need a paintbox; you could use one of the palettes shown on pp.20-1.

19

PALETTES

If you buy pans or half-pans of watercolor and a suitable paintbox (see p.19) you can mix your colors in the box. Although you can mix tube colors in a paintbox (see p.18) many people prefer a palette. Individual palettes, made of china or plastic, are useful for indoor work. You can keep each color separate, and can stack the palettes after use. The circular palette (top left), also made in plastic or china, is favored by many artists.

RECESSED WELLS

There are many different kinds of palette, but they all have recessed "wells" to hold the color and divisions to separate one color from another. The plastic palettes, such as those below left, are a good all-purpose choice; inexpensive, light and therefore ideal for outdoor work.

► **BRUSHES**

There are three main shapes of watercolor brush; rounds, flats, and mops. All are made in a range of sizes, usually identified by number but sometimes by their actual size (e.g. $\frac{1}{2}$ inch).
In most lines, the biggest brush is No.12 or No.14, and the smallest is No.1, No.0, or even No.00. The brushes shown here are (from left to right): Kolinsky sable round No.14; mixed-hair mop No.12; ox-hair round No.12; synthetic round No.11; synthetic flat $\frac{1}{4}$ inch; goat-hair mop No. 6.

CARE OF BRUSHES

You will ruin your brushes if you leave the hairs standing in a glass of water. Keep brushes standing upright in a jar. Or, store them in special cylindrical containers. These are useful for carrying brushes around outdoors, but you must keep the container upright or the tips of the brushes may bend. Make sure that the brushes are dry before storing them in a closed container or mold may develop.

▼ **SPONGES AND COTTON SWABS**

A small natural sponge is an extremely useful piece of equipment. It can be used for putting on color, making corrections, and cleaning up. Cotton balls serve much the same purpose, while cotton swabs are good for creating small highlights (see p.46).

Rinse your brush under running water after each painting session. Use a little soap if traces of dried color stick to the end near the metal band. Reshape gently with fingers or lips.

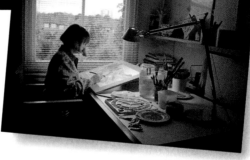

▲ STUDIO LIGHTING

The window provides good light over the artist's left shoulder. This is important because otherwise your working hand will throw a shadow on your work (left-handed people, of course, need the light on the right). The desk lamp can be angled so that it does not cast too much shadow. Such lamps can be fitted with daylight simulation bulbs.

◀ LIGHTS

Working lights need not form part of your "starter kit," but you will need to consider suitable lighting if you intend to work in the evenings. Most of these lamps are available from good suppliers of graphic materials. The daylight simulation bulbs (blue) are particularly useful, as they can be used either in lamps or in overhead light sockets.

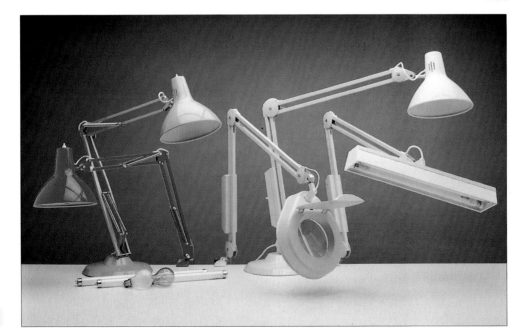

These two pages show all the equipment necessary to begin painting, plus a few optional extras. As you can see, the list of requirements is not large. You can cut down on the initial outlay even further if you choose, by buying fewer brushes and a smaller selection of colors.

EQUIPMENT

Counterclockwise:
- Pencil and eraser for preliminary drawings.
- One square-ended brush and three rounds, in a sable and nylon mixture.
- Palette (or paintbox) and jar for water.
- Pans and tubes of color.
- A drawing board can be made from MDF (medium-density fiberboard) and plywood. Masking tape is useful for fixing paper to the board when you aren't stretching it.
- Selection of ten starter colors.

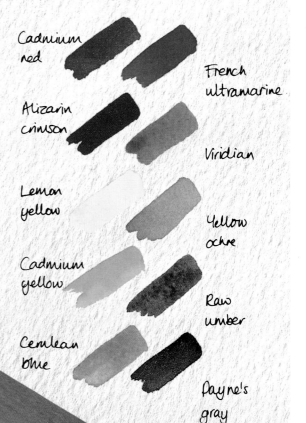

Cadmium red

Alizarin crimson

Lemon yellow

Cadmium yellow

Cerulean blue

French ultramarine

Viridian

Yellow ochre

Raw umber

Payne's gray

Watercolors are almost always painted on white paper, which reflects back through the thin layers of paint, giving them their distinctive luminous quality. The finest-quality watercolor paper is made by hand from pure linen rag. These papers are expensive, and as a beginner you won't need them.

The papers you'll find in your local art supply store are machine-made, and although

Paper

there are many different brands, all with slight variations, they can be divided into three groups: hot-pressed, cold-pressed, and rough.

The other variation occurs in the thickness, or weight, of the papers. This is important, because it dictates whether or not you will have to stretch them. The weight of paper is usually expressed in pounds (lbs), referring to the weight of a ream (500 sheets), not to each individual sheet. As a general rule, any paper heavier than around 200 lbs can be used without stretching. The paper used in most watercolor pads is 140-lb, which is a "borderline case." If you're working on a small sheet you can get away without stretching, but for a big painting, or one where you want to use a lot of wet washes, it's best to use stretched paper.

STRETCHING PAPER

Light- or medium-weight papers tend to buckle when wet paint is applied, but they won't do this if they are stretched. Stretching paper may seem a chore, but there are two excellent reasons for doing it. One is that you can save a good deal of money, because light papers are considerably less expensive than heavy ones, and the other is that stretched paper is more pleasant to work on – it is frustrating to paint over ridges caused by buckling. Stretching isn't difficult, but you need to do it well in advance of painting. The paper has to be soaked and will take at least two hours to dry thoroughly.

◀ **EQUIPMENT**
The only equipment you need is a ruler and pencil, scissors, gummed tape and a sponge. Thumbtacks are not essential, but some artists like to put one into each corner after stretching.

1 *Rule light pencil lines about half an inch from the edges of the paper to help you put the tape on straight.*
2 *Immerse the paper briefly in water, turning it over once to make sure both sides are evenly wetted. You can do this in a bathtub, sink, or plastic tray.*
3 *Place the paper on the board and smooth it with a damp sponge to remove any creases or air bubbles.*
4 *Cut four pieces of gummed tape roughly to length and dampen each one just before use by running it over the sponge. Don't make it too wet or it may stretch and tear.*
5 *Place the strip around all four edges, smoothing it with your hand as you go. Trim the corners with the scissors or a sharp knife, and stand the board upright until the paper is completely dry.*

▲ SKETCHING PADS

The major manufacturers produce their paper in large sheet and sketchpad form. The pads usually contain 10 or 12 sheets, and are available in a variety of sizes.

◄ WATERMARKS

Not all papers have watermarks, but if they do, this indicates that there is a "right" and "wrong" side. Hold the paper up to the light, and if you can read the watermark, this is the side to paint on.

► SHEET PAPER

From top to bottom:
1 watercolor board;
2 cold-pressed paper;
3 rough paper;
4 hot-pressed paper;
5 and **6** two different handmade papers. The board – which is simply paper stuck to a firm backing – is expensive, but useful if you have no time to stretch paper. Cold-pressed paper has a slight texture, or "tooth," that holds the paint well but does not interfere with detail; it is the most widely used.

Rough paper has a distinct texture, and is trickier to handle, because the paint settles mainly in the lower parts of the surface to produce a slightly speckled effect. Hot-pressed paper is fairly smooth; it is suitable for line and wash techniques (see p.84) and fine detail. Handmade paper cannot be categorized, as there are many different kinds. This is paper to experiment with when you become more experienced.

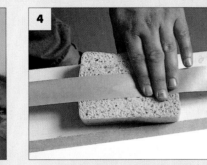

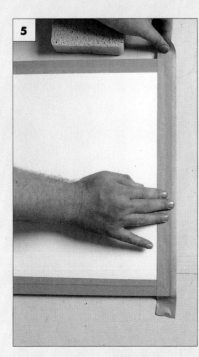

1

2

3

4

5

1
2
3
4
5
6

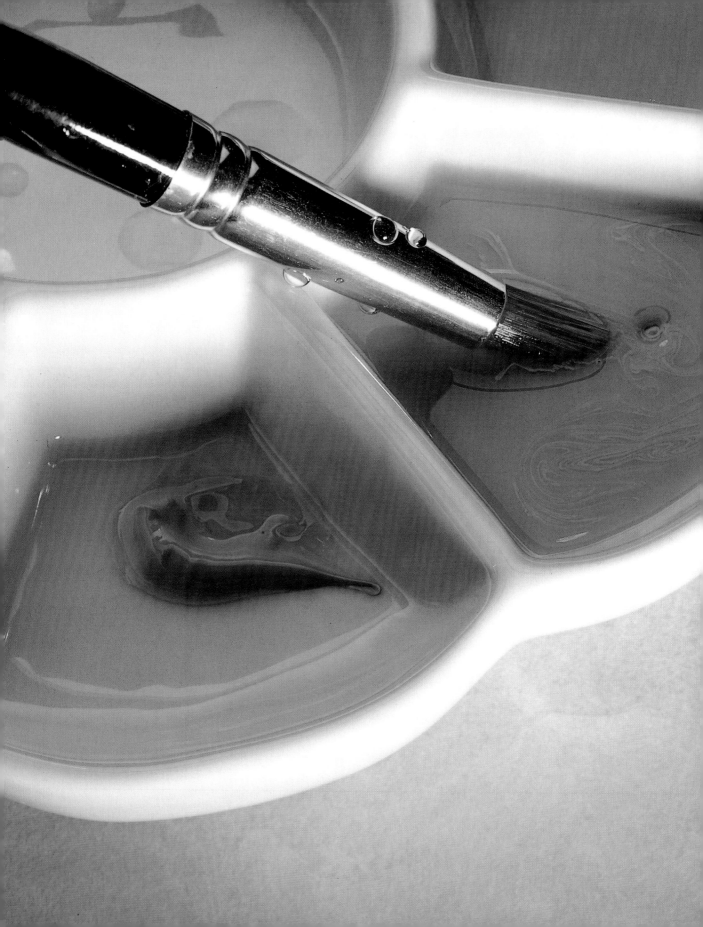

2

Getting to know watercolor

Because of the fluid nature of watercolor, you can spread color over the paper very quickly by laying washes. These are the basis of all watercolor painting. A wash is a veil of color laid over an area of the paper too large to be covered by a single brushstroke. If you are painting a landscape or seascape, for example, you might lay a wash that occupies as much as a third or even half the paper, but a wash can

Laying a flat wash

also be quite small. In a still life with a plain background you would need to lay several washes of different colors, one for each of the objects, perhaps with a much broader wash for the background.

A wash needn't be completely flat; later on you'll practice making the color lighter or darker in one place than another, laying a deliberately uneven wash, and using more than one color in the same wash. But first you need to master the technique of laying a perfectly even wash, where you can see no variations of color and no lines or ripples in the paint.

When laying a wash over a large area, as in the examples here, a lot of paint is needed. And, it must be thoroughly mixed. Start by putting a generous amount of paint into a palette and keep on adding water and mixing until all the color dissolves.

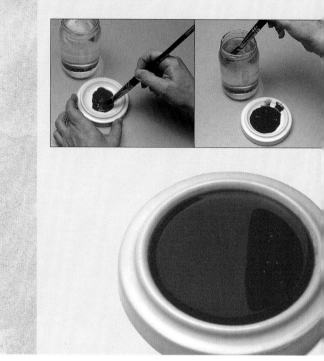

WASH ON DRY PAPER
1 *The board is tilted at a slight angle, and the paint is taken evenly from one side of the paper to the other.*

2 *The tilt of the board helps the paint to flow down the paper so that each band of color runs into the one below.*

WASH ON DAMP PAPER

1 *Dampening the paper helps the colors to blend, but makes it less easy to control the paint, as it will flow into any damp area. However, you won't achieve neat lines of color as with the dry-paper method.*

2 *If runs occur, as you can see here, they will be absorbed into the rest of the wash when further lines of color are added.*

3 *Don't be alarmed if your wash looks a little streaky as you lay it. It will probably dry smooth and flat, as this one did.*

3 *Work in the same direction for each line of color, dipping the brush into the paint before each stroke.*

4 *If you laid the wash correctly, any slight irregularities will smooth out as the paint dries.*

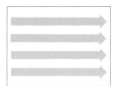

USING A SPONGE

1 A sponge is a useful piece of equipment in watercolor painting. Some artists prefer it to a brush for laying washes. Dampening the paper first will give the best results.

2 Dip the sponge into the paint before each stroke and take it evenly from one side across the paper to the other.

3 Although the paper is damp, the paint doesn't run down as it can with a brush.

4 Slight streaks where one line of color meets the next will merge as the paint dries.

5 Place the board flat to dry. The color will flow gently into the lighter areas producing an even wash.

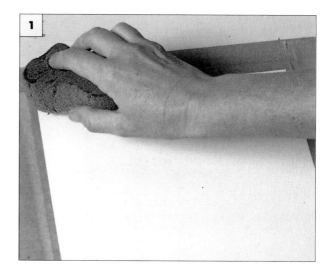

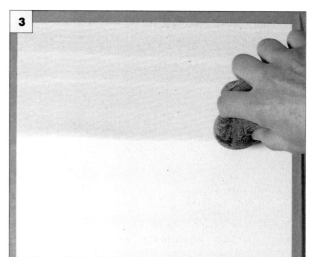

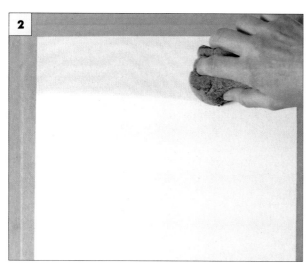

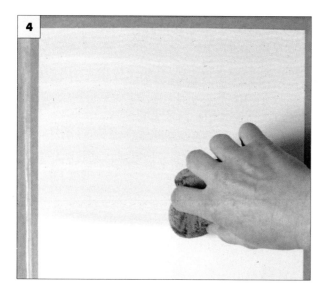

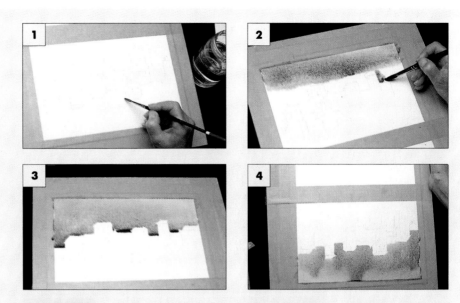

THE WATER METHOD
1 *In this method, clean water is painted over all the areas to receive the color wash.*
2 *The wash is then laid on the dampened areas.*
3 *The paint does not flow over the edges, because the paper is dry.*
4 *Finally, the board is turned upside down so that the "pools" of paint flow back into the wash.*

WORKING UPSIDE DOWN
1 *In this method, the board is turned upside down for the whole wash, so that the edges are painted first.*
2 *Both methods produce similar results, and neither is difficult.*

It is best to work on stretched paper (see p.24), because it will not buckle under the wet paint. However, it is easier to control the wash if the paper is dry. Some artists prefer to dampen the paper again before laying a wash.

EFFECTIVE APPLICATION

The most important thing to remember is that washes have to be put on quickly, so mix up a generous quantity of paint. You won't succeed if you have to mix more paint halfway through – it won't be the same color or strength. Never go back over wet paint. This can cause "flooding," and ugly patches.

Let the wash dry and see how it looks. Don't worry if it hasn't come out right – the next one will be better. You will already have begun to get the feel of watercolor, and you will have made two important discoveries. One is the amount of paint you need, and the other is that watercolor dries much lighter than it looks when wet. Although you can make a color darker by laying another wash over it, too many layers will cause the paint to lose its freshness and sparkle.

SPONGING

When you've done some washes on damp paper, try working on dry paper. You might also enjoy laying a wash with a sponge instead of a brush. It is a bit trickier to achieve a perfectly flat effect with a sponge, but it is the ideal tool where you want a slightly uneven effect. You can control the amount of paint you lay at each stroke by allowing the sponge to absorb more or less of the color.

Nature doesn't often provide totally flat areas of color, so you will sometimes need to lay a wash that is darker in parts, or contains more than one color. Gradated washes are one color that is darker at the top. They are the washes to use for clear blue skies.

The method is identical to that for the flat wash, but in this case you begin with a band of full-strength color and add progressively more

Wash variations

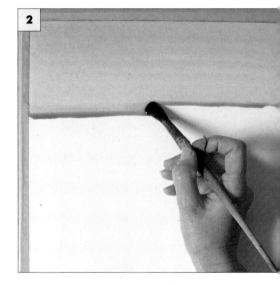

water for each subsequent band. Gradated washes are much trickier than flat ones, and require practice to achieve an even effect. Too much water in one band, or not enough in another, will create stripes.

Using a sponge can help control the amount of water you use. Some watercolorists like to turn the board upside down and begin with the light bands of color, working downward to the dark ones.

USING SEVERAL COLORS

With variegated washes you really start to have fun. These are multicolored washes, blending two or more colors. Although they can't be controlled as precisely as flat or gradated ones, they offer exciting effects.

There are all kinds of occasions where you might want to use a variegated wash. One example is a sunset sky, where the colors range from deep blues to oranges and yellows. Or, you might vary the background of a still life with a subtle combination of blue, grays, and browns instead of a flat wash.

LAYING A GRADATED WASH

1 *Gradated washes are trickier than flat ones, but are equally important to master. Tilt the board at a slight angle, as for a flat wash, and use whichever shape of brush you find comfortable. Begin with a band of full-strength color and make each subsequent band slightly lighter.*

2 *Before applying each band of color, dip the brush into the water and then into the paint. The mixture will become weaker with each application, because it is diluted with increasing amounts of water: one "dollop" for the second band; two for the third, and so on.*

3 *For gradated washes, it is easiest to work on dry paper. If the paper is damp, the dark color at the top will tend to flow into the bands below.*

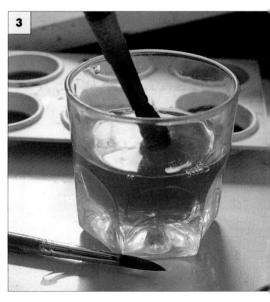

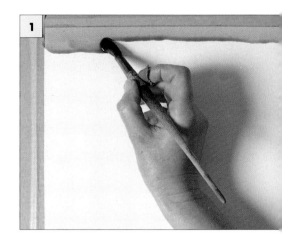

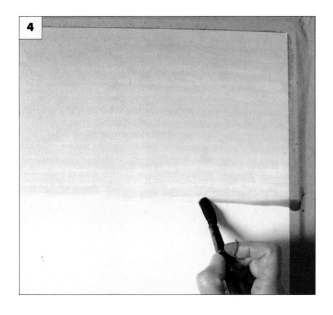

4

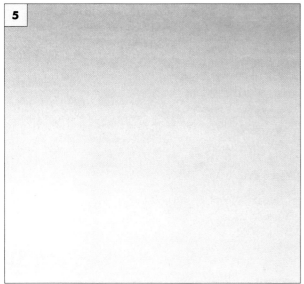

5

4 As long as you work methodically you will find that, with a little practice, you can achieve a gentle, even gradation. For a more dramatic change from dark to light over a small area, try using water alone for the second stroke, or dipping the brush twice into the water each time.

5 The ability to produce an even gradated wash such as this is a key skill for painting skies.

Because you can't judge the colors until the paint is dry, watercolor painting can involve a good deal of waiting. A hairdryer is useful for speedier drying, but don't use it on a flat wash which is still very wet; you may blow the paint around and create ripples. Let the wash dry slightly first.

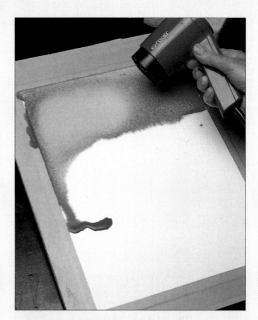

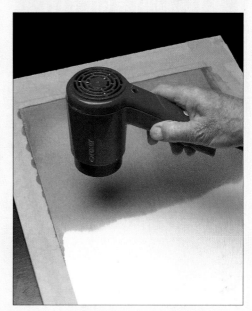

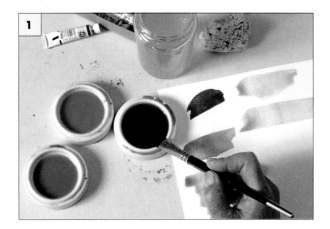

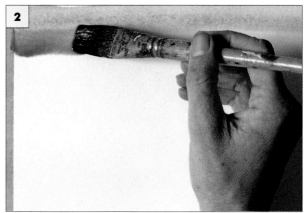

A VARIEGATED WASH

1 Begin by mixing all the colors you intend to use. Try out their strength on a spare piece of paper.

2 Using a large, square-ended brush, she begins with a band of deep blue, deliberately laying it unevenly.

Unlike the previous washes, these are not intended to be perfectly smooth.

3 The paper was dampened in advance to encourage the colors to blend. You can see this effect at top left, where the dark blue runs into the lighter band.

4 The three colors – ultramarine, cerulean blue, and viridian – merge without hard boundaries.

5 The finished wash produces an effect reminiscent of sea.

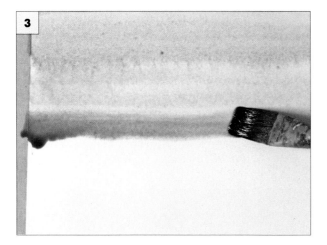

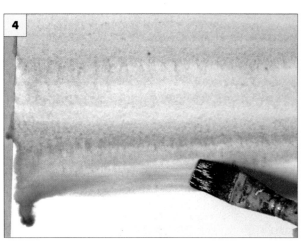

A RANDOM MULTI-COLORED WASH

1 Here the approach is more experimental. Colors are worked in a random way into a still-wet yellow wash.

2 As the first colors spread, more are added, dropped into the wash or touched in with the point of the brush.

3 The paint spreads out, with tiny flower-like tendrils at the edges of each "brushstroke."

4 A wash like this might form an attractive background for a still life, suggesting wallpaper or curtains.

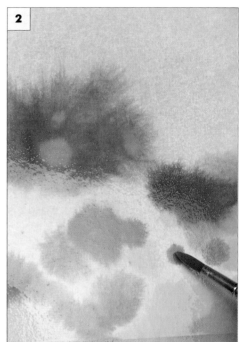

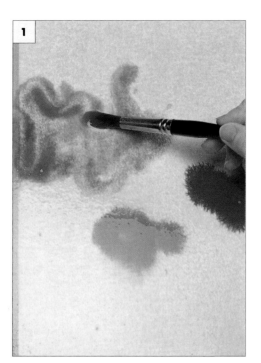

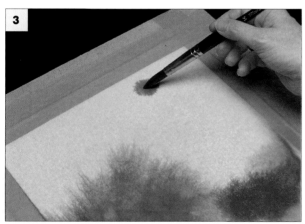

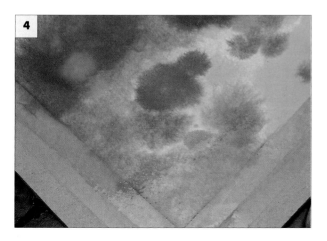

COLOR SWATCHES

You can make exciting random effects by dipping your brush into any color. However, if you want a more controlled variegated wash, try a selection of colors on a spare piece of paper before mixing them. You still won't know exactly how they will look when they begin to mix together on the paper, but you will have an idea of how strong to make them.

35

The gradated wash exercise (p.32) introduced the idea of making a color lighter or darker. Here's the next step, using each of the "basic palette" colors and fading them from full strength to the lightest "whisper" of color.

An ordinary glass of water takes on a deep significance in watercolor work. You'll soon begin to treat it with a new respect. With opaque paints such as oils, you make colors

Dark and light colors

▶ MIXING DARK AND LIGHT COLORS

Watercolors vary enormously, ranging from dark and rich to the merest suggestion of color. The colors shown right are full-strength, that is, mixed with just enough water for application. The color bands (far right) show how to produce progressively lighter colors by increasing the ratio of water to paint. It is not possible to provide precise "recipes" for the proportions, but you will learn to estimate it with practice.

lighter by adding white, but in watercolor painting "white" is the water, combined with the white of the paper – the more water you use, the more white paper shows through, and the paler the color becomes. (Pure white is made simply by leaving the paper bare.)

It is difficult to estimate the amount of water correctly. Beginners tend to use too much, because the colors often look alarmingly dark in the palette. But once the paint has dried on the paper, it becomes much lighter. Then, the only way to get the right strength of color is to put more paint on top. If you want a really dark color you'll have to do this (see p.40), but it's always better if you can get the color right first time. The key to success is to avoid unnecessary over-painting.

DRY COLOR AND WET COLOR

*One of the trickiest aspects of watercolor painting is judging what the color will look like when it's dry. Here there is a considerable difference between the dry color **1** and the wet one **2**. However, it can be much greater than this, as all colors have their own particular characteristics.*

1

2

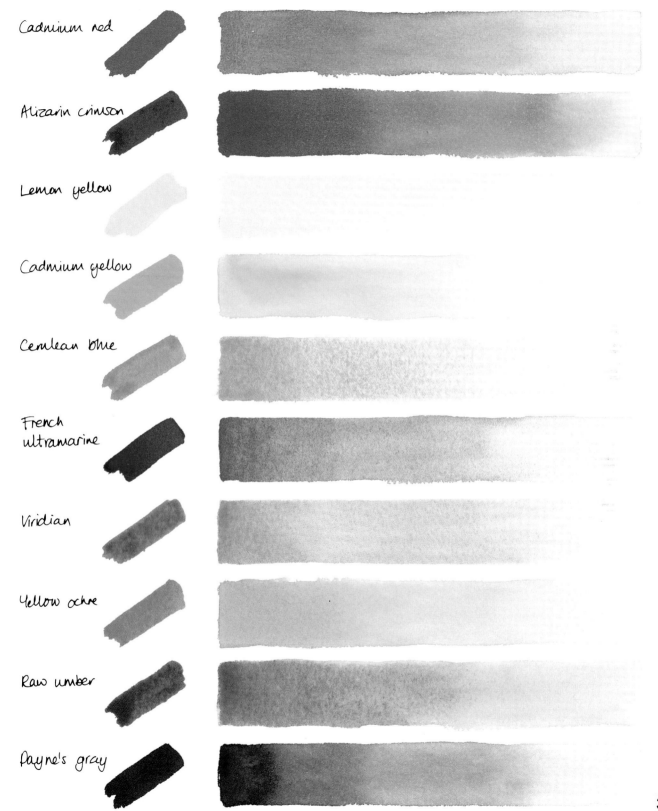

Cadmium red

Alizarin crimson

Lemon yellow

Cadmium yellow

Cerulean blue

French
ultramarine

Viridian

Yellow ochre

Raw umber

Payne's gray

The next stage is to practice making new colors from mixtures of the "basic palette" shown on p.23. There are only 10, which may seem a small number, but the charts show how many more colors those 10 can produce. The chart colors are all two-color mixes; you can make an even wider range by using three. It is not advisable to mix more than three, or all you'll achieve is characterless mud.

Color mixing

Charts like these are useful for reference, but you'll learn more if you do your own experiments on the same lines. First, though, here's a brief look at some of the properties of colors and the terms used to describe them.

Primary colors are the ones you can't produce by mixing other colors. They are blue, yellow, and red. Secondary colors are made by mixing two primaries, such as blue and yellow, which make green. Tertiary colors are mixtures of one primary color and one secondary, or three primaries.

You can buy both secondary and tertiary colors ready-made. (You already have three of them in your palette: viridian, raw umber, and Payne's gray.) However, you can achieve more variety of color through mixing – and it's fun.

▶ **CHOOSING THE RIGHT PRIMARIES**

The basic palette contains more than one of each primary color because artist's pigments comprise many different versions of each. Looking at the two reds, for example, you'll see that one veers slightly toward blue. Mixed with ultramarine, which has a slight red bias, this will make a good purple. To mix intense secondary colors, always choose the two that are related to each other in this way.

▶ **TWO-COLOR MIXES**

The chart shows all the colors in the starter palette (top and left-hand side) mixed with one another in a half-and-half proportion. When you experiment with color mixing you will discover how dramatically the proportions affect the mixture and how much stronger some colors are than others. Compare the cerulean and Payne's gray mixture on the far right of the chart with Payne's gray itself and you will detect little difference. This is because cerulean is a relatively weak color, and Payne's gray is strong.

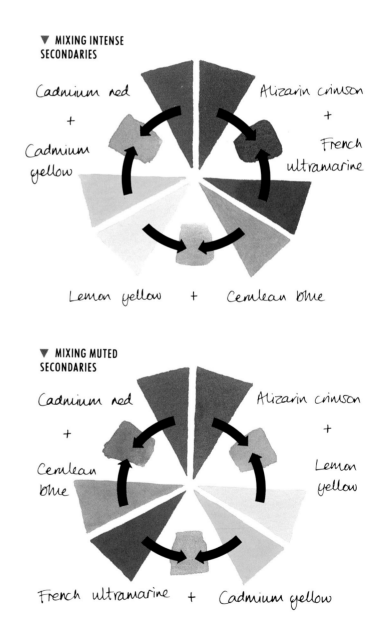

▼ **MIXING INTENSE SECONDARIES**

Cadmium red + Cadmium yellow

Alizarin crimson + French ultramarine

Lemon yellow + Cerulean blue

▼ **MIXING MUTED SECONDARIES**

Cadmium red + Cerulean blue

Alizarin crimson + Lemon yellow

French ultramarine + Cadmium yellow

Column headers (top, diagonal):
Cadmium red · Alizarin crimson · Lemon yellow · Cadmium yellow · Cerulean blue · French ultramarine · Viridian · Yellow ochre · Raw umber · Payne's gray

Row labels (left):
Cadmium red
Alizarin crimson
Lemon yellow
Cadmium yellow
Cerulean blue
French ultramarine
Viridian
Yellow ochre
Raw umber
Payne's gray

► **THREE-COLOR MIXES**

Although the primary colors are bright on their own or when mixed with another primary, a mixture of all three makes a neutral color, and often a more interesting one than a mixture of two secondary colors. Here, a small quantity of a third primary color (shown in the middle) was added to a mixture of two other primaries.

Alizarin crimson · French ultramarine · Cadmium yellow

French ultramarine · Cadmium red · Cadmium yellow

Cerulean blue · Alizarin crimson · Lemon yellow

39

Because watercolors are transparent, you can't make a color lighter by putting another one on top; you can only make it darker. Also because of this transparency, you can't achieve a really dark color with a first wash, as the white paper always shows through to some extent. This is done by laying one color over another. Building up a picture by overlaying colors, known as working "wet on dry,"

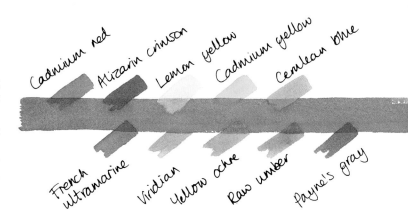

Cadmium red Alizarin crimson Lemon yellow Cadmium yellow Cerulean blue

French ultramarine Viridian Yellow ochre Raw umber Payne's gray

Overlaying colors

▲ **RELATIVE TRANSPARENCY**
Some colors are less transparent than others. The more opaque colors in the starter palette are cerulean, lemon yellow,

and yellow ochre. Any of these, used in a fairly strong solution, will lighten the value of a darker color beneath.

is the standard watercolor technique, although there is another method called working "wet on wet" (see p.64).

Overpainting is generally reserved for small areas of a painting. It isn't the ideal method for darkening a large area of flat wash as the new paint tends to stir up the layer below. Even in small areas, you need to take care, laying each new color quickly and with the minimum of brushwork. And you should aim at no more than four layers of color, as too many will spoil the fresh sparkle which is one of the attractive features of watercolor.

You can also change colors by overpainting, "mixing" them on the paper rather than in the palette. As the examples show, you can alter colors by painting light ones over darker ones. This is comforting, because it takes away the fear that nothing can be changed once it's down on paper. Don't rely too much on overpainting, though – it's still best to achieve the right color first time.

GRANULATION

When mixing colors, either on the palette or by laying one over another, you sometimes get an uneven, speckled, granular effect. This is caused by pigments separating from the water (the technical term is precipitation). At first you might wonder what you've done wrong, but it is one of the tricks that watercolor plays. It can be extremely effective, and artists often use granulation to suggest texture or simply to enliven a wash.

▼ The colors laid over French ultramarine in the panel below left are, from top to bottom: yellow ochre, cerulean blue, and alizarin crimson. The colors laid over cadmium yellow in the panel below right are French ultramarine, cerulean blue, and a mixture of raw umber and cadmium yellow.

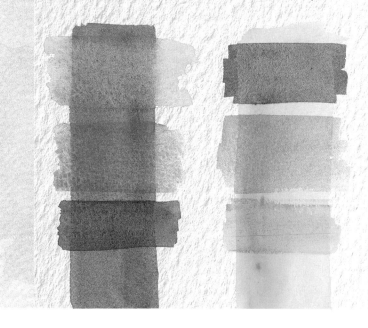

Cadmium red

Raw umber

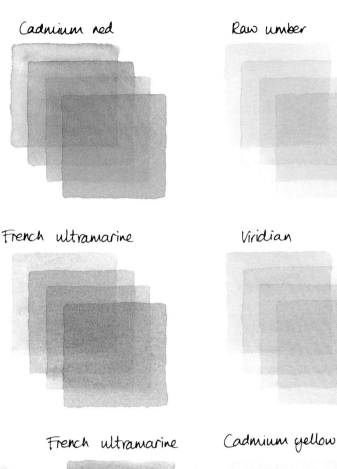

◄ OVERLAYING TO DARKEN COLOR

In watercolor painting, colors must always be overlaid to some extent, and the crisp edges so formed are among the charms of the medium. Make sure that the first color is completely dry, and work quickly so that each new layer of color does not stir up the one below.

French ultramarine

Viridian

Cerulean blue

French ultramarine

Cadmium yellow

Viridian

Alizarin crimson

French ultramarine

◄ LAYING ONE COLOR OVER ANOTHER

Although you can alter a color by laying another on top, you can't obliterate the first one; the new color will be a mixture of the two.

French ultramarine

Raw umber

Payne's gray

Cadmium yellow

Lemon yellow

Yellow ochre

◄ LIGHT OVER DARK

A light color applied over a dark one does not disappear. Although you can change the nature of an underlying color in this way, you can't significantly change its tone (value) – the lightness or darkness of the color – unless you paint over it with one of the more opaque colors.

41

A successful watercolor looks surprisingly spontaneous, which is one reason why so many people are attracted to the medium. But one of the paradoxes of watercolor work is that this apparent spontaneity can only be achieved through careful planning.

Before you start a painting, whether it's a landscape, a figure, or simply an object on a table top, you need to consider where you're

Planning
the washes

Different methods

All artists agree on the importance of making a preliminary drawing, but the procedure followed will differ according to individual working methods. This is illustrated in the work of two artists shown here and on the following pages. Each approached the same subject in an entirely different way. The work of Artist One runs along the top of the page with the work of Artist Two placed directly below to allow for comparison.

going to place the first wash. In a landscape you'll probably want to lay a flat or gradated wash for the sky, so you'll have to decide where the horizon is. There may be trees, buildings, or mountains jutting into the sky, so that you have to lay your wash around a series of edges.

Begin by making a drawing. This may seem a chore, but it is essential, and you'll find that you enjoy painting much more if you have mapped out a "skeleton" in pencil first. The drawing need not be detailed; a simple outline is best. Avoid shading, as pencil can show through the lighter colors.

Use a pencil that will neither dig into the paper nor smudge – a 2B grade would be a good choice. Use a soft plastic or kneaded eraser, because some papers scuff easily, and this spoils the surface for painting. If your subject includes straight edges, such as sides of buildings or the edge of a table top, don't be ashamed to use a ruler – anything that makes drawing easier is perfectly acceptable, and ruled lines won't show once you paint.

▶ *How would you go about painting these mugs? Try copying the photograph, but don't feel you have to follow the procedure suggested.*

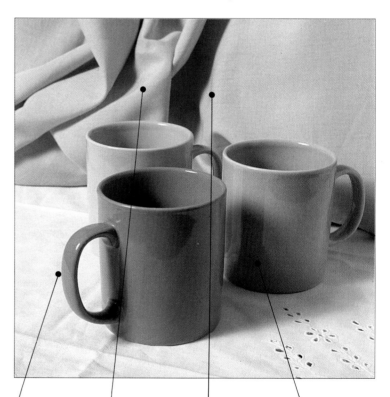

● **Make an outline drawing in pencil, taking care over the handles and tops of the mugs, which could be tricky.**

● **Lightly draw the main folds and shadows of the drapery. The drawn lines will show through the first wash and guide you when you darken the colors.**

● **Lay a pale blue wash over the entire background. It may be easier to turn the board upside down and begin with the tricky edge.**

● **Let the background wash dry and lay separate washes for each of the mugs. Leave the painting to dry before you begin to build with darker colors.**

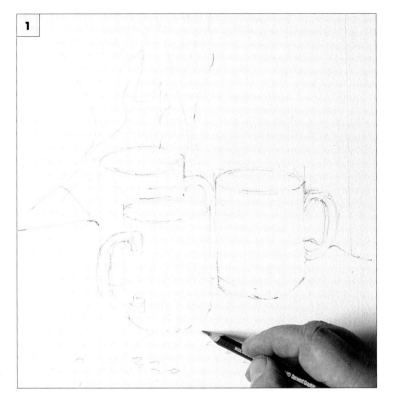

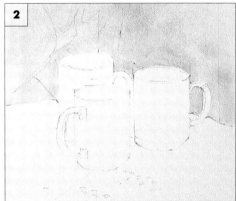

ARTIST ONE

1 He is using a very sharp 4B pencil for this preliminary drawing. The lines will be covered by the dark colors he will put in later.

2 Next he lays a deliberately uneven background wash. A flat wash would not be suitable, as he wants to suggest the play of light and shade on the drapery. This wash is left to dry.

continued ▷

ARTIST TWO

1 This artist varied the composition by turning one of the mugs on its side. She made a very light drawing with a 2B pencil.

2 She leaves the background unpainted until she establishes the colors of the mugs. The blue she uses for the shadow area will be overlaid with other colors later (see p.44-5).

continued ▷

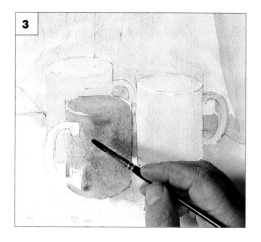

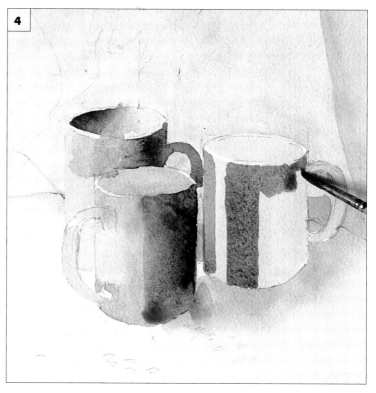

ARTIST ONE (cont.)

3 *Once the washes for the pink and yellow mugs have dried, the artist lays a gray wash. And, with the paint still wet, he gently dabs darker gray into it to create a soft shadow effect.*

4 *On the pink mug, a sharp boundary between light and dark areas exists, so the artist uses the wet on dry method to lay a pinkish-gray mixture over the first pale wash.*

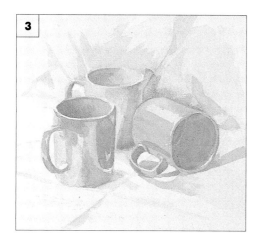

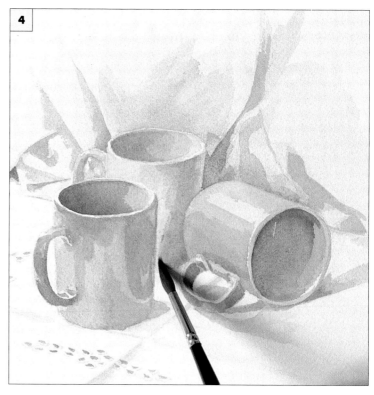

ARTIST TWO (cont.)

3 *The pinks and yellows used for the mugs were laid over the blue shadows (see p.43). All the colors are now in place, although they will be darkened by subsequent layers of color.*

4 *The artist decided to use a touch of yellow in the background to suggest a reflected color from the mug. She then paints the shadow on the mug in a color that blends with the background.*

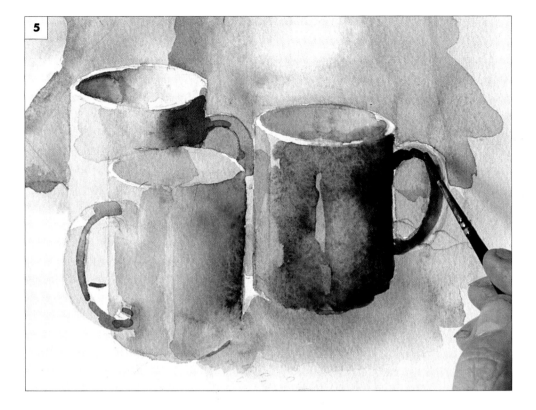

5 On the shadowed sides of the mugs, dark colors were worked into still-wet washes. This wet on wet method (see p.64) is ideal for soft effects. For the handles of the mugs a crisp edge is needed, so dark paint is applied over a dry wash. The contrast between hard and soft edges, apparent throughout the picture, is a feature of this artist's work. □

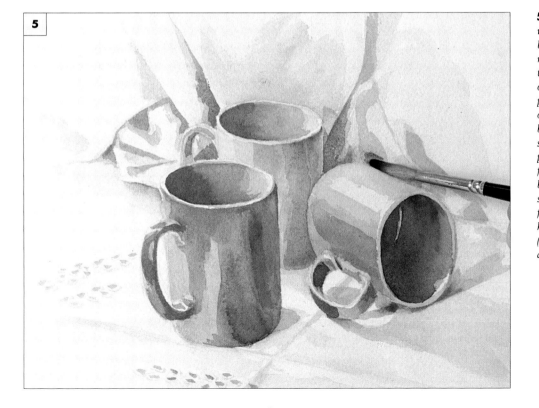

5 Even if you lay a wash for the background first, you may find that you have to darken it in places once the objects are painted. The pale pink of the mug needs to be brought out by contrast, so a deep blue shadow is painted behind it. The forms of the mugs were built with a series of separate washes, care-fully reserving the crisp highlights on the rims. (See p.46-9 for more about highlights.) □

White doesn't absorb light, as dark colors do, and watercolors derive their luminous quality from light reflecting back from the paper through the veils of color. This reflective quality is particularly important in the creation of highlights. Although you can make white highlights by putting on opaque white paint, the purest highlights are made by reserving: that is, leaving the paper bare.

Different methods

Each artist approaches highlights in a different way. One aims for clearly defined highlights, and the other seeks a more diffused effect.

GETTING TO KNOW WATERCOLOR

Creating highlights

▼ *Make your own painting from the photograph. In doing so, attempt to reserve highlights by painting around them. If you find small shapes difficult, use the masking fluid method demonstrated on page 80.*

You'll need to plan which areas of paper to reserve. This may entail a more elaborate drawing, depending on the size and shape of the highlights. On a curved reflective surface, such as a glass vase, you will probably see several small highlights. It's important to get their shapes and positions exactly right, because they are the vital clue to the vase's shape. A highlight in a landscape, on the other hand, could be a simple shape – a white house, say – which wouldn't present many difficulties.

When you make a highlight by reserving, the surrounding washes will form a hard, crisp edge. This can look effective, but is not always true to life; a rounded form will often have a gentler, more diffused highlight. In such cases you can easily soften the edges, either before or after the paint dries, with a brush or small sponge dipped into clean water.

MORE HELP WITH HIGHLIGHTS

If you find it difficult to reserve white paper for highlights, with your washes slipping over the edges to spoil the shapes, protect the white areas with masking fluid (see p.48 and p.80), a thick, rubbery solution sold in small bottles.

Tiny highlights, such as those on blades of grass where they catch the light, can't be reserved, even with masking fluid. For these you can use a simple method called scraping back: scratching into dried paint with a sharp point such as that on a craft-knife blade. Of course, not all highlights are pure white: many

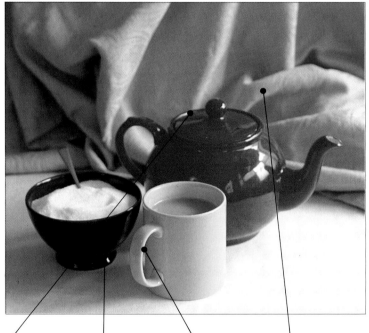

● Draw the position of the highlights on the teapot, and lay wash carefully around them.

● The highlight on the blue bowl reflects yellow from the mug. Reserve initially as white paper surrounded by dark blue washes, then lay a touch of yellow over the white.

● The highlight on the yellow mug handle could be left white. If it looks too bright when the other colors have been painted in, lay a light yellow wash over it.

● The highlights on the drapery could also be left white, or you could follow the procedure suggested for the blue bowl.

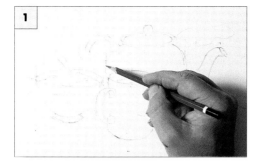

ARTIST ONE

1 *A good outline drawing enables the artist to place the highlights accurately. When highlights are on rounded forms, their shape is vitally important.*

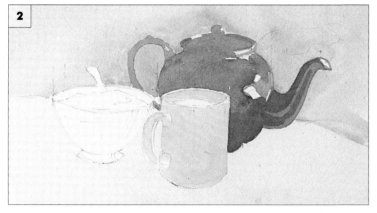

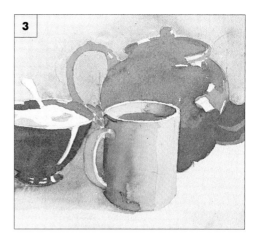

2 *Four separate washes were laid, and the highlights reserved by painting carefully around the white shapes. When laying washes around small shapes, it helps to turn the board sideways or upside down.*

3 *You'll sometimes need to simplify highlights. Compare this stage of the painting to the photograph to see how the artist has identified the main shape of the highlight on the teapot.*

continued ▷

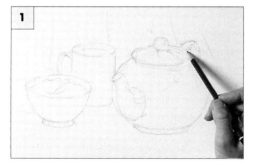

ARTIST TWO

1 *Again, a drawing is made prior to painting, and the shape of the main highlight is sketched in lightly.*

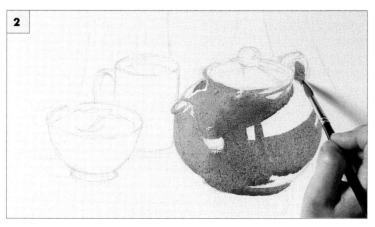

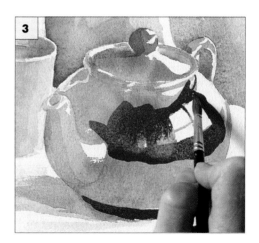

2 *The highlight is to be an important feature of the painting, so the teapot is painted first. Because the pot has a reflective surface, the edges of the highlights are crisp, an effect the artist wants to fully exploit.*

3 *The background and the other objects were painted with all the highlights reserved as white paper or a pale color. The artist now begins to build darker colors.*

continued ▷

ARTIST ONE (cont.)

4 *The highlight on the body of the teapot, although less precisely defined than in the other artist's picture, is accurately placed, and so are those on the lid and rim of the bowl.*

5 *The highlight on the bowl makes an exciting shape, so the artist chose to exaggerate it slightly.* ☐

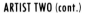

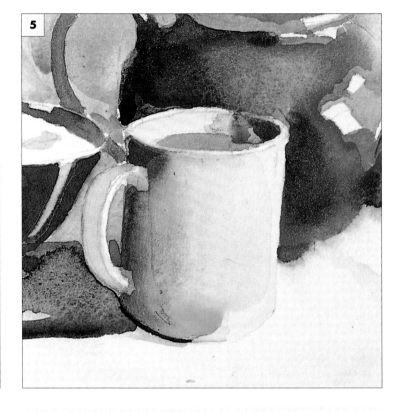

ARTIST TWO (cont.)

4 *The softer highlight on the spout of the teapot is made by reserving the lighter color, that is, painting darker washes around the original light pinkish brown.*

5 *The strong white shapes make an exciting pattern. Before painting, the artist moved the teapot around until she found the position that gave the most interesting highlight.* ☐

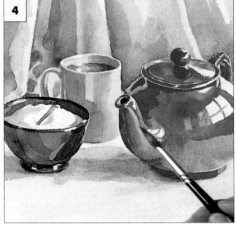

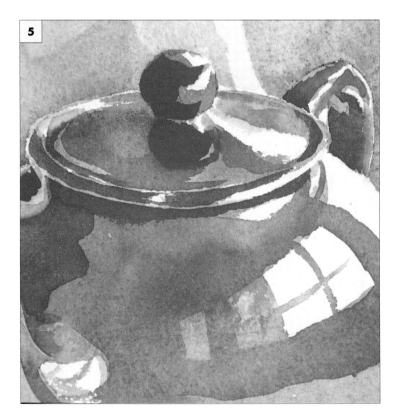

are a paler version of the main color of the object. You can still use the reserving technique – laying a light wash and putting darker colors around the highlight – but there are two good alternatives, both of which involve leaving the highlight until last.

One way is to paint on top of the color with slightly diluted Chinese white or white gouache. The white will sink slightly into the color below, giving a soft effect, perfect for matte surfaces. The other way is to lay your wash and then "lift out" some of the wet paint by blotting with a small sponge or a cotton ball. You can't control the shape as precisely as you can by reserving or using opaque paint, so this method is more suitable for soft, diffused highlights than for sharp, clear ones.

FOUR ALTERNATIVE METHODS

1 *Here masking fluid was used for the highlights on the rim and handle. Paint it on, leave it to dry, and then paint over it. When the washes are dry, remove the fluid by rubbing with a finger or eraser.*

2 *It's difficult to reserve fine-line highlights with masking fluid because it is so thick, but it's easy to paint them in with Chinese white.*

3 *Not all highlights are crisp and hard-edged; on matte surfaces they are soft and diffused. You won't be able to achieve this effect by reserving, but you can by lifting out. Here a piece of tissue is lightly dabbed into still-wet paint; you could also use a sponge, or for tiny areas, the tip of a paintbrush.*

4 *Another method for fine highlights is scratching into dry paint with a knife. This must always be the final stage in a painting, because the knife will scuff the paper, and you won't be able to paint over it without making blotches.* □

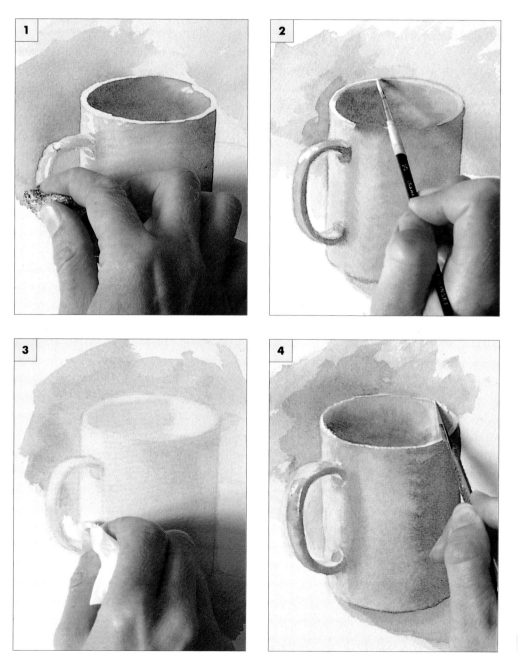

The form of any object, whether a teacup, a tree, or a human face, is defined by the light that falls on it. The lightest and brightest parts are where the light strikes directly; the shaded, or shadowed, ones occur wherever the object turns away from the light.

Another kind of shade is the cast shadow, made by the object blocking the light rays (when you're sitting in the "shade," you're

Light and shade

actually sitting in the shadow cast by a tree or building). A discussion of cast shadows follows, but first you'll experiment with making things look solid by painting the light and shade on the objects themselves.

Unless you work on dampened paper, watercolor washes will dry with hard edges. This is helpful when you're painting a building or table, where the divisions between the shaded and light-struck areas are clear. It is less so when you want to depict a rounded form with soft transitions between light and shade. Solve the problem by laying two or more washes side by side, blending them gently into one another. Take care not to over-work, though. Too many blended overlays of color can begin to look tired and muddy, so try to judge the strength of the darkest part correctly. You may find it helpful to paint a few "swatches" on a spare piece of paper and hold them up to the object to check the strength of your darkest color.

Modeling form

When depicting the form of an object you should adapt your technique to suit its shape. For example, it would be difficult, if not impossible, to give a realistic impression of a crisp-edged object such as a table if you let the colors run into each other. The demonstrations on this and the following pages show how the two artists have tackled three very different subjects.

First you have to work out how dark the shadows are in relation to the highlights. This helps you decide how strong or weak each mixture should be. It is difficult to judge tones, because your eye registers the colors first; it helps to half close your eyes.

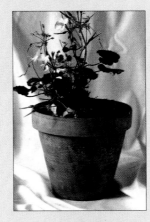

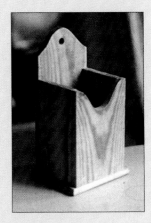

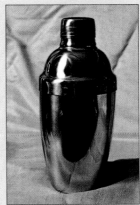

Practice trying to turn objects into black and white photographs in your mind.

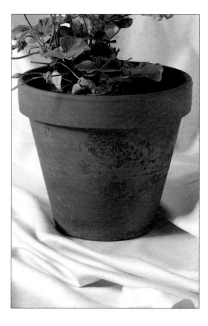

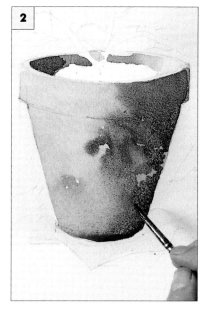

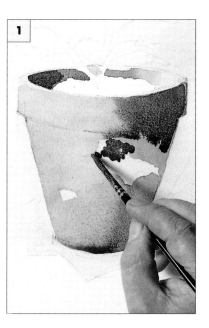

BLENDING COLORS

The intensity of the light and the texture of the object will determine the degree of contrast between light and dark areas. The surface of terra cotta doesn't reflect much light, so the contrasts are relatively small.

1 The artist began by laying a light pink-brown wash and working darker color into it while still wet. He creates the mottled area with blobs of dark green dropped into very light yellow.

2 Because the first washes were not allowed to dry completely, the dark colors blended into the lighter ones to give a soft effect. Hard edges and obvious light-dark contrasts would not suit the subject.

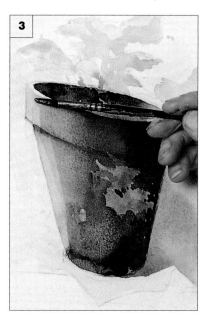

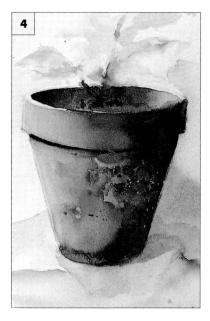

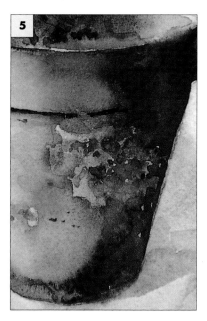

3 The colors were strengthened all over the pot, leaving a small strip of light color at the edge. Using the tip of the paintbrush, the artist works the colors lightly into one another.

4 The pot looks convincingly solid and rounded, with the colors well blended but not overworked. The only hard edges visible are those on the rim of the pot and the tiny light strip on the left side.

5 Effects like this patch of mottled light and dark color need careful handling or they may dominate. In Step 4, the overall color was too light, so blobs of dark blue were laid on top in the final stages.

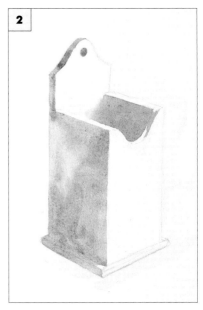

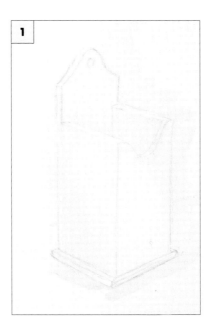

PAINTING HARD EDGES

On curved surfaces, the light areas flow into the darker ones with no obvious boundaries. But on a square-edged object like this, the divisions are clear, and the shadowed side can be surprisingly dark.

1 Although the shadowed areas are much darker than the light-struck ones, the predominant color is yellow-brown. A pale wash is laid over nearly all of the object and the background.

2 When clear edges are needed, each wash must be allowed to dry before another is put on. If the paper is at all damp, the shadow color could "bleed" into the lighter areas and destroy the effect.

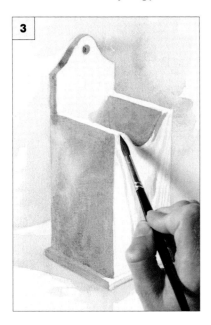

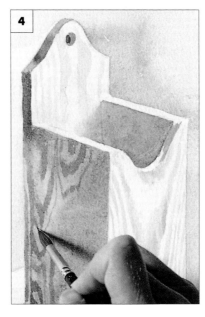

3 As in the case of the terra cotta pot on the previous page, the texture of this object is an attractive feature. Without some indication of the wood grain, it could look characterless.

4 The grain of the wood is painted with the tip of a pointed brush. You'll see from Step 2 that the wash over which the artist is painting was not flat; small variations of color create a more realistic impression.

5 The strength of the colors used for the wood grain was carefully assessed. On the light-struck surfaces they are hardly more than a "whisper."

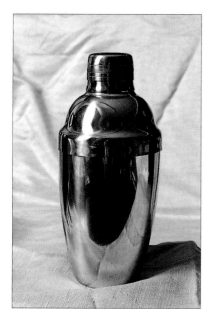

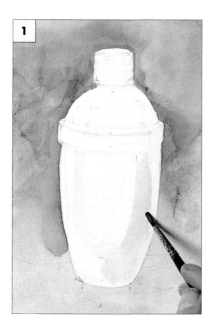

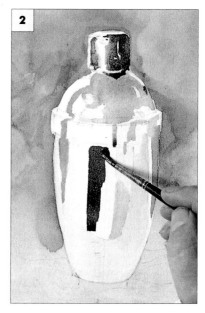

PAINTING REFLECTIVE SURFACES

The reflective surface of metal creates strong highlights and dark shadows. An object like this will also reflect anything else that happens to be near it, which can create a jumble of shapes and colors.

1 *The background is painted first, and a little of the same color applied to the mid-toned parts of the cocktail shaker, large areas of which are to remain white.*

2 *When using strong contrasts of color it is helpful to put in some of the darkest ones early on. Once you have the darkest and lightest colors in place it is easier to judge the middle ranges.*

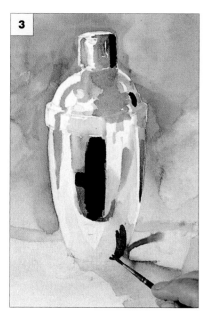

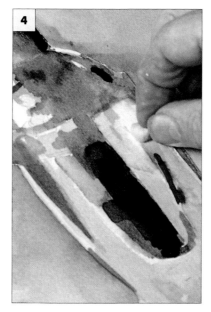

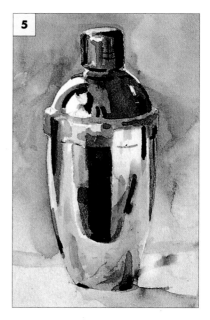

3 *The curve of the dark shadow at the base of the shaker helps to describe its shape. This, too, is put in at an early stage. The color used is Payne's gray, mixed with enough water to moisten it.*

4 *Although most of the shadows and highlights are sharp, there are softer areas of blurred reflection. A cotton ball is used to lift out paint for one of these gentler highlights.*

5 *One of the most exciting things about shiny surfaces is the number of different colors they reflect. Here you can see a range of pinks, pinkish-browns, and gray-greens in addition to the whites and near-blacks.*

Shadows are very important in painting for two reasons. First, they act as an anchor, "tying" an object to whatever it is standing on. If you're painting a pitcher on a table, for example, and you leave out the shadow below it, the pitcher will look as if it's floating in space. Second, shadows are a good way to make your picture look more interesting.

Cast shadows

In a still life you can use cast shadows to make links between objects. In a landscape you can feature the intricate patterns created by the shadows of winter trees, or the dappled effects in a summer woodland. Don't forget that shadows have their own colors. Beginners often paint them brown or gray, but they seldom are. See if you can detect blues, greens, or purples in them.

There are two ways of painting shadows. First, take the example of a shadow on a patterned tablecloth. The best method would be to paint the tablecloth with its pattern, let the paint dry, then lay the shadow on top. Even if the shadow is fairly dark, the colors below will show through. Now suppose the tablecloth is colored but plain. You can do the same as before, but another approach would be to use two separate washes, one for the shadow and another for the lighter areas, blending them where you want soft edges. The first method is probably easier, but as always, don't overwork; shadows should be luminous, and you won't achieve this quality if you keep adding washes.

Different methods

If you were to ask a group of artists how they paint cast shadows, each one would probably give a different answer. You'll ultimately discover a method that works best for you. In the meantime, observe how two artists tackle the task.

▼ *Make a painting from the photograph without referring to the demonstrations. If you're not satisfied with the result, try the methods opposite and see which you prefer.*

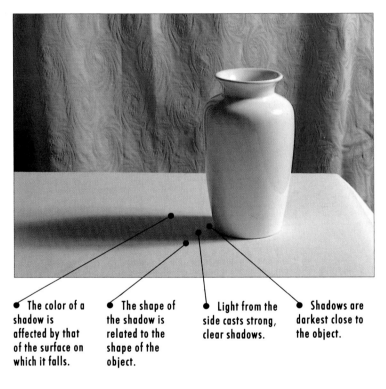

● **The color of a shadow is affected by that of the surface on which it falls.**

● **The shape of the shadow is related to the shape of the object.**

● **Light from the side casts strong, clear shadows.**

● **Shadows are darkest close to the object.**

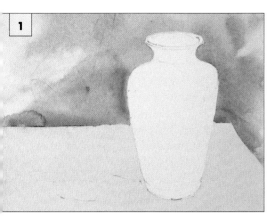

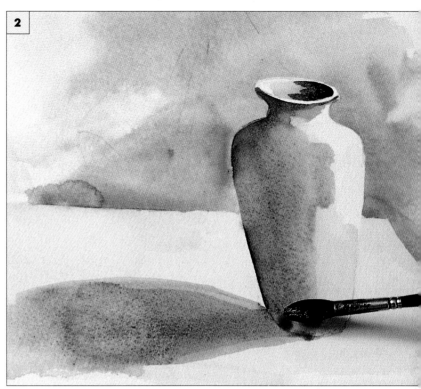

ARTIST ONE

1 *Shadows often have some blue or green in them, but their color is always related to that of the surface on which they are cast. This artist painted the main color first so that a little of it shows through the shadow color.*

2 *Blue-gray is painted over the yellow and up the side of the vase. The darkest parts of a shadow are directly below the object. To create the soft effect at the far end, the blue wash was blended slightly into the yellow.* □

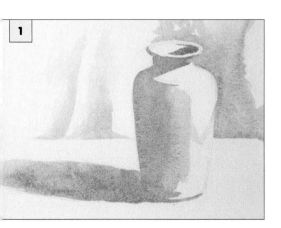

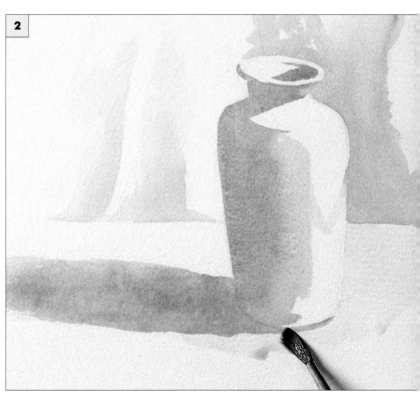

ARTIST TWO

1 *Here the shadows were painted first. Again, the same color was used for the cast shadow and the dark side of the vase; since both cloth and vase are yellowish, the shadows are also similar in color.*

2 *This time the yellow cloth is painted around the shadow, overlapping it in the foreground just below the vase. The soft edge at the end of the shadow was achieved by adding more water to the wash in that area.* □

It isn't always easy to decide where and how to begin a painting. The standard advice about watercolor is that because the colors are transparent, you have to work "from light to dark." This means that when putting color on in layers, you must begin with the lightest ones, because you can only make colors darker by adding a layer. It does not mean that you must always start with the palest bit of the picture.

Where do I begin?

Suppose you're painting a bunch of white flowers in a dark blue vase against a light blue background. The conventional method would be to lay a light blue wash over the vase and background, reserving the flowers and any highlights as white paper, let this dry, and then paint the vase on top. But you could begin with the vase, and paint the background around it. Some artists prefer to put down areas of dark color first, because this gives them a point of reference for the rest of the picture.

Whichever method you choose, your first task is to analyze your subject in terms of light and dark blocks of color. Look at the photographs on these pages and see whether you can figure out which colors you would put on first. Then turn the page to see how the artists dealt with the same still life subject each going about it in a slightly different way.

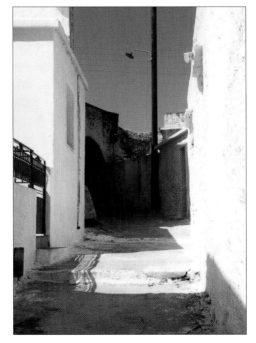

Order of working

Because there are no rigid rules in watercolor painting, it can be hard to know how to begin. The diagrams indicate a possible order of working, starting with the lightest areas and finishing with the darkest.

PAINTING BUILDINGS
1 *First make a drawing, then lay a flat or gradated blue wash for the sky and leave it to dry. Lay a very pale wash, perhaps yellow ochre with a touch of alizarin crimson, over the rest of the painting.*
2 *Paint the shadowed side of the building, then begin to darken the colors in the central area and foreground shadow. Paint the lamp post over the other colors.*
3 *Add further dark washes to the central area (notice shadows are blue-gray) and then begin to build up detail on the buildings.*
4 *Continue to add detail and strengthen colors where necessary.*

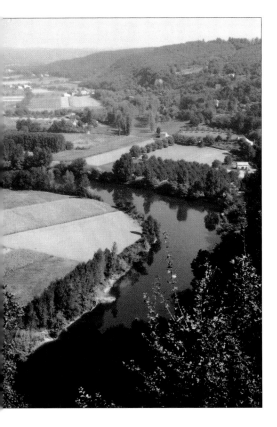

PAINTING A LANDSCAPE

1 *Draw the main shapes. Lay a pale wash for the sky and a slightly darker one for the distant hills. Lay ochre washes over the main areas of the painting, but not the river. If blue is painted over ochre, it will turn green.*

2 *Paint water with mid-blue wash.*

3 *Start on all the green areas, painting over the ochre washes. Begin in the distance with pale washes, building to darker color in the foreground.*

4 *With all areas blocked in, gradually add detail and strengthen colors, reserving ochre highlights in the foreground.*

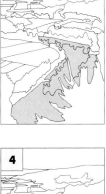

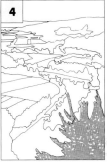

PAINTING A STILL LIFE

1 *Make an outline drawing, then lay a light yellow-brown wash over the background, reserving white flowers. Leave it to dry.*

2 *Lay separate washes for the vase and the blue pot.*

3 *Block in the checked cloth with blue, reserving white squares. Block in the main shapes of leaves, painting individual leaves over the background wash.*

4 *Begin to add detail and continue to darken colors where necessary.*

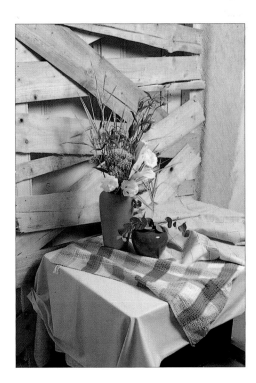

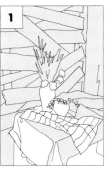

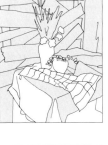

57

ARTIST ONE

1 *This is quite a complex subject, so the drawing needs to be fairly detailed. The artist gave himself guidelines for the shapes of the flowers and the pattern on the cloth.*

2 *The background washes were laid and left to dry. A light pink-brown was applied to the vase, and is dabbed here with absorbent cotton to create soft highlights.*

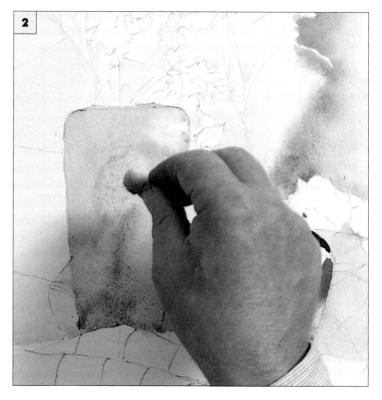

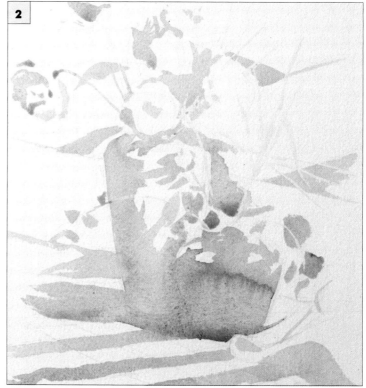

ARTIST TWO

1 *This artist wants to feature the spiky variegated leaves. After completing her drawing she painted the leaves with masking fluid before laying the first washes. Notice that she did not begin with the background.*

2 *Her method of working is the same whatever the subject. She starts by blocking in all the shadows in light blue, and lays other colors over this as the picture proceeds.*

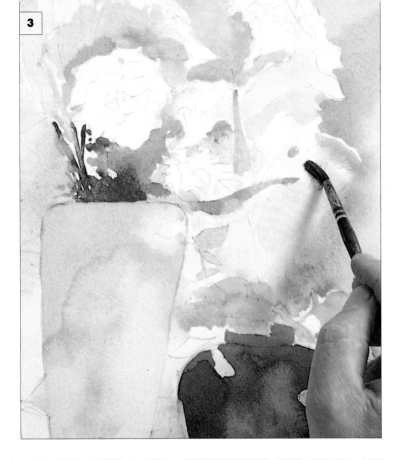

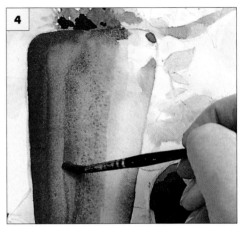

3 *Having blocked in the blue pot and strengthened the yellow background behind the white flowers to make them stand out better, the artist starts to paint the leaves.*

4 *He uses darker colors, blended wet on wet, to model the vase. It is easier to judge the strength of the colors used for the rest of the painting when some dark ones are in place.*
continued ▷

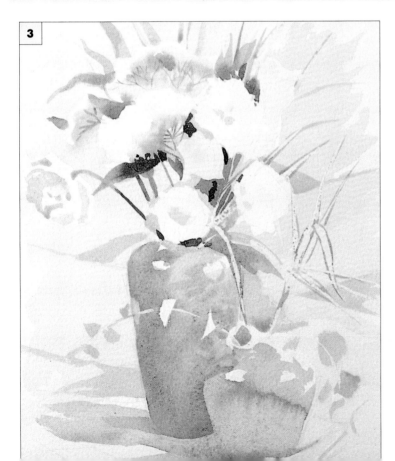

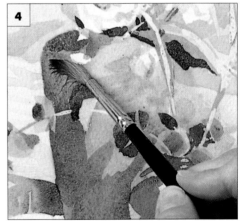

3 *The yellow background was painted over the blue "underpainting," with the white flowers reserved. Laying one color over another produces a mixture, as seen on the vase and in the shadow behind it.*

4 *Detail was added to the flowers and leaves. Now the vase is darkened in places without spoiling the edge of the highlight.*
continued ▷

59

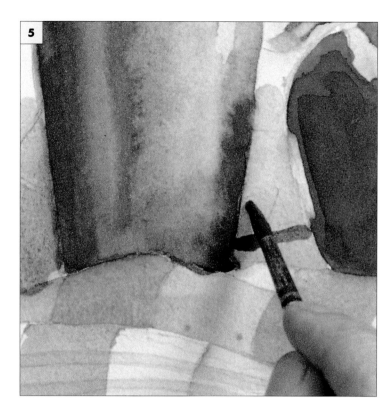

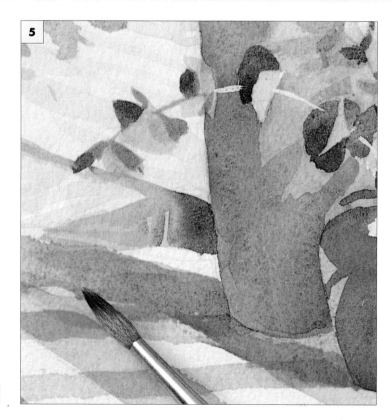

ARTIST ONE (cont.)

5 *The color of the blue pot was strengthened, and touches of the same blue were used for the pattern on the cloth and the deep shadow on the side of the vase.*

6 *The larger highlights on the blue pot were created by reserving, but for these tiny ones, Chinese white is laid over the dry paint with a fine brush.*

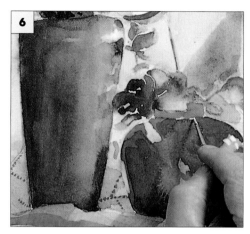

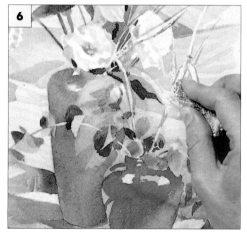

ARTIST TWO (cont.)

5 *The tablecloth pattern was painted and allowed to dry before the deep shadow is added. The edges are softened with a brush dipped in clean water.*

6 *The masking fluid is removed with an eraser, leaving clear white shapes against the yellow background. Some was erased at an earlier stage and overlaid with yellow to create the effect seen in step 7.*

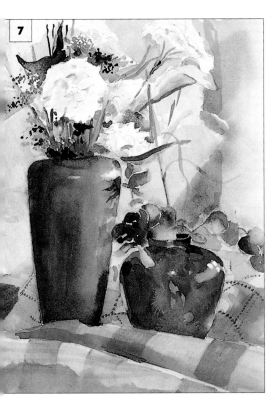

7 The painting is complete. Notice that the artist didn't paint the white flowers in detail but retained his pencil drawing, which gives all the definition needed.

8 Chinese white was used only in the final stages. Sometimes, when you've almost finished a picture and can judge the relationships of all the colors, you'll notice that a highlight is not bright enough. □

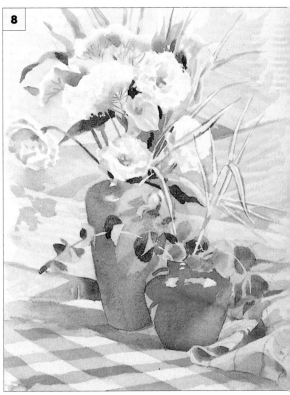

7 The light centers of the long leaves stand out against the dark colors. Opaque white mixed with a tiny amount of green was used for the pale blue- greens on the rounded leaves.

8 Flower paintings need a light touch; you want to convey a feeling of freshness and life. Although the two artists' methods are different, both avoided overworking the paint by trying to put in too much detail. □

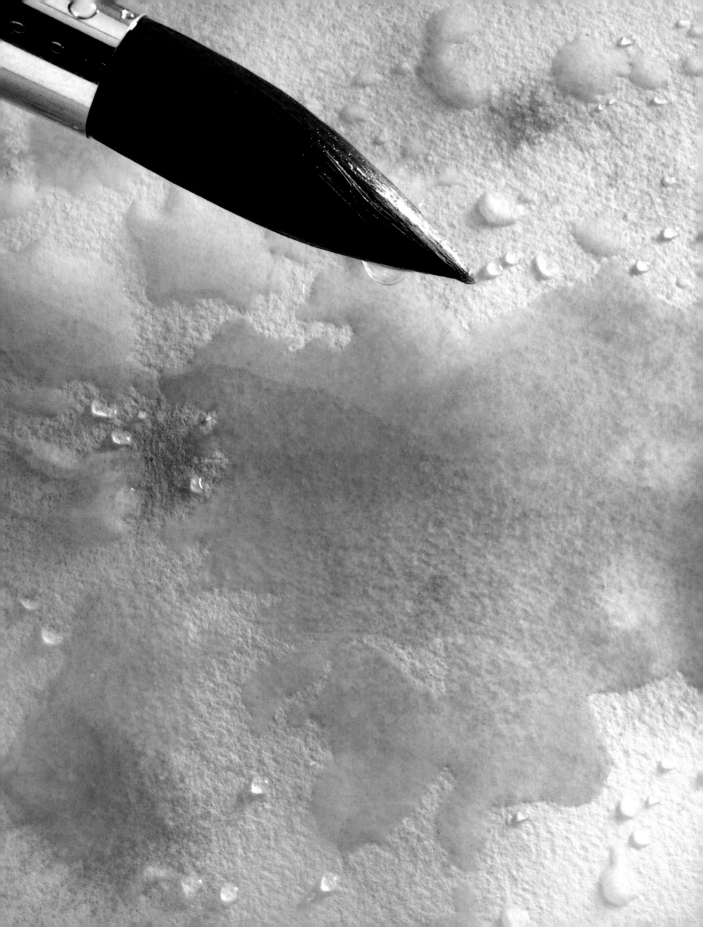

3

Developing your skills

ainting wet on dry means allowing each wash to dry before putting on another color (see p.40). In the wet on wet method new colors are added to damp washes so that they bleed into one another, creating soft edges and a variety of exciting effects.

The two techniques are not entirely separate. And, it's difficult to avoid painting wet on wet altogether. The variegated wash

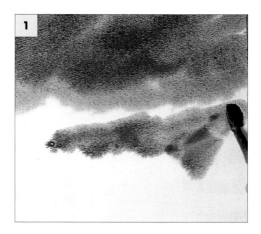

► *Mop brushes are ideal for large areas painted wet on wet.*

Working wet on wet

DEVELOPING YOUR SKILLS

(p.34) is a step toward wet on wet, and so is blending (p.50). Most watercolorists use the two methods hand in hand.

Painting wet on wet over a large area involves a lot of water, so you must stretch the paper (see p.24). Even a heavy paper is liable to buckle. You'll also have to work fast, because the paper must remain wet, or at least damp, all the time. This doesn't mean that you have to dash off a picture in 10 minutes, or even half-an-hour, because well-dampened paper takes a while to dry. Apart from these two cautions, there are no firm rules: one of the great attractions of working wet on wet is that it is never predictable.

CONTROLLING THE PAINT

The effects vary according to how wet or dry the paper is. However, you can exert some control. Placing a loaded brush of wet paint into a

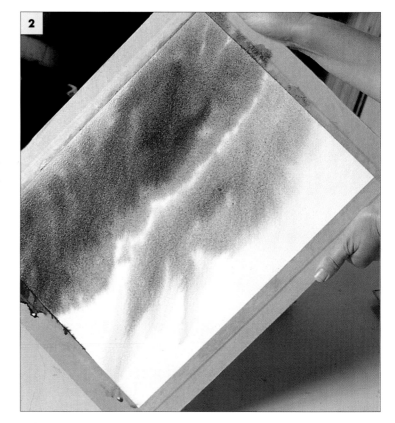

CONTROLLING PAINT FLOW

1 *Working on stretched and well-dampened paper, the artist begins by dropping dark gray paint into light to create the effect of heavy clouds.*

2 *Holding the board sideways at a sharp angle makes the paint flow toward the bottom corner. You can exert control by varying the angle of the board; if the paint flows too far in one direction, simply reverse the angle.*

3 *The mountain was created by allowing the paper to dry slightly, laying a rough band of gray, and tilting the board upside down until the paint flowed into a suitable shape. The board was then laid flat.*

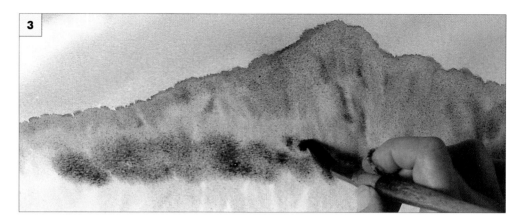

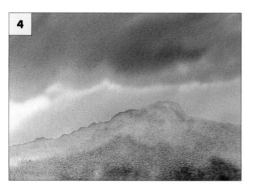

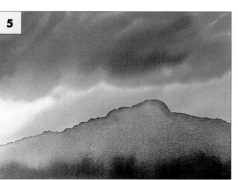

4 *The paint will continue moving until it has dried. Be prepared to lose an effect you liked. The detail added in Step 3 became a series of blurred, rounded shapes.*

5 *The color flowed upward and downward, creating a jagged edge at the top of the mountains, and giving a realistic impression of a dark forest below.*

Morning Headland – Robert Tilling

This artist exploits the wet on wet method extensively in his atmospheric seascapes, but always combines it with wet on dry work. The sky and parts of the sea were painted wet on wet. The paper was allowed to dry before the dark headland – which required crisp edges – was added, and darker blues introduced into the sea.

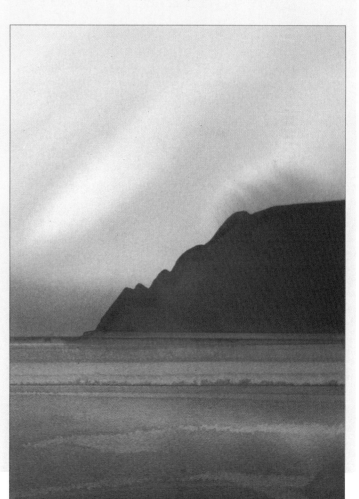

sopping-wet wash is similar to dropping a stone into water: the weight of the water in the new brushstroke causes the first color to draw away, so that the two don't mix, although they may bleed into each other. If the paper is just damp, the colors will blend more subtly.

Artists who work in this way learn to judge exactly how wet the paper must be, something that only practice can teach. Another way of controlling the paint is by altering the angle of the board. If the board is flat the colors will stay more or less where you put them, but by tilting it you can make the paint flow downward, upward, or even sideways. This can be a useful method for subjects such as rainy skies, or flowers, where drips of paint can suggest leaves or petals.

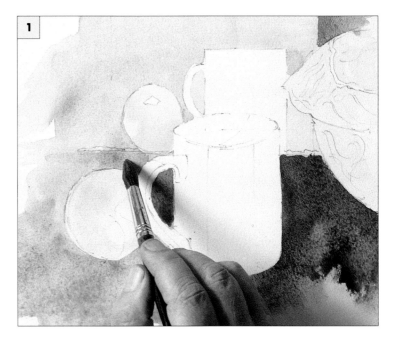

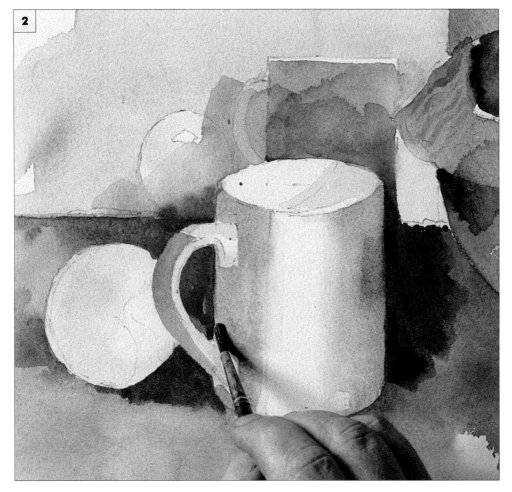

COMBINING WET ON WET WITH WET ON DRY

1 *Because he wants to paint wet on wet in certain areas of the picture while keeping the edges of the objects clean, the artist works on dry paper. Here he lays touches of fresh paint into a damp wash.*

2 *Before working on the mug, he used a hairdryer on the background washes. Dampness would cause the dark color to run into the lighter one used for the side of the mug, destroying the definition.*

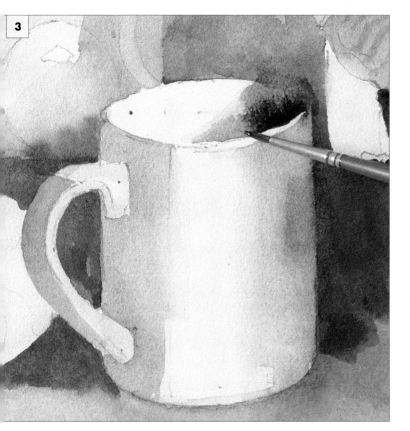

3 *The wet on wet method is used again on the right-hand side of the mug and for the shadow inside the rim, for a soft effect. A small, pointed brush allows a precisely controlled application of paint.*

4 *This is an effective use of contrast between hard and soft edges. Although it is enjoyable to drop colors into still-damp ones to see what happens, the best results come from combining the fuzziness of wet on wet with the clarity of the wet on dry method.*

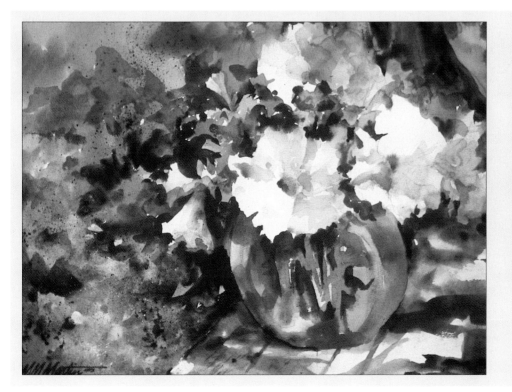

**Dancing Shadows
Margaret M. Martin**

This painting shows a thoughtful combination of the two techniques. Most of the left-hand side and much of the background is painted wet on wet, so that the shapes and colors are suggested rather than literally described. In the center, however, wet washes were laid carefully around the edges of the petals, giving sharp, clear definition.

There's a common belief that brushwork is only important in oil paintings. Watercolors are painted in gentle flat washes, are they not? Well, yes and no. You can paint entirely in washes, as with wet on wet, where you certainly can't see any brushmarks. But, the marks of the brush can be quite expressive. Some watercolorists build entire paintings by drawing with their brushes, using few if any

Brushwork

► Brush held almost upright. Light stroke made with tip.

flat washes, as in classical Chinese painting with its almost calligraphic brushstrokes.

It is worth practicing brush drawing. Try out different brushes and vary the way you hold them and the pressure you exert. See if you can duplicate some of the marks here.

Drawing with a brush is very satisfying, and discovering the range of marks you can make will help later on. A picture painted mainly wet on wet usually has small details laid in with a flick of the brush. And you'll paint with more confidence if you know how best to represent the foliage on a tree, the leaves or petals of a flower, waving grass in a field, or reflections in moving water.

▲ Brush slanted, pressure reduced at end of stroke.

► *Beginning painters often assume that a brush should be held tightly between two fingers and the thumb, like a pen. Although this is fine for detailed work, it does not allow much variety. To loosen up your brushwork, try different hand positions to see how they affect your strokes. Also vary the pressure on the brush, drawing the paint out lightly or flicking it at the end of a stroke.*

▲ Brush held near the top. Light pressure.

▲ Brush twisted in mid-stroke.

The Garden, Summer
Paul Millichip

Although there are some flat washes, the brushwork in this painting gives it a feeling of energy and excitement. Long, tapering strokes have been used for the tree and the grass on the left of the foreground. The foliage is depicted with shorter marks in varying shapes and sizes.

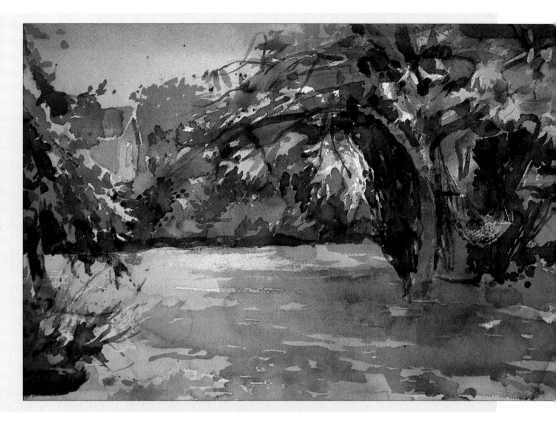

Environs of Pamajero
No. 105
Alex McKibbin

This is one of a series of paintings of the woodland near the artist's home. It consists almost entirely of separate brushstrokes; long, sweeping, directional ones for the tree trunks and banks in the foreground, overlaid in places with shorter marks. Small, flicking sideways strokes were used for the leaves. The effect of dancing light is beautifully captured.

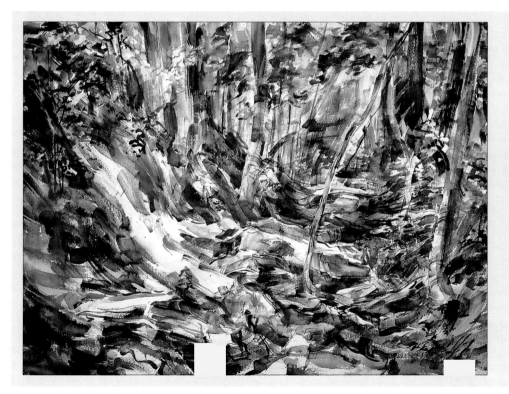

ry-brush painting is another kind of brush-work, but is very different from the calligraphic approach. In dry brush painting you work with the bare minimum of paint on the brush, dragging it over the paper so that it catches on the raised grain but does not sink into the paper as a wash does. It is a useful watercolor technique, particularly where you want to create texture: animal painters use it

Dry brush

for painting fur; portrait painters for hair; and landscape painters for depicting grass, weathered stones, or the hazy effect of distant winter trees merging into the sky.

You can build complex color effects by working one layer of dry brush over another, splaying out the bristles to make a series of little parallel lines.

The best way to ensure that you don't put on too much paint is to dip the tip of the brush into the paint mixture and then dab it lightly on a paper towel. It takes practice, so experiment on a spare piece of paper before working on a painting.

A word of warning: Once you've got the hang of the technique you'll find it so easy that you may over-use it, and too much dry-brush work in one painting can look monotonous.

LANDSCAPE TEXTURE

1 *Depending upon the effect you want, you can work on white paper or on top of light washes (which must be dry), as shown here. To outline individual grasses, a pointed brush with very little paint on it is dragged lightly over the paper. The color catches only on the raised grain. The effect is a broken line, similar to that made by charcoal on rough paper.*

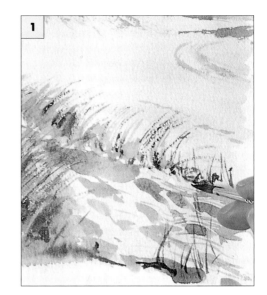

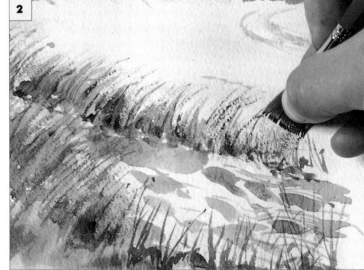

2 *The artist uses a square-ended brush for the larger clumps of grass. The hairs of the brush are splayed between thumb and forefinger and pushed gently over the paper.*

3 *Dry-brush work creates a realistic impression of the windblown marram grass, and a nice contrast with the larger, "wet brush" strokes used for the immediate foreground. The fine white lines, where the sun catches a few of the grasses in the foreground, are made by scratching into dry paint with the point of a knife.*

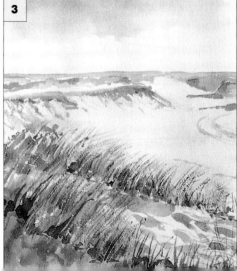

ANIMAL TEXTURE

1 *As before, dry-brush work is applied over washes. The main colors of the horse's head are lightly painted and allowed to dry before shadows are added.*

2 *A square-ended brush is dipped into paint and partially dried. Make sure that there is not too much paint on the brush by experimenting on a spare piece of paper before painting.*

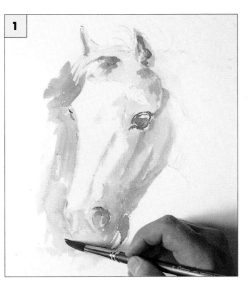

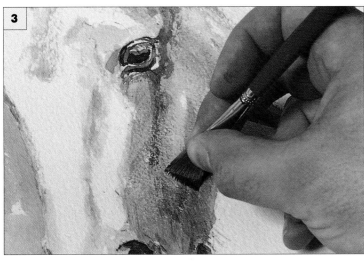

3 *Because he wants to give just a hint of the hair texture, the artist uses a color that is only very slightly darker than the wash beneath, and makes quick, light brushstrokes.*

4 *By means of successive light applications of dry brush, the artist models the forms accurately, suggesting the different textures of the horse's head and mane.*

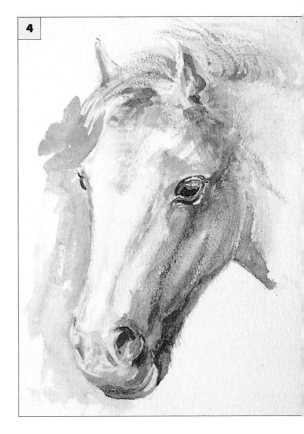

If you're interested in landscape or architectural subjects, you'll find that one of the problems you face is showing texture. How, for example, do you set about painting a sandy or pebbled beach, or the lightly pitted surface of old stone or brickwork?

There are several tricks to use. Dry brush is one of them, and sponge painting (see p.76) is another. You can even abandon the tradi-

▲ *Toothbrushes are good for spattering, but you can also experiment with other implements, such as a nailbrush.*

DEVELOPING YOUR SKILLS

Spattering

tional brush and wash method and spatter paint onto the surface with an old toothbrush.

Spattering can create exciting effects provided you don't overdo it. It works best when it doesn't look too obvious, so keep the color and tone of the spattered paint close to that of the wash below. You can use the same paint for both wash and spatter – the spatter will be slightly darker because you'll have added an extra layer of paint. You'll find that paint flicked on in this way sometimes travels too freely. To avoid spoiling other parts of the painting, use a rough mask cut from paper.

A variation on the method is water spatter, where you flick droplets of clean water into a wash. You can do this either when the wash is very wet or just damp – water spatter is often used in conjunction with wet on wet (see p.64). It isn't as good for texture as paint spatter, but it has other possibilities.

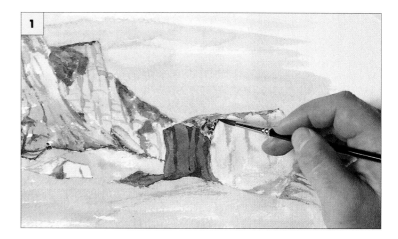

WATERCOLOR SPATTER

1 *Spattering is one of the final stages in a painting. Here the artist has completed the cliffs and rock. The foreground, however, looks fairly flat and lifeless.*

2 *Because he wants to prevent the spattered paint from going over the finished areas of the picture, the artist masked these with tracing paper. He now spatters two layers of paint over the light brown foreground wash.*

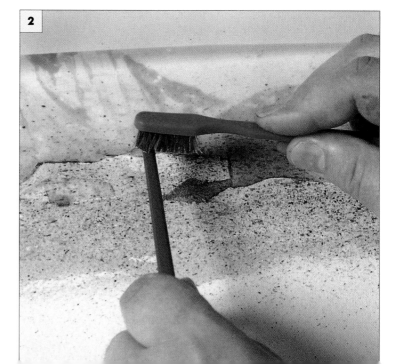

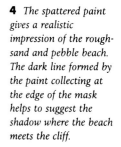

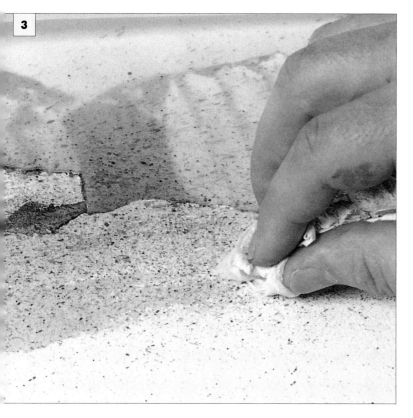

3 Any over-large or over-dark blobs can be removed with a cotton ball or sponge while the paint is still wet.

4 The spattered paint gives a realistic impression of the rough-sand and pebble beach. The dark line formed by the paint collecting at the edge of the mask helps to suggest the shadow where the beach meets the cliff.

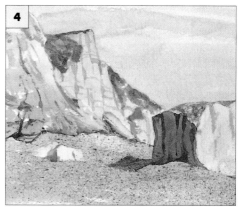

Still Life with Grapefruit – Rachel Gibson

Spattering can be purely decorative. Here it provides a touch of additional interest in the background. The pattern on the *wallpaper was painted with masking fluid (see p. 80). Paint was then spattered on top and the fluid removed, leaving clear white marks.*

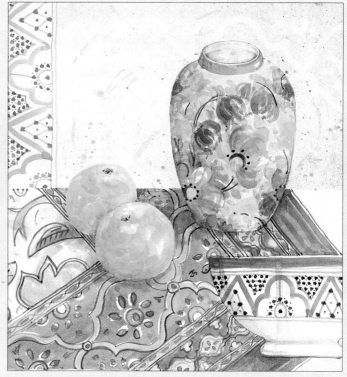

GOUACHE SPATTER

1 *Occasionally you will encounter an effect, such as the fine spray of windblown foam above a breaking wave, that is difficult to render in transparent watercolor. In this case, opaque white gouache spattered over dry watercolor provides the answer.*

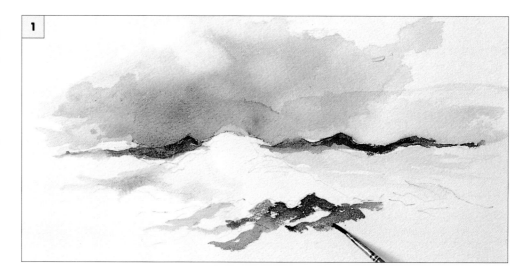

EXPERIMENT WITH SPATTER

WATER

1 *Spatter water with the brush held upward and draw your thumb across it.*
2 *Water flicked onto damp or wet paint will produce irregularly shaped drops and blobs.*

MASKING FLUID

3 *Masking fluid is tricky to spatter, so you will have to experiment to find the best position.*
4 *When the wash has dried, remove the fluid by gently rubbing with a fingertip.*
5 *This could be the perfect method for winter-weather effects; the pattern of tiny white spots is reminiscent of a snowstorm. Make sure you lay down plenty of newspaper for masking fluid spatter, as it can travel a long way, and is hard to remove.*

MOUTH DIFFUSER

6 *These devices produce a finer spray than the standard toothbrush and paint method shown opposite.*

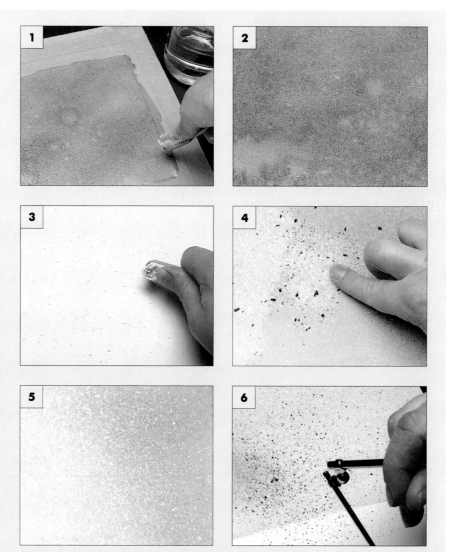

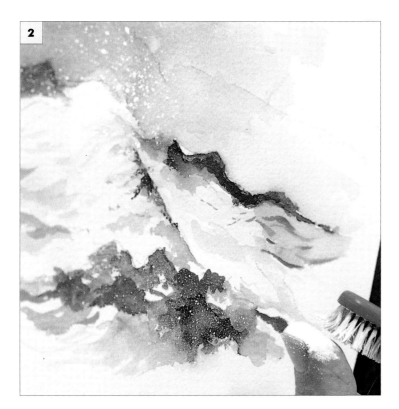

2 *White gouache spatter should be the final stage of a painting. Working over it will stir up the paint, sacrificing the effect. The paint needs to be mixed fairly thickly – too thin and it will sink into the watercolor washes. Always try the mixture first. If it goes wrong, you can remove the gouache, but this involves washing the entire area and beginning again.*

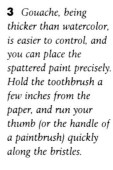

3 *Gouache, being thicker than watercolor, is easier to control, and you can place the spattered paint precisely. Hold the toothbrush a few inches from the paper, and run your thumb (or the handle of a paintbrush) quickly along the bristles.*

4 *Don't overdo the spatter; it is most effective when kept light, as in this example.*

You've already encountered that vital piece of equipment, the small sponge (which can be natural or synthetic), and seen how to use it for laying washes (p.31). It's worth using the sponge in a more adventurous way, since this too is an excellent way of creating textures.

Paint dabbed onto paper with a sponge looks entirely different from paint applied with a brush. You'll find you have an attractive mot-

DEVELOPING
YOUR SKILLS

Sponge painting

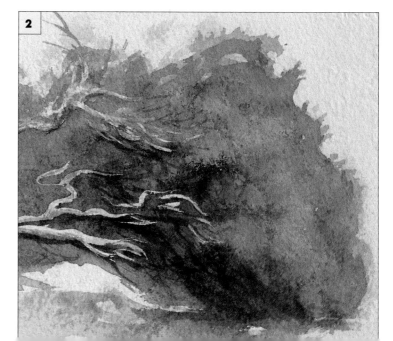

▲ *The type of sponge affects the texture. Small natural sponges vary from coarse to very fine.*

tled effect that is perfect for subjects like weathered stones, massed foliage, or flowers.

It's easy to control the amount of paint you put on simply by squeezing the sponge slightly where you want a drier application. You can suggest form as well as texture by putting the paint more densely in shadowed areas. If you've applied too much paint – perhaps obscuring the highlights – remove some by dipping the sponge in clean water, squeezing out the surplus, and dabbing back into the paint. You can do this even when the paint is dry.

It is quite possible to paint a whole picture with a sponge, but it does have a limitation: you can't create fine lines or crisp edges. You'll almost certainly want to bring in brushes for final touches of definition.

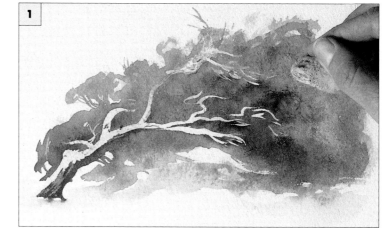

FOLIAGE TEXTURE

1 *For this study of a tree, the artist begins by painting the trunk and branches with masking fluid (see p. 80). Having laid in dark green for the mass of the foliage, allowed it to dry, and removed the masking fluid, she now dabs a thick solution of lemon yellow onto the lighter areas of the tree.*

2 *The effect is attractive and realistic – an ideal method for this "fluffy-looking" Mediterranean pine.*

ROCK TEXTURE

1 *The sponging method is to be used only for the large rock in the foreground, which at this stage is left unpainted.*

2 *The rest of the picture is brought to a final stage, and a pale gray wash is laid over the rock with a brush.*

3 *Several layers of sponging, using a pale gray-brown mixture with touches of yellow, create an accurate impression of the weathered, mottled surface of the rock.*

4 *The dark crevices of the rock and the shadows below form fine lines which could not be achieved with a sponge. A small pointed brush was used for these essential descriptive touches.*

In the previous chapter you saw how to make soft highlights by putting on paint and then removing it. This technique is an important help in watercolor work, particularly for skies, so here we'll look at it in a wider context.

Beginning watercolorists are often afraid of painting clouds, and justifiably so, since they can be tricky: there's always a danger of ruining the effect by overworking. How, you might ask,

DEVELOPING YOUR SKILLS

Lifting out

do you paint white clouds in a blue sky when you can't put light colors over dark ones? The answer is by lifting out. To produce realistic windclouds, lay a flat or gradated blue wash, and while it is still wet, sweep a dry sponge, paintbrush, or piece of tissue across it. For the tops of cumulus clouds use a similar method – a dabbing rather than wiping motion of the sponge or tissue.

As seen from the examples here, you can produce beautiful and surprisingly complex effects by laying one wash over another and lifting out to the color below. The technique need not be restricted to skies: it is equally valuable for other landscape features, such as the gentle highlights on massed foliage or color variations in fields and hillsides. Use it wherever you want soft-edged effects.

You can lift out dry paint too, although it takes more coaxing, and you may not be able to reveal perfectly white paper. A small quantity of gum arabic (sold in bottles as a painting medium) added to your paint water gives the paint extra body. Because it is soluble in water, it makes the paint easier to lift out when dry.

CIRRUS CLOUDS

1 *To create the effect of clouds in a blue sky, first lay a gradated wash. Don't worry if it is not perfect, since you will be removing much of the paint.*

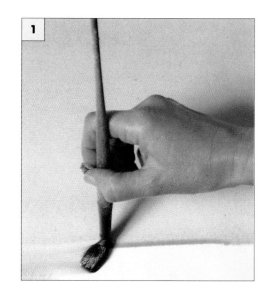

2 *Use a slightly damp sponge or a piece of absorbent cotton. Sweep it over the wet wash in the desired direction.*

3 *An effect like this would be virtually impossible to achieve by any other method. Lifting out is one of the easiest and most useful watercolor techniques.*

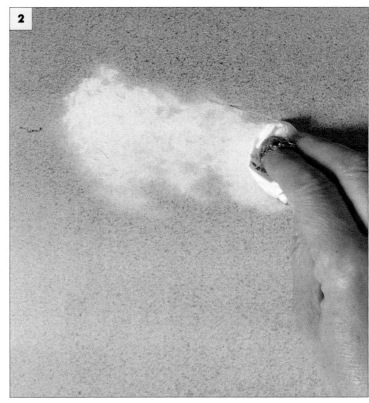

CUMULUS CLOUDS

1 *For more complex effects, two washes can be laid one over the other (allowing the first to dry before laying the second). Here a variegated wash is laid over pale yellow ochre.*

2 *This time, a piece of tissue is used in a dabbing motion. For the best effect, crumple the tissue so that it removes only some of the paint, leaving little dark patches. Absorbent cotton would be less suitable for clouds like these, because it would soak up too much of the paint too evenly.*

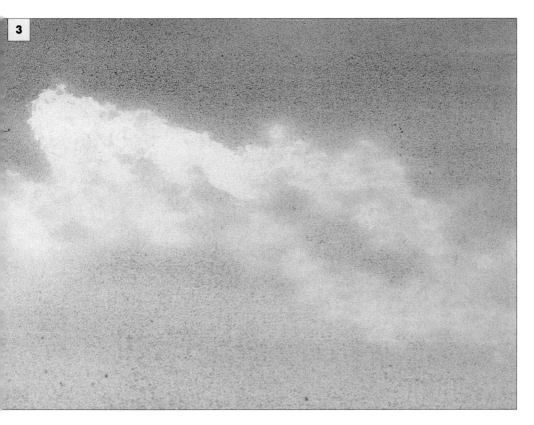

3 *Because there are no hard edges, clouds painted in this way look extremely convincing. To add more detail in a sky like this, combine lifting out with the wet on wet technique (see p. 64), adding touches of darker color at the bottom of the clouds. Be careful not to overwork; skies should look fresh and airy.*

The previous pages showed the effects of putting paint down and then removing it; now let's consider ways of preventing the paint from reaching the paper. The most obvious of these is masking fluid.

Masking fluid is often used because it is easier than painting around highlights (see p.46). But it can be much more than a mechanical aid. Since masking fluid, like paint, is

◄ *Masking fluid is available in yellow and white. Yellow is easier to use because you can see where you have put it.*

DEVELOPING YOUR SKILLS

Masking fluid

applied with a brush, the marks made with it can be just as expressive. It's the perfect way of getting around the problem of painting white. In theory, you can't do this with watercolor, but with masking fluid you can – when the fluid is removed you will have perfectly shaped brushstrokes of pure white.

You can also make exciting random patterns by trailing masking fluid over the paper, and can use it for spattering (see p.72). In this case you spatter onto white paper before laying a color. When the wash is dry and the fluid is removed, white flecks and droplets will remain – the ideal way of painting a snowstorm. Take care not to spatter your clothes, as the rubbery substance can be hard to remove. And if you're using a brush, wash it immediately afterward.

1 *A drawing was made first to ensure the correct placing of the masking fluid, which was then applied in varying amounts over much of the picture area. When it is dry, yellow-brown washes are laid on top.*

2 *With further colors added, the painting reaches its final stages, with the fluid still in place. The small blobs caused by the paint settling unevenly on the rubbery substance will come off with the fluid.*

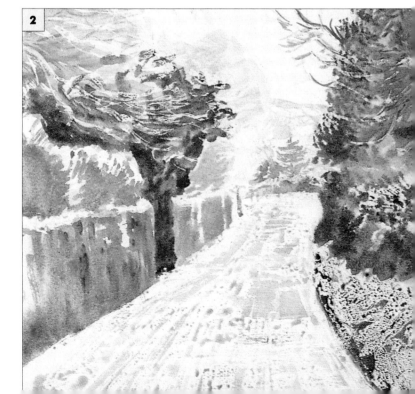

3 *The masking fluid can be rubbed off with a fingertip or an eraser. The brushstrokes made with the masking fluid echo those made with the paint.*

4 *With the fluid removed, the artist decides that there is too much white, so she adds cerulean blue washes on the right-hand bank and in the foreground.*

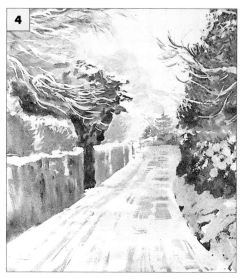

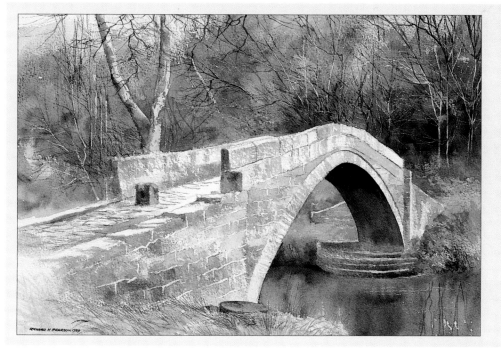

Beggar's Bridge Glaisedale Richard Pearson

Since pure whites were not wanted in this picture, the artist laid a yellow wash over the entire area of the bridge and trees before painting the small tree trunks and the divisions between the stones with masking fluid. The delicate cobweb of tiny branches behind the bridge was made by scratching into the dry paint with the point of a knife. Masking fluid is too thick for fine work like this.

This technique is also based on blocking the paint, but it yields a different and more subtle effect from that created by masking fluid. The principle is simple: wax repels water. If you draw on paper with a wax crayon – or an ordinary household candle – and lay a water-color wash on top, the paint will slide off.

The method was pioneered by British sculptor and painter Henry Moore (1898-

Wax resist

DEVELOPING YOUR SKILLS

▲ *These crayons have good points enabling you to draw quite precisely with them.*

1986), who used it for a series of drawings of people sleeping in the London Underground during World War II. Try to find a book of re-productions in your local library and have a look at these marvellous drawings.

The effects of wax resist are always exciting, and you can vary them according to how much pressure you put on the crayon (or candle) and the kind of paper you use. If you were to push the wax into smooth paper it would block the paint completely, but water-color paper is not smooth, so the wax settles only on the "peaks," allowing paint to seep into the "troughs" and create a slight speckling.

Wax resist is yet another way of imitating textures, such as rocks, cliffs, tree-trunks, and old buildings, and is also much used for clouds and the broken effect of light on water. It's an excellent way of creating pattern in a painting, too. With inexpensive colored wax crayons you can create all kinds of different effects, building up layers of wax, then paint, and more wax.

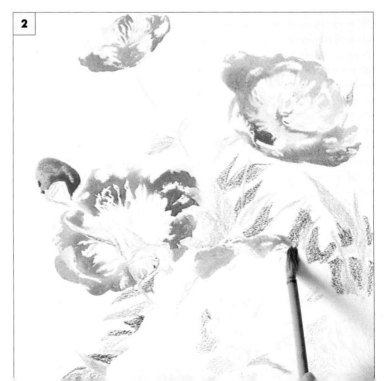

1 *The stamens are drawn with the tip of a yellow wax crayon. Black and green are used for the leaves. Pressure is kept light so that the wax does not repel too much of the paint.*

2 *A fairly strong solution of alizarin crimson is applied over the wax drawing with a Chinese brush. These brushes are excellent for flower painting, as they are capable of a wide range of strokes as well as fine definition.*

Forest Glade
Debra Manifold

The wax resist method is perfect for expressing contrasting textures, such as the water and trees in this picture. Here the artist began with the paint, applying loose washes all over the paper. When these were dry, she applied wax to the lighter areas, and continued to build up the picture with alternate layers of watercolor and wax crayon.

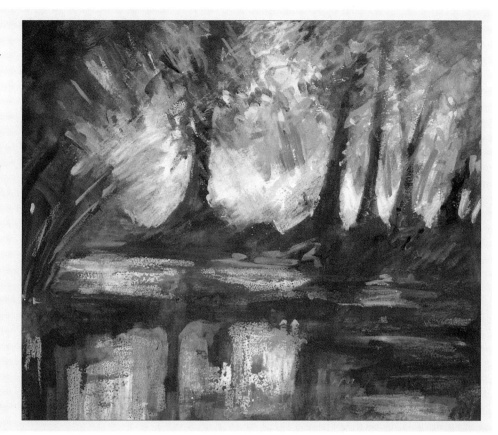

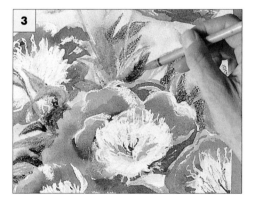

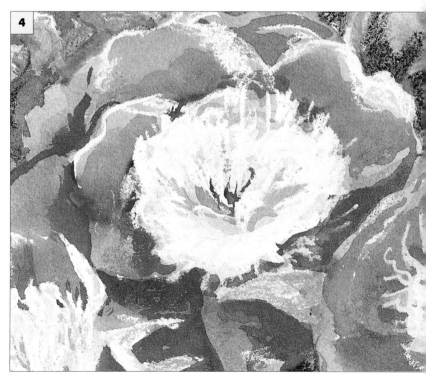

3 Green paint – a mixture of viridian and cadmium yellow – is laid over the black wax crayon. The green is most visible where the pressure of the crayon was lightest.

4 This detail of the flower heads clearly shows the effect of the resist method. Notice the way the paint has slipped off the waxed areas, leaving the yellow stamens outlined against the deep pink of the petals.

Most of the techniques we've looked at in this chapter are relatively modern, the result of generations of painters experimenting with watercolor. Line and wash, however, is as old as watercolor itself. Historically, it was mainly used to put flat tints over drawings, usually done in pen and ink. This type of line and wash drawing can still be seen mainly in illustration work. But many watercolorists now

▲ *You may need to try out a variety of pens and nibs before you find the one that suits your style of working.*

Line and wash

use the technique in a bolder and freer way, integrating the line and color to avoid the appearance of "coloring book" drawings.

There aren't any rules about line and wash. You can do the drawing first, or start with color and add drawn details, or develop both at the same time. There's no prescription for the materials either. You can use a dip-pen, a fountain pen, or a pencil; but pencil lines, being lighter, are best if your colors are pale. If you decide on pen, you will probably have to try out several types before you find one that suits you. The important criteria are that it feels comfortable and provides the kind of line you like. First, go to an art store where you can test pens before buying. Be wary of felt-tips; although they are inexpensive and easy to draw with, the colors tend to fade quickly.

Traditional line and wash drawings were done with waterproof ink, which didn't run when the washes were laid on top. Some contemporary artists like the effect of runs and therefore prefer water-soluble ink. This is another decision you'll only be able to make after experimenting.

1 *The artist chose a pale color scheme, keeping the initial pen drawing light. She selected a fine nib pen and water-soluble ink, because she wants the ink and paint to run together in places.*

2 *She uses a Chinese brush to make a series of loose, varied brushmarks that complement the drawing.*

84

Rhododendrons
Audrey Macleod

This artist likes to exploit the contrast between the crispness of pen lines and the delicacy of watercolor. She uses the line and wash technique extensively in her studies of flowers. To enhance this contrast, she sponges the paint in places to soften the color, an effect seen on the leaves. She never overworks the paint, and on the blooms, touches the color in lightly to the edges of the shapes.

3 *On the stone structure, the drawing is still clearly visible. Where the ink has run into the paint the lines soften to suggest the small shadows seen on old stonework.*

85

One of the charms of watercolor is its unpredictability, but sometimes the unexpected result is more exciting than the planned one. Backruns are a good example. If you have tried to correct a wash before it has dried you may have noticed how the new paint seeps into the old, creating irregular blotches with jagged edges. Backruns are sometimes called "cauliflowers" because of their appearance.

Backruns

They can be alarming when you're doing your best to lay a perfect flat wash, and even more so when you've started a painting and have to abandon it. But backruns, like granulation (see p.41), are one of the "happy accidents" that can become a technique in their own right, and many artists induce them deliberately. You can't control their shape very precisely, so they are best for suggesting a shape rather than delineating it. But, they can be perfect for cloud effects, foliage, or the petals of a flower. You might also try the method for reflections in water, working new paint or clean water into a still-damp wash so that it spreads outward, giving an area of soft color with the crisp but irregular edges characteristic of reflections.

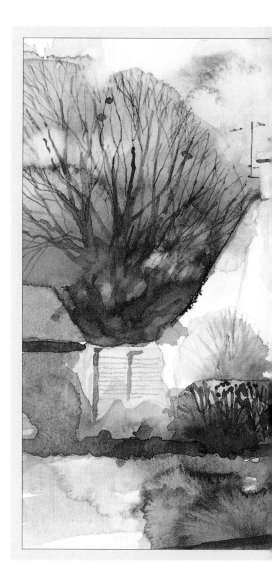

CREATING A BACKRUN

1 *Two colors are laid down and allowed to run into one another wet on wet. Backruns look most effective when the painting is free and loose.*

2 *To make backruns, use a color with a higher water content than the original colors. Here yellow is dropped into the central area of red, and smaller touches are added with the tip of the brush.*

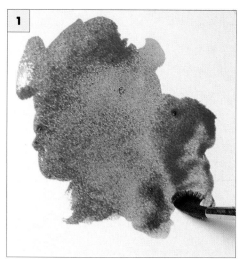

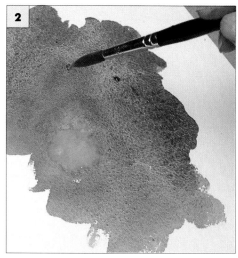

86

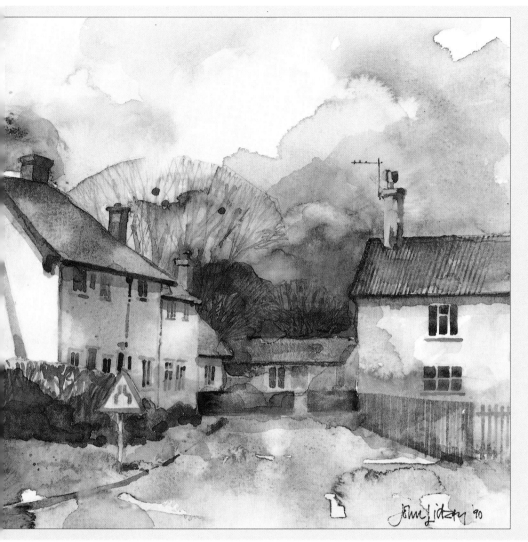

Village Road
John Lidzey

This artist loves to exploit the characteristic of "accidents" in watercolor work. On the left-hand side of the foreground he allowed three backruns to form, one behind the other, providing irregular jagged edges and intriguing shapes that balance those of the trees behind. It is not necessary to ask what these shapes are; they just work in the context of the painting.

3 *Backruns take a minute or two to begin forming, then continue to spread for as long as the paint is wet.*

4 *A further backrun is made in the center of the original one by working into the still-wet paint with clear water.*

Before painting complete pictures, you'll need to know how to correct mistakes. Every watercolorist may sometimes find that a wash has gone over an edge that was meant to be clean, or decide halfway through a picture that a color isn't quite right, and it is comforting to know that there are remedies.

The methods depend on how far you have progressed with your painting. As seen on

▲ *Useful for making corrections: opaque white and a small brush, a scalpel or craft knife, a small sponge.*

page 76, paint can be removed by lifting out with a sponge and clean water, but you can lift out paint more radically by actually washing it off. If you notice at an early stage that something is badly awry – perhaps the proportions are wrong or an initial color doesn't look right – put the entire painting under cold running water and gently sponge off the paint.

In the later stages of a picture you may want to change a small area without disturbing the surrounding colors. In this case, sponge off the paint, and let the paper dry before repainting. For tiny areas you can use a cotton swab, which is also ideal if you want to add highlights or soften over-hard edges. Sometimes you may find that a white area has been spoiled by small flecks and spatters of paint. You can touch these out with opaque white, but a better method is to remove them by scraping with the flat of a cutting or craft knife blade; don't use the point which could dig into the paper and spoil the surface.

DEVELOPING YOUR SKILLS

Making corrections

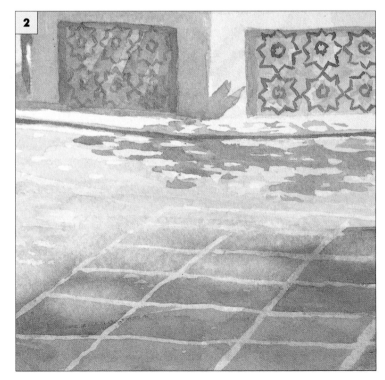

1 *This major correction was made at a late stage in the painting shown on pages 126-129. The artist decided that a shadow in the foreground was too hard-edged, so she washed down part of it with a sponge dipped in clean water.*

2 *The edges of the shadow were successfully softened, but the divisions between the light and dark areas are now insufficiently defined. The aim is to give a crisp, dappled effect, similar to the shadow below the fountain.*

3 *A little more of the mauve-blue watercolor was applied at the back of the shadow and left to dry. Then a mixture of red watercolor and white gouache, carefully matched to the pinks of the courtyard paving, was painted over the blue shadow. It is almost impossible to see that a correction was made.*

STAINING PIGMENTS

The success of washing off or lifting out paint depends upon the paper you are using and on the color you are trying to remove. Some pigments come out cleanly, leaving almost white paper, but others act like a dye, staining the paper so that you can't remove them. Some papers too, hold on to the color with great tenacity, so when you're trying out different brands of paper, do a few tests to see whether you can remove the paint easily.

▼ Alizarin crimson is a staining color, so it cannot be removed as thoroughly as ultramarine, which washes out with almost no trace. Some yellows, and greens with yellow in them, are also impossible to wash out completely.

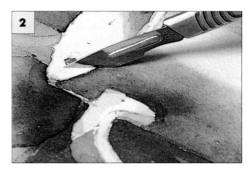

1 *It is only too easy to splash drops of paint onto an area that should be white, but this is easily rectified.*

2 *You can paint over the offending mark with opaque white, but this may show, so it is best to scrape away the mark with a blade, taking care not to dig into the paper.*

4

Making pictures

U nless you have a very clear idea of what you want to paint, it can be difficult to get started. You may have the perfect subject already lined up – perhaps the view from a window, or a bunch of flowers you've just bought – but if there's no obvious source of inspiration, why not use a photograph as the jumping-off point for your first attempt? If you have a collection of photographs look for

Working from photographs

something simple, such as a landscape without elaborate detail. Alternatively, browse through some magazines and find a picture that appeals to you. This is not something you should go on doing – if you want to work from photographs you should really take your own, looking on them as a definite stage in planning a painting – but a magazine picture will do as a starting point. Avoid subjects that include people, as human subjects don't always come out well in photographs – at least not well enough to use as a model.

Some art teachers frown on the use of photographs, but, although there are good reasons for this, it makes more sense to look at the question realistically and to see how you can get the best out of them. After all, amateur painters don't usually have a great deal of time at their disposal. If you've set aside a Sunday for painting landscape and it pours with rain, it's more satisfying to paint a similar subject from a photograph than not to paint at all.

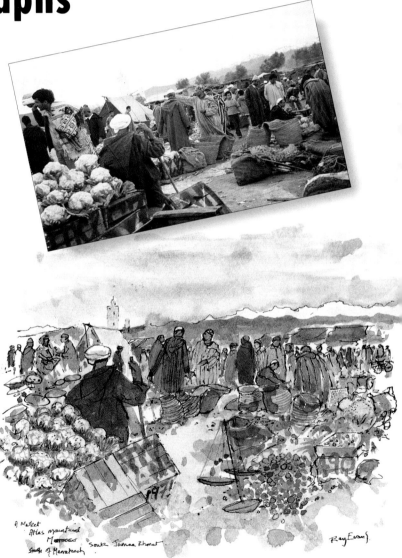

▶ **A Market in Morocco – Ray Evans**

Although the painting is recognizably based on the photograph, the artist excluded several of the figures and some of the details in order to make a stronger composition. Notice in

particular that the figure on the left of the photograph was omitted, because it would lead the eye out of the picture. The scales in the foreground were invented.

92

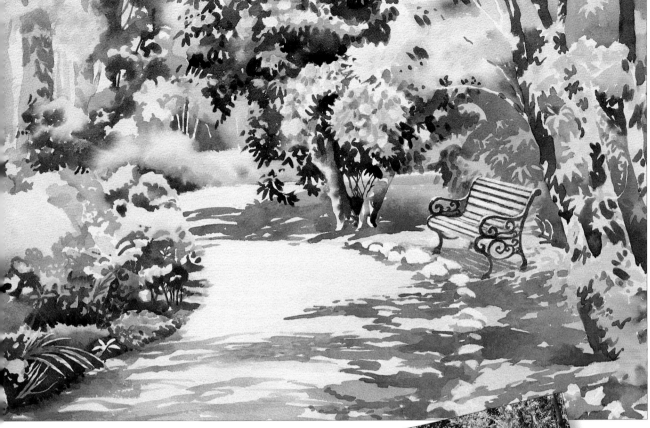

CREATIVE CONTROL

Always be aware that there are pitfalls. A photograph exerts a kind of tyranny, making you feel obliged to copy it accurately, and this does not usually make for a good painting, although it may be useful practice. Remember also that photographs don't tell the truth; the colors are often not true to nature, particularly when it comes to shadows, which are usually too dark, and skies, which are too blue.

So try not to copy the photograph too precisely; see whether there are colors you can play up or play down, and elements you can simplify, or leave out altogether. And don't feel you have to stick to the same format. You may find that you can make an interesting picture by taking a vertical section from the middle of a horizontal photo or vice versa. It helps to cut four strips of paper so that you can mask the photo in different ways to decide on the best arrangement. The key to making successful paintings from photographs is to be creative, and not allow them to dictate to you.

▲ **Exploring Wisley – Hazel Soan**

This artist uses photographs a lot, although she also paints on the spot when time permits. Here, the basic composition of the photograph was retained, but the colors *are more positive, and a feature was made of the foreground shadow. The introduction of the bench on the right of the path (not in the photograph) provides a focus to guide the eye* *into the picture. It is always wise to take more than one photograph so that you can combine various compositional elements.*

93

If a photo tempts over-close imitation, much the same applies to working from life, whether you are doing a landscape or urban scene, a still life, or a figure painting. A painting, although it should be recognizable as something real, is not a copy; it is a "translation," and you, as the translator, have the power to select what is most important about your subject and to rearrange things as you see fit.

Working from reality

Selection (and rejection) and rearrangement are very important parts of painting. If you're embarking on a still life (see p.130) you will carry out this process automatically when you set up your group, taking away one or two objects because the arrangement looks crowded, and moving things around until they look right. When you're painting a landscape you can't alter things as radically as this, but you can choose the viewpoint that gives you the best natural arrangement, and you can select what is most important. You couldn't possibly paint every leaf on a tree or every blade of grass in a field, so think about what else you might omit. Don't leave things out just because they might be difficult, though. For example, a group of brightly clad picnickers might conflict with the brooding, silent atmosphere of a mountain landscape, but they may provide just the right touch of color.

▶ **Pembrokeshire Coast
Paul Millichip**

The figures are an important part of this painting; they give it depth and scale as well as providing atmosphere and human interest. But you do not have to include people, even if they are there. Another artist might have made an equally exciting picture of an empty beach, perhaps giving more space to the sky and sea.

▶ **Tulips
Shirley Felts**

Reality was used here as the starting point for a personal interpretation. Although the flowers are painted with great accuracy, it was the pattern that caught the artist's attention. This is the element she stressed, making no attempt to define the plane of the tabletop or to suggest space between the flowers and the wallpaper.

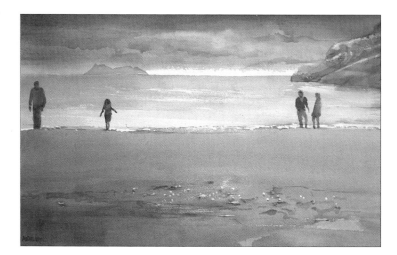

▶ **Battery, Charleston – Neil Watson**

When working from a photograph you can't always change things as much as you might like. You can't alter the viewpoint, or bring in some element that was outside the frame. But you can do these things when you're working from reality. Here the artist made a composite by shifting together two buildings that, in fact, were widely separated.

One of the best ways of getting used to painting from life is to make a series of quick color sketches rather than trying to complete an entire painting in one session. Watercolor is an excellent medium for sketching; if you don't work on too large a scale you can put down impressions very quickly.

Sketching is usually thought of as an outdoor activity, but it doesn't have to be – you

Sketching

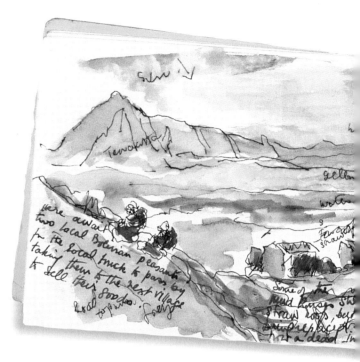

can sketch anything you like, from a corner of your living room to a landscape or urban scene. It is, however, particularly useful in the context of landscape. It can be difficult to complete a painting on the spot (see p.98), so artists often make sketches that they can use as a basis for paintings to be done indoors later on. If you're going to take photographs to work from it's a good idea to make a sketch or two at the same time. You'll find them a valuable back-up, because you will have experienced the subject first hand – photographs are impersonal and tend to distance you from the subject.

There is a difference between sketching simply because you enjoy it and making the kind of careful visual notes from which you can compose a painting. Sketching for painting takes practice, and you need to have an idea of the finished painting in your mind so that you can collect the right visual information for it. When you're working fast you can only record broad impressions, and you probably won't have time to get all the colors down. It can be helpful to make some written notes on your sketches, describing any colors you particularly noticed. You might put down, for example, "clouds mauve-blue," or "shadows blue-green." Even if you don't use the sketches in the end, this is good training, because it teaches you to recognize and analyze colors.

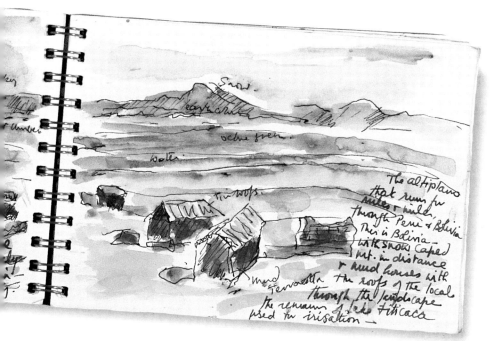

◀ **Bolivia, Altiplano Mountains**
Daphne Casdagli

It takes practice to confidently fit a large subject like this landscape into the confines of a small sketchbook. A spiral-bound book is ideal, allowing the sketch to expand if you want it to. The artist made extensive notes about the place, the people, the construction of the huts, the colors of the landscape, and the direction of the sun.

◀ **Irish Landscapes**
Clarice Collings

These two sketches are from a series of 11, all done on the same day in the same place, but in dramatically changing weather conditions. None took more than half an hour, but the artist created a vivid record of her impressions.

▶ **Objects on a Windowsill**
John Lidzey

Like many artists, Lidzey is a compulsive sketcher. Being particularly interested in the effects of light on interiors, he has sketchbooks full of studies such as this. They are a valuable source of reference for finished paintings.

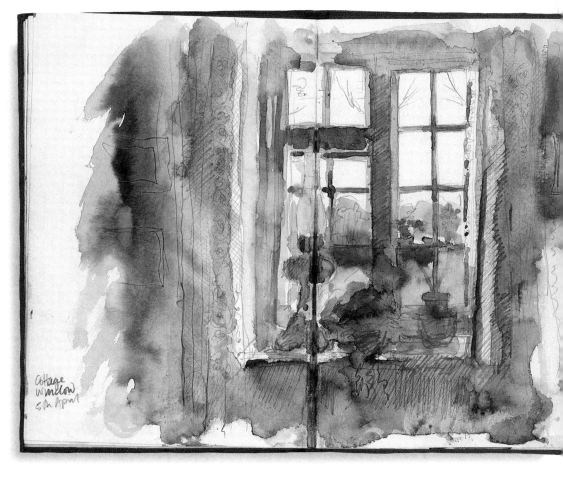

Working outdoors, whether you're doing quick sketches or a complete painting, needs more organization than indoor work, so plan your painting trips carefully. It's a good idea to make some form of checklist like the one shown opposite and pin it up in the place where you keep your painting materials.

You may also need a few pieces of special equipment. A small folding stool is essential.

▼ *There are two main types of sketching easel – wooden ones and metal ones. They both weigh about the same, and the height and angle can be adjusted.*

▶ *A viewfinder is a great help in planning a composition. Most artists use one, and some even take a picture frame out with them to assess how their landscape will look when completed and framed!*

MAKING PICTURES

Working on location

You won't paint well if you're uncomfortable, and sitting on the ground can be very trying after a time. Besides, it doesn't always provide the best viewing angle – if you're painting in an overgrown field, all you might see is grass! You don't necessarily need an easel, as you can paint with your board or sketching pad held on your lap. If you want to invest in an easel, make sure it's light and can be adjusted so that the board is held near-horizontally.

Watercolors dry very fast under a hot sun, and bright light on your paper will dazzle you, making it hard to see the colors. It's generally best to find a shady spot. However, if you do have to paint in the sun, consider wearing a broad-brimmed hat.

◀ *An easel carrier is far from essential, but can be helpful if you have to walk long distances.*

◀ *If you are working under a hot sun, it is wise to wear some form of hat or cap.*

▶ *A garden chair (near right) is adequate, but may be too high for you to reach your materials on the ground comfortably. A specially designed sketching stool (far right) is better.*

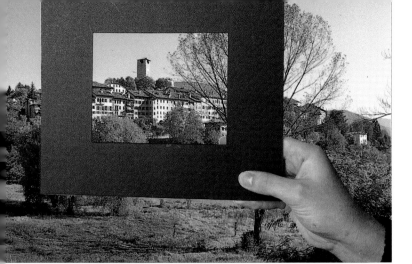

Fortunately, the most important piece of equipment for outdoor work could cost nothing at all. This is a viewing frame, or viewfinder, which is a rectangular window cut in a piece of cardboard. When you're faced with a large expanse of landscape it can be very difficult to decide which bit of it to concentrate on, and the frame helps to isolate parts of the view. Hold it up at arm's length and move it around until you see the makings of a picture.

Since you won't want to traipse around with your painting equipment looking for a good place to paint from, it's best to plan this in advance too. You could explore the area the day before and choose your spot so that you can go straight to it. If you're intending to complete an entire picture rather than making sketches, you might also consider doing the drawing on one day and painting on another. One of the difficulties of location work is coping with changing light – you may think you have the whole day to paint in, but the scene will have changed completely between morning and evening, so you have to work fast. If you've already done the drawing you can start immediately without wasting valuable time.

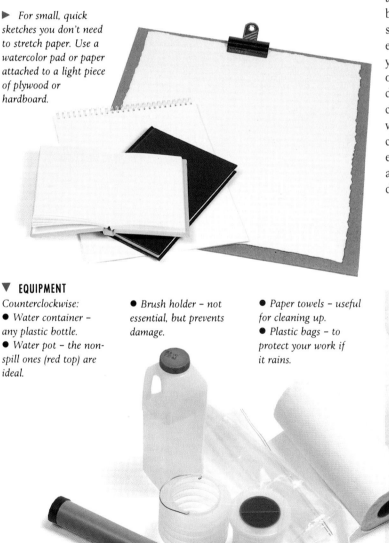

▶ *For small, quick sketches you don't need to stretch paper. Use a watercolor pad or paper attached to a light piece of plywood or hardboard.*

▼ **EQUIPMENT**
Counterclockwise:
● *Water container – any plastic bottle.*
● *Water pot – the non-spill ones (red top) are ideal.*

● *Brush holder – not essential, but prevents damage.*

● *Paper towels – useful for cleaning up.*
● *Plastic bags – to protect your work if it rains.*

EQUIPMENT CHECKLIST
● *Brushes – you don't need many.*
● *Paintbox – make sure you haven't run out of any colors.*
● *Or tube color and mixing pans.*
● *Sketching block or light drawing board and sheets of paper.*
● *If the latter, take thumbtacks, masking tape or a bulldog clip.*
● *Bottle for carrying water.*
● *Jar or plastic pot for paintwater.*
● *Pencil and eraser for preliminary drawing.*
● *Knife for sharpening pencil.*
● *Sketching stool.*
● *Sponges and paper towels for general mopping up.*
● *Plastic bag to protect your work in case of rain.*
● *Viewfinder.*

99

Landscape and seascape

I t's no coincidence that the great development of the watercolor medium in the 18th and 19th centuries went hand in hand with a new interest in landscape painting. Watercolor, with its fluidity and transparency, seems almost designed for capturing effects of light and atmosphere.

If you can, have a look at some reproductions of paintings by British artists such as John Sell Cotman (1782-1842) and J. M. W. Turner (1775-1851), and the great American artist Winslow Homer (1836-1910); you'll find them a source of inspiration.

CHOOSING A SUBJECT

The only trouble with looking at other people's paintings is that it can make you envious of their subject matter – it seems so much more inspiring than anything you have at your disposal. It's not the subjects, however, but the way they have been "visualized" that creates the impact: a good artist can make a fine painting out of anything, from a dramatic storm at sea to a small back yard.

A landscape doesn't have to be a panoramic view; it can be a single tree in a field or park, or some stones on a beach. So if you have decided to work outdoors, begin with something familiar and close to home. And give some thought to the lighting, which will differ according to the weather and the time of day. You'll often see a subject that appears uninspiring under a gray sky come glowingly alive in early morning or evening sunlight, with lovely shadows and sparkling colors.

If you feel nervous about painting on the spot, begin by working from a photograph. If you've taken some good vacation shots of

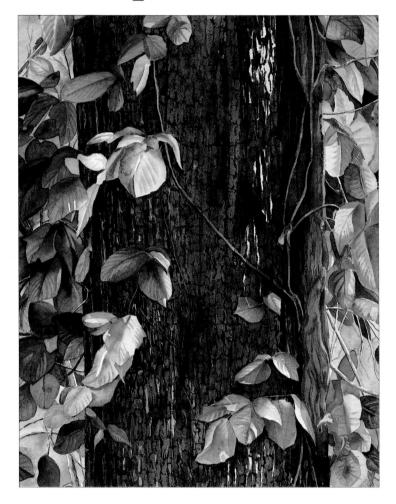

▲ **Changing Season – Joel Smith**

Often you can make a stronger and more personal painting by homing in on one aspect that appeals to you. Here the artist was interested in the shapes and colors of the leaves against the rough texture of the bark. He excluded everything that might have diluted his "message."

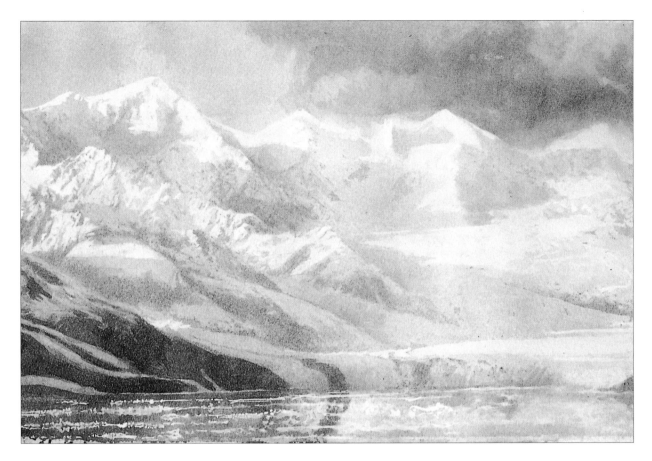

▲ Harvard Glacier, Alaska – Tim Pond

A subject like this derives its drama from its grandeur. The main difficulty is fitting everything into the space available. It is helpful to work on a larger piece of paper than usual, so that you can let the composition spread outward as you work.

landscapes that excited you, see whether there's one in particular that begs to be painted. It is important to start with a subject you respond to, so that you can enjoy painting it rather than treating it as an exercise.

COMPOSING THE PICTURE

The next consideration is how to turn your subject into a picture – or compose it. Suppose you have decided to paint a tree: Should you place it right in the middle of the picture or slightly to one side? Should you paint the entire tree or let it go out of the picture at the top? If you are working on the spot, settle

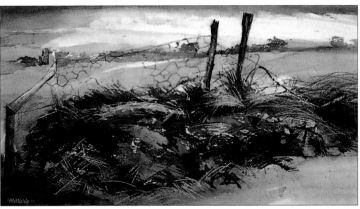

▲ North Wales, Wind – Paul Millichip

As in Joel Smith's painting, the artist chose to focus on a small part of the landscape: the tangle of fencing and foliage in the foreground. The sweep of landscape beyond is suggested by a few light washes and brushstrokes of green and gray.

101

▶ **A Walk on the Downs**
Elisabeth Harden

When composing a picture you need to think about ways of linking its parts: foreground, middle ground, and distance. The success of the composition here derives from the way the curves of the grasses in the foreground lead to the curves of the field, guiding the viewer's eye into the landscape.

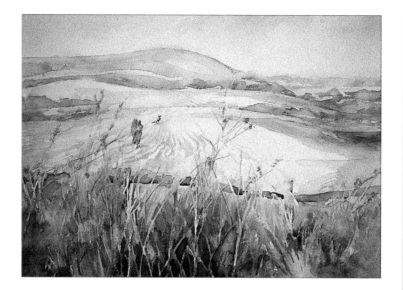

▲ **High and Dry, Hastings**
Ashton Cannel

A dominant shape needs some form of counterbalance. Here the large boat is balanced by its shadow and by a series of smaller shapes.

these important questions before you begin to paint, using the viewing frame shown on page 99 and moving it around until you have the makings of an interesting picture.

You'll probably find that the tree looks better placed slightly to one side, perhaps with a bold shadow to provide a balance. Although there are few hard and fast rules about composition, it is usually best to avoid very symmetrical arrangements. These look simultaneously dull and disjointed – the different parts of the

picture don't "hang together." So if you're painting a seascape or a flat landscape, avoid placing the horizon right in the middle. You can often give much more space to the sky, particularly if it's cloudy or stormy, with just a small strip of land and sea to "anchor" it.

Another aspect of composing a painting is "editing" reality. You don't have to put in everything you see just because it is there: a good landscape is not a copy of the world so much as a translation of it. If there are fences, telephone

poles, or people in your view, ask yourself whether they will detract from the painting or improve it; if the former, be ruthless and exclude them. But don't automatically rule out people or human-made features; you may find that a picket fence provides just the right touch of foreground interest, or that a small figure in the middle distance gives a sense of scale to the landscape, or a splash of contrasting color.

All the above advice applies equally when working from photographs. Even if you have

▲ **The Tempest – Roland Roycraft**

Besides being exciting to paint, skies also play a vital role in landscape composition. Here the sky is the main subject of the painting. Even when the sky occupies *only a small part of a picture, you can use clouds (invent them if you like) to give extra color and movement to a landscape.*

103

▼ **Grand Canyon,
Winter
Pat Berger**

*Space is suggested by
the paling of the colors
in the distance, and the
very dark shadow in the
foreground. You will
never see dark colors,
or strong contrasts of
tone, in landscape
features that are far
away from you.*

taken a picture specifically with a painting in
mind, always look at it critically to see whether
you can improve it by changing the composi-
tion, perhaps excluding some details and
emphasizing others.

CREATING SPACE

If your subject is a modest one, such as a park
or garden, you won't have to worry too much
about space, but in a seascape, a grand moun-
tain scene, or a panoramic view, you need to
suggest the vastness of the landscape, and the
way it stretches away from you.

How do you represent this great sweep of
three-dimensional space on the flat surface of a
piece of paper? Fortunately, it isn't difficult pro-
vided you remember some simple rules. You
probably will have noticed that far-away hills
look blue or blue-gray, and are much paler
than anything directly in front of you. This
effect, known as aerial perspective, is caused by
particles of dust and moisture in the atmos-
phere, which diffuse the light, effectively
drawing a series of ever thicker "veils" over dis-
tant landscape features. To keep the colors pale
in the background, it's easiest to work from the

back to the front of the picture, beginning with light washes of blues and grays and progressing to stronger colors in the foreground. You'll always see more detail in things close to you, and also more obvious light/dark contrasts. If you save the detail and the contrasts of tone for the foreground you will effectively "push" the background further away.

Linear perspective, and how it relates to buildings (see page 118) is also important in landscape. Don't forget that trees and fields will appear to become increasingly small as they recede into the distance, and that any

▶ **Edge of a Field, Sedgemoor**
Ronald Jesty

In this painting the impression of space was created mainly by linear perspective, with the objects becoming increasingly smaller as they recede. Note the size of the trees on the horizon in relation to the plants in the foreground.

◀ **Rain, Pembrokeshire**
Paul Millichip

One way to give an impression of space is to emphasize one or two foreground objects with strong light-dark contrasts. This painting, in keeping with its subject, has an overall "soft focus," but the bright stream and the tiny white stones on the bank bring the foreground to the front of the picture.

105

▶ **Ajmer, Rajasthan**
Paul Kenny

The light but bright color scheme, with the yellow mountains fading into the sky, gives a feeling of space and airiness. Because the painting's center of interest – the domes and delicate, spiky minarets – are some distance away, the artist had to take care not to stress the foreground. The central reflection, growing larger as it nears the front of the picture, defines the flat plane of the water and acts as a "signpost" to the gleaming city.

parallel lines going away from you will appear to converge. You won't, of course, find many perfectly straight lines in a landscape, but your view might include a field with roughly parallel lines made by a plow, or perhaps a river, whose banks will apparently draw closer together as they recede. Correct observation of such features is a powerful aid to creating space and depth in your paintings.

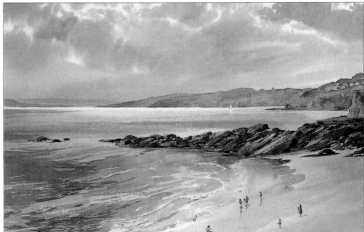

COLORS FOR LANDSCAPE

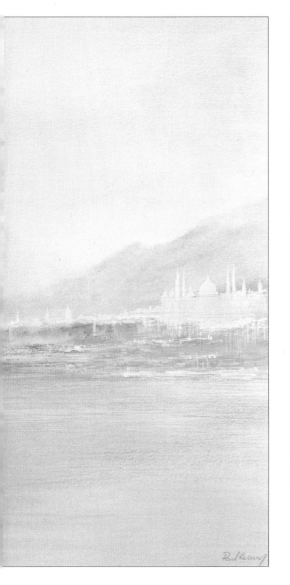

◄ **Carbis Bay, St Ives – Ashton Cannel**

The spaciousness of this painting is due in part to the treatment of the sky. There is perspective in skies, just as in land features. Clouds appear largest and most clearly defined when high in the sky directly above you, and smaller the closer they are to the horizon. The colors are also paler on the horizon, and usually lighter than distant cliffs or hills.

SUGGESTED NEW COLORS

Although you can achieve a wide range of colors with the 10 in the starter palette, you may find that you can't achieve a particular shade by mixing. If you need to add to your basic palette, or to save mixing time, consider including one or two of the colors shown here.

Sap green Cobalt green Olive green

Cobalt blue Indigo Phthalocyanine blue

Indian yellow Naples yellow Burnt sienna

Venetian red Lamp black

MIXING GREENS

This chart shows mixtures from the starter palette colors. There are many more greens than this in nature, however, and you will find that some of the blues, yellows, and ready mixed greens suggested above give you a wider range. If you invest in new colors, use them to make your own chart of greens.

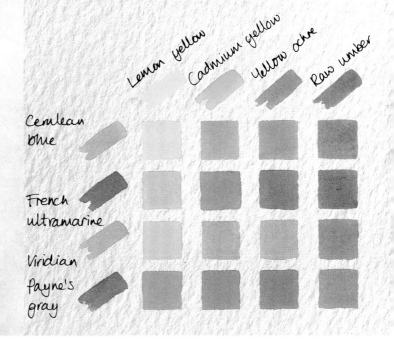

Lemon yellow Cadmium yellow Yellow ochre Raw umber

Cerulean blue

French ultramarine

Viridian Payne's gray

L eaf clad trees are not the easiest subject to paint, especially when they are close and you can see every twig and leaf in sharp focus. This makes it difficult to discern the shape of the tree. However, it is important to establish the shape at the outset, because the overall contours and the way the branches grow from the trunk give a tree its character. Try looking at the subject through half-closed eyes, which

Using dark and light colors

Simplifying tree shapes

Adding details with a pen

MAKING PICTURES

Painting foliage

cuts out many of the small, distracting details and helps you to concentrate on the shape of the tree.

Remember, too, that there are always some dark colors among the foliage. In sunshine, the light-struck side of a tree can be a vivid green, sometimes almost yellow, while the shadowed areas are often dark blue-green or almost purple. Unless you observe these color variations accurately, you won't be able to make the tree look solid, so take time to analyze your subject before painting.

PALETTE USED

From left to right the colors used in this demonstration are: Alizarin crimson, scarlet lake, Indian red, yellow ochre, aureolin yellow, cadmium yellow, ultramarine, mauve, indigo, Payne's gray.

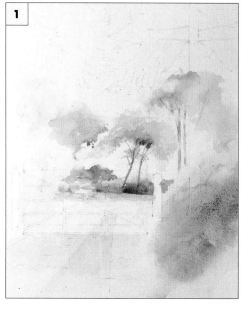

1 *The artist began by making an outline drawing, taking particular care with the tall tree trunk and the gate. These are important features, and the proportions must be correct.*

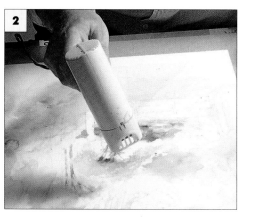

2 *The first light washes are dried with a hairdryer. Unless you are working wet on wet, and want the colors to run together, always make sure the paint is thoroughly dry between stages.*

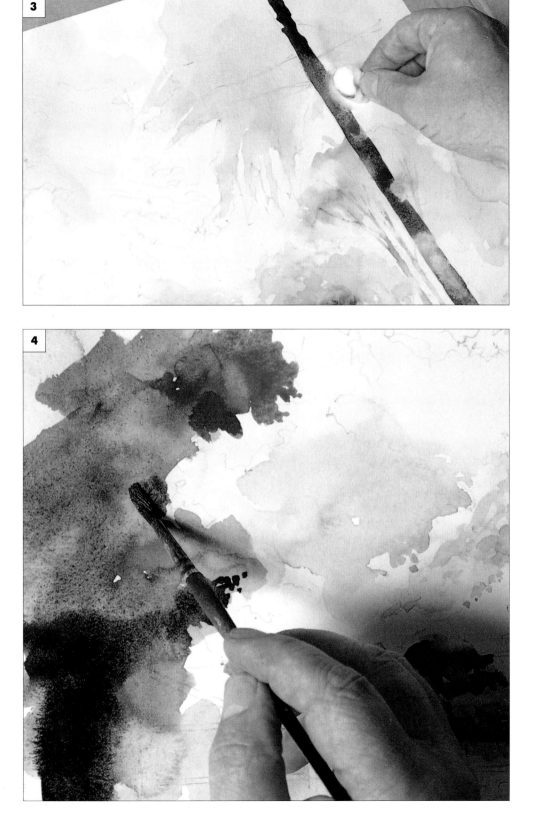

3 The tall tree trunk was painted with a pointed brush to give a precise edge. While the paint is still wet, some of it is removed with a cotton ball to create soft areas suggesting patches of light. Tree trunks and branches won't look realistic if you paint them in a flat color all over; there are always variations of tone and color.

4 The foliage of these trees is very dark, in contrast to the bright tree on the right of the photograph. The artist uses no green at this stage. A rich brown and indigo are blended wet on wet to give a soft effect.

continued ▷

5 *After further drying with the hairdryer, a strong solution of indigo is used to outline the edges of the dark leaves. Adding this color created a strong contrast with the bright yellow, where the sun strikes the bush in the background.*

6 *You can build dark colors gradually in layers. It is a good idea, however, to establish the main light-dark contrasts early on. Having brought the dark tree on the left to a fairly complete stage, the artist now has a "key" for the painting. He uses similar combinations of color for the right-hand tree.*

7 *The gate is painted with great care. Because it is so centrally placed any small mistake would be immediately obvious.*

8 *Some parts of the painting, such as the gate and the lower part of the left-hand tree, are now complete. Certain areas will be darkened, and detail added to trees and foreground.*

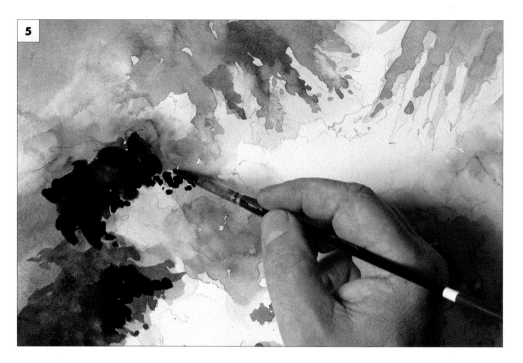

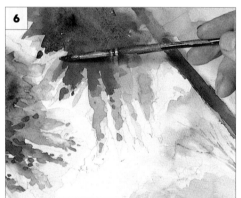

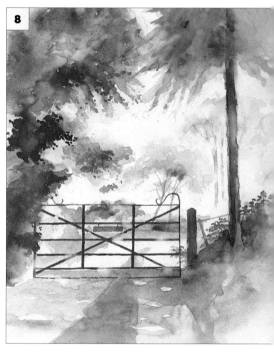

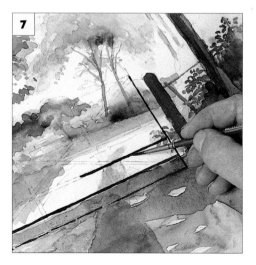

9 This larch has a distinctive growth pattern, with the foliage-bearing twigs hanging almost straight down from the slender, near-horizontal branches. A pen, which gives a finer line than a brush, was used to draw these delicate details.

10 Ink is the traditional medium, but the artist prefers a strong watercolor solution. He fills the pen nib with a brush dipped into the paint.

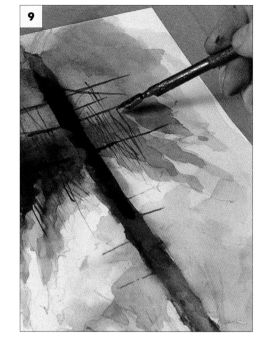

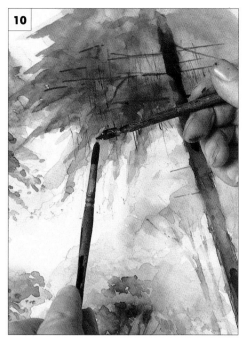

▶ **Landscape with Larch Tree John Lidzey**

In the final stages, further pen drawing was added to the trees and foreground. The area at top left was darkened, first by a fresh application of paint, and then by scratching over the dry wash with a soft pencil. Small touches of gouache were added to the gate, and the patch of light on the path, which was accidentally painted over, was also touched in with gouache. Notice how the trees have been simplified. Having treated the foliage initially as broad masses of color and tone, the artist put in just enough detail to make it look convincing.

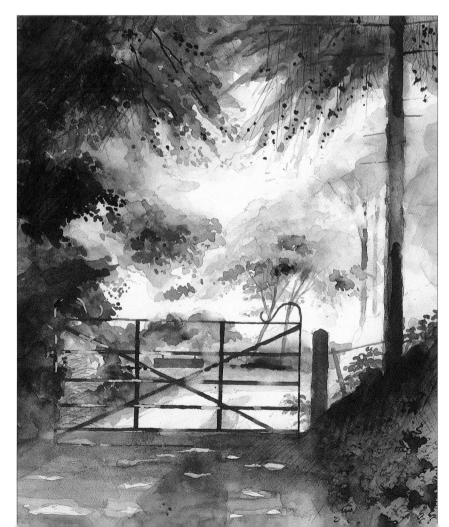

111

There are few more exciting subjects than water, but its intricate shapes and often surprising range of colors are hard to capture. The commonest mistake is trying to include every ripple or wavelet. This can lead to an overworked painting without the feeling of movement that is the essence of the subject.

As with trees, you will need to simplify. Look for the main shapes and patterns; waves

Creating a sense of movement ✎

Using the wax resist technique ✎

Working from a photograph ✎

Painting water

and ripples, although constantly moving, continuously repeat the same movements.

Special techniques can also help. The wax resist method shown here is favored for seascapes. Try mixing in some white gouache, or use masking fluid to reserve small highlights on the crests of ripples.

PALETTE USED

From left to right the colors used in this demonstration are: Alizarin crimson, burnt sienna, yellow ochre, ultramarine, viridian, sap green, Payne's gray, Chinese white.

1

1 *The artist began by laying a pale wash for sea and sky and blocking in the shapes of the cliffs. Although she is working from a photograph (above), she has imposed her own ideas. Slanting the lines of the cliffs creates a series of diagonals, which are more exciting than the verticals in the photograph.*

2 *A white oil-wax crayon is used to draw over the light blue wash. The artist does not attempt a precise definition of the swirling water, and she draws freely for a bold effect.*

2

3 Darker blue is laid over the wax crayon, sliding off the wax and leaving droplets and bubbles suggestive of water. The crayon is then used again to draw into the cliffs; you can see the effect of this in Step 4 and in the finished painting.

4 Because the crayon is soft, she is able to scratch parts of it away with a knife, revealing the original layer of paint to suggest the linear strata of the rocky cliffs. A tough paper is needed for this method, and care must be taken not to dig with the point of the blade.

5 The photograph shows a tree in the foreground, which was originally to be included in the painting. However, the artist decided that it weakens the composition, so she washes down this area with absorbent cotton dipped into clean water.

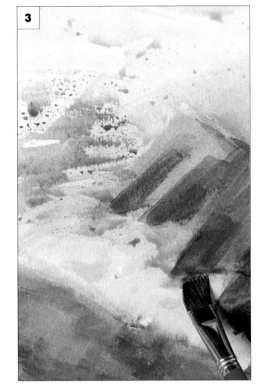

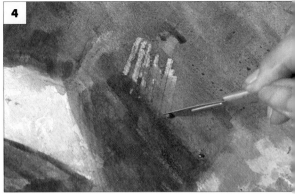

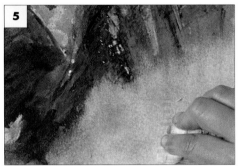

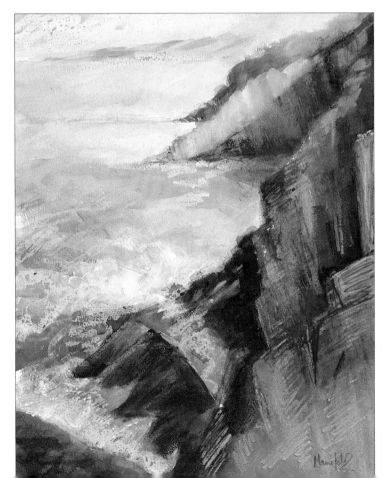

◀ **Devon Cliffs**
Debra Manifold

The correction and repainting were carried out so skillfully that you would not guess a major change was made. The painting, which is full of movement, departs from the somewhat bland photograph in a number of other ways. When using photographs, always consider what you might leave out or exaggerate to make a better picture.

113

Finding your own style

Although the paintings shown on these and the following pages are related by subject, they vary widely in style and in the way the paint was handled. You will probably find some more sympathetic than others, which is all to the good. Deciding which paintings you prefer helps you to develop your own painting style.

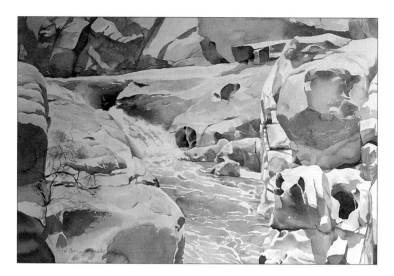

▲ **The Falls – Hazel Soan**

A series of small washes following the main shapes was used for the rocks and water, with the contrast of hard and soft edges skillfully exploited. Although there is no visible sky, the crisp boundaries between highlights and shadows show that the light is strong. In the shadows themselves, where hard edges would not have been suitable, the wet on wet method was used, with the colors blending softly into one another.

▶ **Cottage in the Woods**
Ronald Jesty

This artist works wet on dry, laying one wash over another to create deep, intense colors. The brilliant highlights were crucial, and the picture was carefully planned. The effect of the bright leaves on the left was achieved by painting on small dabs of masking fluid, laying washes on top, then removing the fluid and overpainting in yellow.

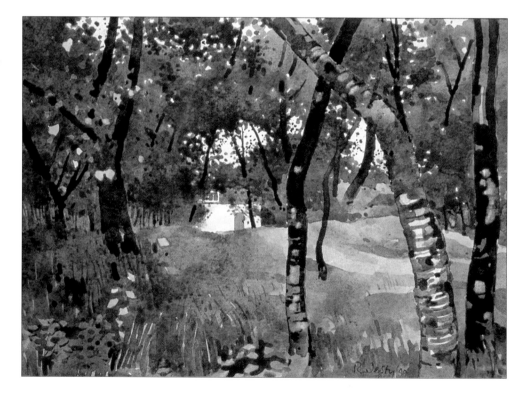

▲ **Jubilee Drive,
Malvern Hills
David Prentice**

*The brushwork is
evident in this painting,
particularly in the
foreground trees, where
dark strokes of different
directions were laid over
lighter colors. Prentice
also works in pastel –
where the marks made
by the sticks of color
play an important part
in composition – and he
uses watercolor in a
similar way.*

◀ **L'Elégance
La Vere Hutchings**

*The wet on wet method
is the perfect technique
for the soft effects seen
on a misty or overcast
day, as this picture
shows. The trees and
their reflections merge,
and there are no hard
edges where trees meet
sky. A few crisp touches
of line to suggest tree
trunks and branches
were added wet on dry
in the final stages.*

115

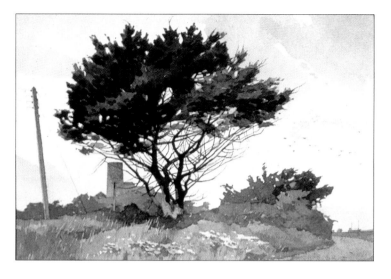

▲ **Monterey Pine – Ronald Jesty**

When painting distant trees you can treat them in a generalized manner. But for a "tree portrait" like this, close attention to detail is needed. Because the tree is silhouetted against the sky, the mass of the foliage is simplified, although every branch is clearly outlined, making an attractive pattern.

► **Sunset from Whale Research Camp Tim Pond**

Brushwork is a feature of both Jesty's painting and this one, but Pond's technique is very different. He built the dark colors of the clouds and their reflections with small, multi-directional brushstrokes, which give movement to the picture as well as creating a realistic effect. The dark sky and foreground make a frame for the picture's center of interest, the reflection of the setting sun.

◀ **Landscape in Cyprus**
David Ferry

This painting was done quickly, direct from the subject, as a study for a full-scale work. The artist's main concern was to convey the sweeping lines of the landscape and the patterns made by the plantations of trees. He did this by using the brush almost as a drawing implement, letting it follow the directions of the curving lines.

▶ **The Clearing**
Roland Roycraft

Even in the highlight areas, snow is seldom pure white, and the shadows are darker than you might think. Here pale yellows and blues were laid as preliminary washes, but the strength of the deep blue-gray and blue-green shadows ensures that the highlights appear white.

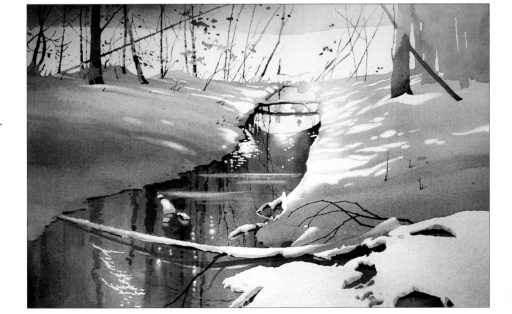

Buildings and cityscapes

MAKING
PICTURES

Watercolor is particularly well suited to architectural subjects. You can lay broad flat washes of one color, or deliberately uneven ones suggesting the slightly irregular surface on old buildings. You can make clean crisp edges, and define decorative details with a small brush. The paintings made by architects or professional architectural "renderers" to show prospective clients are more often in watercolor than in any other medium, and some of these are fine works of art in their own right.

CHOOSING A SUBJECT

The term "architectural subjects" covers a wide field – it can mean anything from an urban scene through a grand church or cathedral to an old railroad station or an old wooden barn set in a landscape. It can even be a detail of a building, such as a door or window.

The choice is up to you, but if you're uncertain of your drawing skills, don't overtax yourself by beginning with a very complex subject such as a panoramic view of a city. Buildings are not easy to draw, and although you can get away without much drawing in a landscape, paintings of buildings need a solid foundation – just like the structures themselves. Even when a building is only an incidental feature of your painting, you'll need to make it look convincing. So before you start you will have to come to grips with perspective.

PERSPECTIVE

In fact, perspective is much less daunting than it sounds. It is based on the central principle that objects appear to diminish in size the further away they become from the viewer.

▲ **The Staircase – Elisabeth Harden**

Building interiors are an excellent painting subject, with many of the advantages of still life. As the artist did here, things can be moved around to make a better composition.

**▲ The Friday Market,
Doncaster
David Curtis**

Painting an urban scene
like this requires careful
observation, correct
scale, and accurate
perspective. Curtis
draws and sketches
constantly, and has
sketch books full of
detailed studies of
buildings, people, cars,
and "street furniture"
such as lamp posts,
which he uses as visual
reference for his finished
paintings.

**◀ Derelict Farmhouse
Roy Preston**

Old buildings, with
crooked roofs, broken
windows, and crumbling
stonework, are always
popular with artists.
Like romantic ruins,
they are a "piece of
history"; there is
something poignant
about a place in which
people no longer live.
Preston chose a close
view that allows him to
make the most of the
contrasting textures,
one of his particular
interests.

Consistent viewpoint

When you make the drawing for an architectural subject it is important to remain in the same position. The horizon line will change if, for example, you begin a drawing standing up and finish it sitting down. The next few pages take you through various positions of the vanishing points and the horizon.

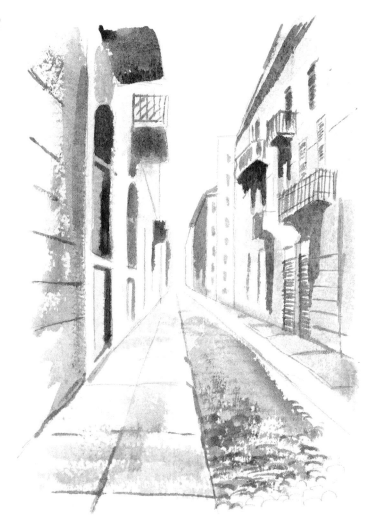

If these objects are the same height and the same distance apart – a row of telephone poles, for example – they will appear to become shorter and thinner, with the spaces between them getting smaller and smaller. This is an illusion but in a sense, so is all painting: you are creating an illusion of the three-dimensional world on the flat surface of a piece of paper. Perspective is a way of helping do this.

Consider how perspective affects buildings, which are composed largely of straight lines. Since objects appear smaller as they recede, it follows that parallel lines going away from you appear to draw together until they converge. They converge at the "vanishing point" on the horizon. The horizon is important; it has a precise meaning in perspective. The horizon is your own eye level. It is this that determines whether the parallel lines slope up or down. When you're standing on a street lined by houses, your eye level will be roughly at door height, and the roofs of the buildings will slope down. If you looked at the same street from the top of a nearby hill your eye level would be high, and the lines of the roofs would slope up.

The exact position of the vanishing point on the horizon is also determined by where you are. If you're in the middle of a straight road, the vanishing point will be directly in front of you. If you're viewing at an angle, however, it won't be in the middle, but to one side or the other. Sometimes, if you're viewing at a very oblique angle, it will be some way outside

CENTRAL VANISHING POINT

When there is one vanishing point (VP), and it's in the middle of the picture, you can see clearly how all the receding parallel lines slope down or up to it. Unfortunately, a straight-ahead view can yield a dull, over-symmetrical composition, and it is more usual to choose an angled view, where the vanishing point will be to one side of the buildings (see opposite).

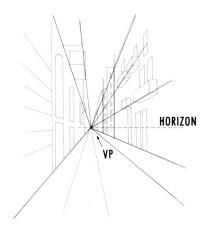

120

cont. on pg.124 ▷

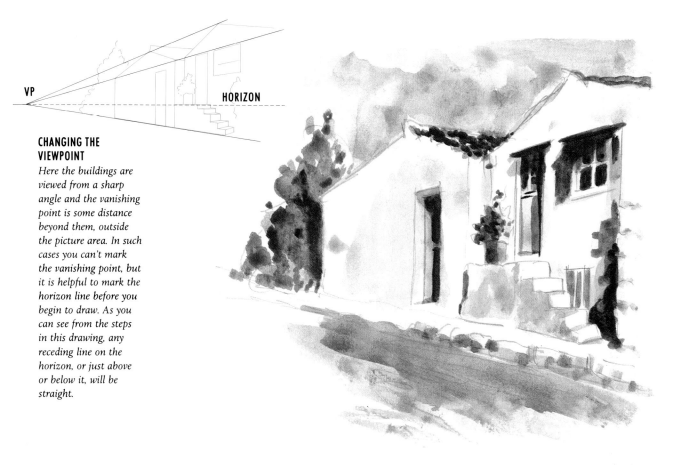

CHANGING THE VIEWPOINT

Here the buildings are viewed from a sharp angle and the vanishing point is some distance beyond them, outside the picture area. In such cases you can't mark the vanishing point, but it is helpful to mark the horizon line before you begin to draw. As you can see from the steps in this drawing, any receding line on the horizon, or just above or below it, will be straight.

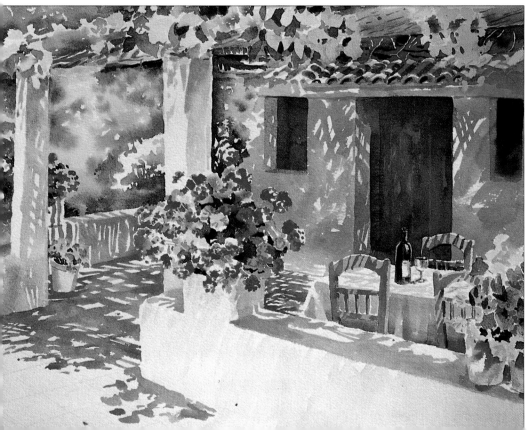

◄ **Hacienda**
Hazel Soan

This lively painting illustrates the dual role of perspective. It's important to get it right so that your buildings look solid and convincing, but it also helps you to make a good composition. The series of gentle diagonals formed by the receding parallels are very important in this picture; they provide a balance for the verticals of the pillars, door, and windows.

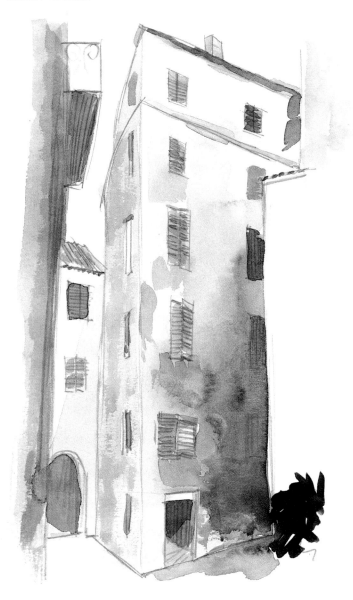

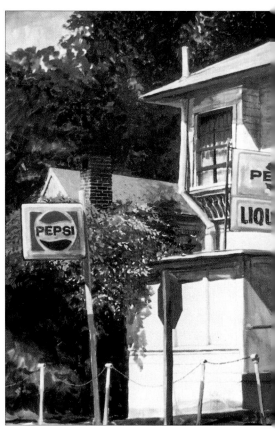

▲ Ed's Superette – Bryn Craig

Here there are two main vanishing points, one for each plane of the building. The horizon is roughly at the level of the roof of the front extension. Once you have marked in the horizon line it is quite easy to plot the angles of the other lines.

TWO VANISHING POINTS

When you can see both planes (sides) of a building, there will be two separate vanishing points, but they will both share the same horizon line because this is your eye level. The buildings in this drawing are tall, so they slope down at an acute angle. To check these angles, hold your pencil up at arm's length and move it until it coincides with a roof or window top.

HORIZON

VP **VP**

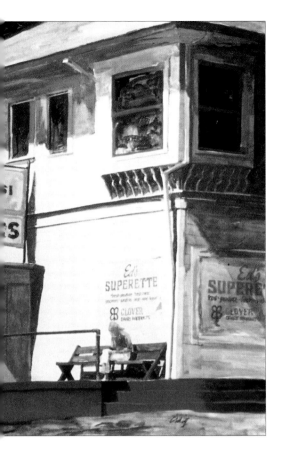

COLORS FOR BUILDINGS

MIXING GRAYS AND NEUTRALS

The predominant colors of buildings are browns and grays, so practice mixing neutral colors that don't look dull. Remember that mixtures of three primaries make good neutrals. Although you may not need any new colors, useful additions could be cobalt blue, a "cooler" blue than ultramarine, and burnt sienna and/or Venetian red. The latter are excellent for the colors of brick.

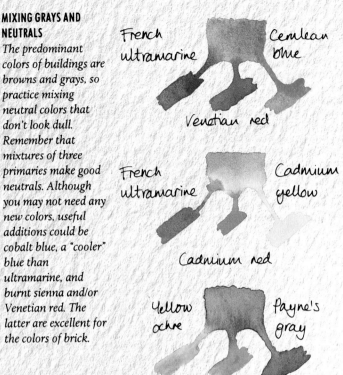

French ultramarine — Cerulean blue — Venetian red

French ultramarine — Cadmium yellow — Cadmium red

Yellow ochre — Payne's gray — Alizarin crimson

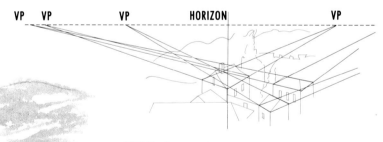

MULTIPLE VANISHING POINTS

Buildings are not always conveniently arranged in straight lines, so when you are painting a group of houses each one may have a different vanishing point. Here there are several, and the converging lines slope upward to a high horizon line.

123

▲ Salzburg,
Archbishop's Residence
John Newberry

The low viewpoint provided an exciting composition. The sharp angle of the receding parallels slopes down to the horizon to emphasize the height and slab-like shape of the foreground building.

your picture area, and sometimes there will be two or more vanishing points, one for each set of receding lines. You'll need to rely just as much on careful observation as on the rules, but it helps to know them.

COMPOSING THE PICTURE

It may surprise you that perspective comes into this aspect of painting too. It isn't just a dry set of rules; it can be a live force in composition. Look at a building from several different angles, first straight-on, then from one side, and then from a very low or high viewpoint (if possible). You'll probably find that the dullest view was the first one, and this is because a

frontal view only provides horizontal and vertical lines, with no diagonals. Whatever your subject is, you want to aim at creating a sense of movement in your compositions, and horizontal lines have a leaden, static effect, whereas diagonals have a natural dynamism.

You don't always have as much leeway with architectural subjects as you do with landscape, where it's fairly easy to move a tree from one part of the picture to another. If you want to paint a house that looks like a house you can't make the windows smaller or the roof a different shape, so most of the composing is done by choosing the best viewpoint. A tall building tends to look more dramatic from

This picture owes its strength to the foreground. The posts and steps push upward to the building and echo its vertical lines. This is the best, and possibly only, vantage point from which to paint this famous London pub. Composition, which is largely determined by viewpoint, is sometimes chosen for you, and you need only make a few refinements.

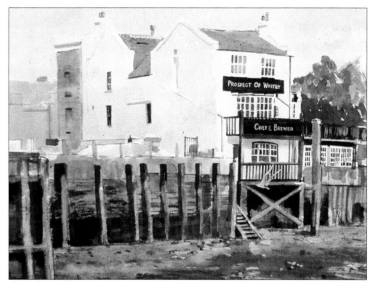

◄ **The Ruin**
Hazel Soan

This picture is beautifully planned. The doorway, which is the center of interest, is placed to one side and viewed at a slight angle so that we can see the inside of the arch. This is balanced by the stone wall on the right. The strong shape of the blue shadow creates foreground interest as well as setting off the golden yellows of the sunlit stone.

below, with the parallel lines sloping sharply down to the horizon, and a cityscape can look exciting from above – perhaps seen from an upstairs window.

Remember also that you don't have to paint the whole of a building. In a town street you can't usually get far enough away to do this anyway, and you'll find that a detail of a storefront or some windows and balconies makes a better picture than a view of the entire street. Be careful with "cropping in," however. If you do it, crop thoroughly; don't just let a sliver of roof slide out of the picture at the top because you couldn't fit it in – this can give a cramped and uncomfortable feeling.

125

Painters who are not inspired by buildings are often fascinated by their appearance on a sunny day. The play of light and shadow can transform the most featureless wall into a "theater" of unexpected shapes and colors.

The problem is that you have to work fast to capture shadows. They keep changing, and each new shape seems more interesting than the last. If you are working on the spot, it's

Sun and shade

MAKING PICTURES

best to choose the subject (complete with shadows) the day before. When you start painting, block the shadows in immediately and don't change them. If you are working from photographs you won't have this problem. But photos may not give the true colors, so you'll need to remember them, or make notes as you take the photograph.

Planning the composition

Painting shadows

Using masking fluid

1 *The painting was conceived on a weekend trip to Spain. The artist made a rough sketch (left) to plan the composition and took several photographs to help her with specific details when working in the studio. Having made a careful drawing she now applies masking fluid where she wants to reserve small highlights.*

PALETTE USED

From left to right the colors used in this demonstration are: Alizarin crimson, cadmium red, cadmium yellow, yellow ochre, ultramarine, cobalt blue, cerulean blue, Hooker's green dark, sap green.

1

126

2 Although she is not working directly from the subject, she adheres to one of the procedures she follows when on location; painting the shadows first. It is always wise to do this when the shapes and/or colors of the shadows are an important feature.

3 The masking fluid is removed from the shadowed area of pavement in the foreground. Further color will be laid over the initial blue wash to darken it, so that the white lines will not remain white.

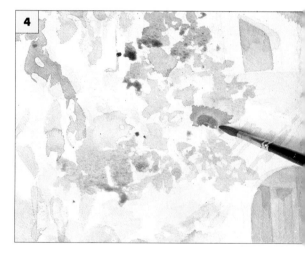

4 The pinks and yellows of the blossom tree are as important as the colors of the shadows, so these are begun next. Again, the colors will be darkened as the painting progresses.

5 Although most of the picture is painted wet on dry, here the artist is working wet on wet, as she wants a soft effect for the leaves and flowers.

continued ▷

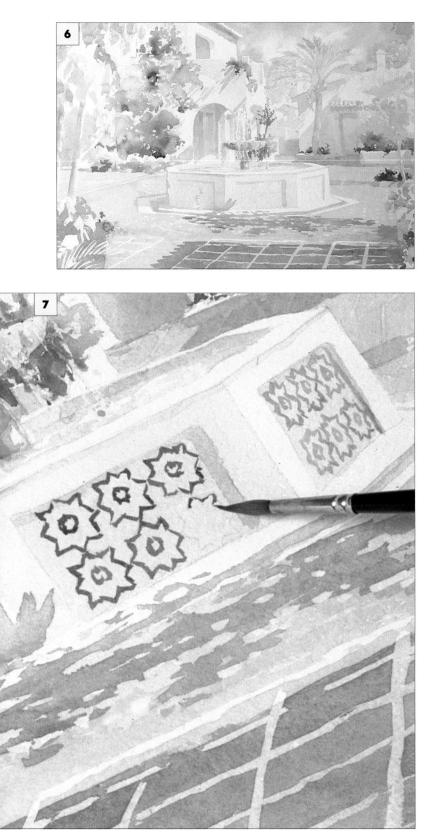

6 At this stage, the color scheme is established, although subsequent washes will darken and enrich it. It is important to see the painting as a whole from the minute you begin.

7 A strong blue-brown mixture is used to paint the delicate pattern on the front of the fountain, and a dilution of the same color for the right side. The artist gets the perspective right, with the star shapes diminishing slightly in size as they recede. Because this is the central feature of the painting, the smallest mistake would be instantly apparent.

8 A small natural sponge is used to dab paint onto the right-hand tree, giving an attractive broken texture. You can see the effect clearly in the completed painting opposite.

9 One of the elements that gives this painting its vitality is the variety of brushmarks. A large round brush is used for the oval leaves of the foliage. The artist is working on a tilted board, so that paint runs downward, forming a pool at the bottom of each stroke.

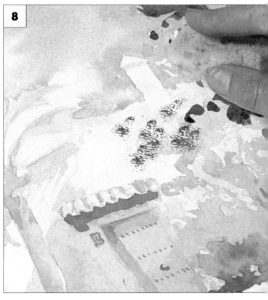

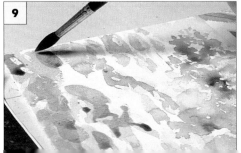

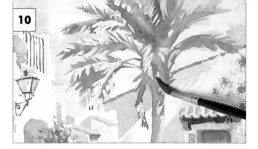

10 *The spiky, elongated leaves of the palm tree were painted with a smaller brush, used in a light, flicking motion.*

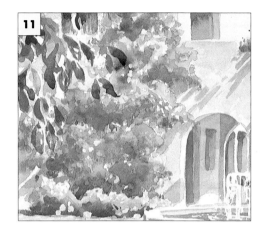

▼ **A Courtyard in Spain**
Hazel Soan

11 *The rounded blobs for the flowers on the tree were made with masking fluid. This was removed after the initial washes were laid, and pale yellows were laid on top in places, leaving other patches white. The dark leaves were painted over the blossom tree.*

In the final stages of the painting, the artist decided that the foreground shadow was too heavy and too regular a shape. As you can see from previous steps, this was the shadow of another building. She decided to wash down the area and change it to a dappled tree shadow, softer and more in keeping with the rest of the picture. See how this correction was made on p.88-9.

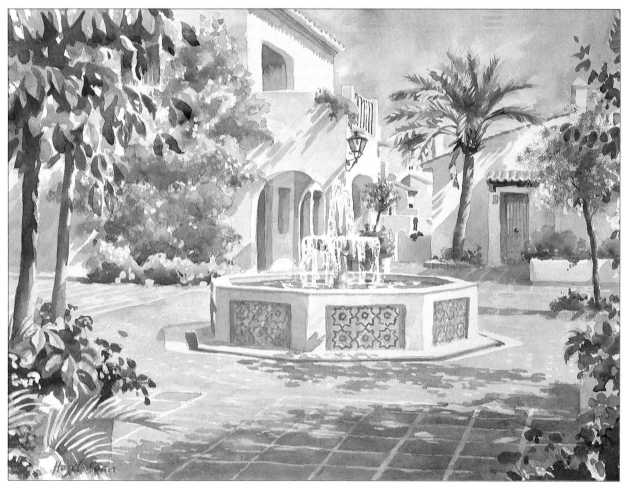

Sometimes you may feel drawn to a subject because of a certain atmosphere about it. Atmosphere is an important quality to communicate in your paintings, and to do so you need to choose your colors carefully.

Suppose you are painting a summer beachfront and want to convey a carefree feeling. Do this by using light bright colors; if dark ones are present, simply ignore them. If,

Using a limited color range

Painting wet on wet

Mixing the media

MAKING PICTURES

Creating an atmosphere

on the other hand, you want to express the melancholy of a deserted building or the grimness of an industrial town, go for dark, somber colors, perhaps working on an overcast day. The colors are your choice, and to paint what you feel you may have to take liberties with what you see.

1 *The misty, diffused light calls for a soft treatment. The artist begins by painting wet on wet, letting the colors flow into one another. Because only the top part of the paper has been dampened, the paint does not run down to the foreground area of sidewalk, which is to be a different color.*

PALETTE USED

From left to right the colors used in this demonstration are: Alizarin crimson, ultramarine, yellow ochre, cobalt blue, viridian, Vandyke brown, Payne's gray.

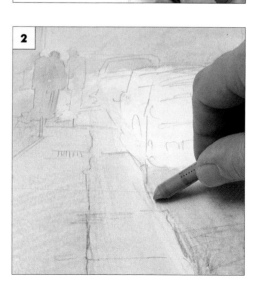

2 *A yellow ochre wax crayon is used to draw on top of a dry wash of light yellow ochre. This will later be overlaid with paint of the same color, so that the crayon marks will be just visible.*

3 *The wet on wet washes are now complete; the rest of the picture will be built wet on dry. The backruns that formed on the right-hand building can be seen in the finished painting, but are less obvious because of the sharp detail elsewhere.*

4 *More work is now done on the foreground sidewalk, this time by spattering droplets of a brown-ochre mixture with a toothbrush.*

5 *The shadow of the bus stop sign is carefully painted. It is important to the composition, and reinforces the shaft of sunlight by making it doubly clear where the light is coming from.*

6 *The effect of the cloud was created by a technique known as "blotting." Paint is applied to a spare piece of paper which is placed face down on the painting surface, leaving irregular blotches.*

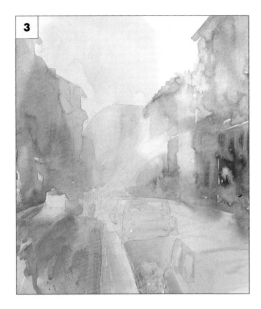

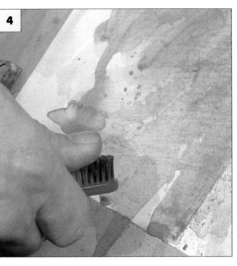

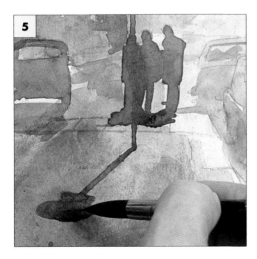

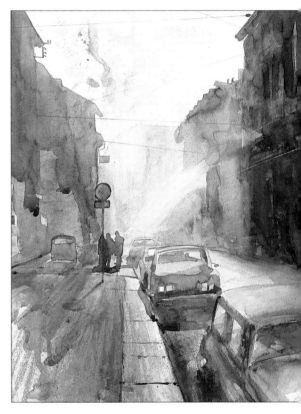

▲ **A Street in Milan – Phil Wildman**

This painting is full of atmosphere. The somber colors, and limited range, consisting entirely of browns, ochres, and purple-grays, create a sense of quiet loneliness. This feeling is accentuated by the shaft of misty sunlight, the empty cars, and the small group waiting for the bus.

Suiting the technique to the subject

You may have already established a personal style and method of painting that serves you well. But a fresh subject could call for a change in technique. For example, you may find that you want to make a feature of the crisp edges of buildings, or the detail on a balcony. In this case a technique such as wet on wet, which may work well for landscape, would not meet your needs. The paintings shown here offer some ideas you may like to try.

◀ **Evening Glow**
Margaret M Martin

Here the artist is less concerned with detail than with the quality of the light, and the way the evening sun transforms the ship and the great hulk of the quayside. She has used the wet on wet method over much of the painting, adding crisper touches wet on dry in the final stages.

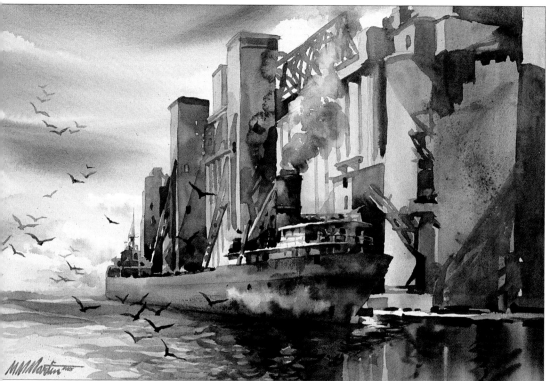

◀ **The Doll Shop,
Salisbury
Ray Evans**

*If you are focusing on a
small area of a building,
detail is important;
without it the picture
could become dull and
meaningless. The artist
has wisely chosen the
pen and wash
technique, which has
allowed him to exploit
the charm of the
shopfront, the contents
of the window, and the
brick wall. Putting in as
much detail as this with
a small brush would
have been a tedious
process, probably
resulting in a tired,
overworked painting.*

▶ **Whitehall
Alan Simpson**

The drawing in The
Doll Shop *was done
with a fine nib and
black ink. Here the
artist used a bamboo
pen, a relatively blunt
instrument that gives a
coarser, somewhat dry
and broken line that
integrates well with the
delicate washes of color.*

**▲ Brighton Pavilion
Dennis Roxby-Bott**

*For a complex subject it
is vital to begin with
careful drawing. You
can erase the lines after
the first washes have
dried, or strengthen
them by further pencil
drawing on top of the
washes, as the artist did
here. Pencil lines, being
paler than those made
with pen and ink,
combine well with
watercolor, especially
when the overall color
scheme is delicate.*

**◀ Balconies
Neil Watson**

*Again, watercolor was
combined with touches
of ink drawing. The two
are so perfectly
integrated that it is
difficult to see where
painting ends and
drawing begins. The
artist worked on a very
rough paper, which
breaks up the lines of
the pen and the
watercolor washes,
giving an attractive
sparkling effect.*

▶ Boy on a Dolphin
Janet Boulton

The strength of the foreground is an important element in this painting. A soft, dark pencil was used to draw into the dry paint.

It is no coincidence that five of the seven paintings on these four pages show versions of the line and wash technique. It is the ideal method for architectural subjects and is widely used in this context.

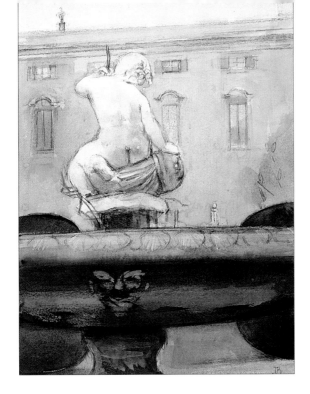

▼ Across the Harbor, Hydra
David Curtis

Here all the details were painted with a small brush. With a distant view you don't want to over-emphasize detail, but it is important to look for the main characteristics of each building – its height, the number of windows, and so on. Although the artist generalized the buildings at the back, he detailed the occasional roof and window, making them completely convincing.

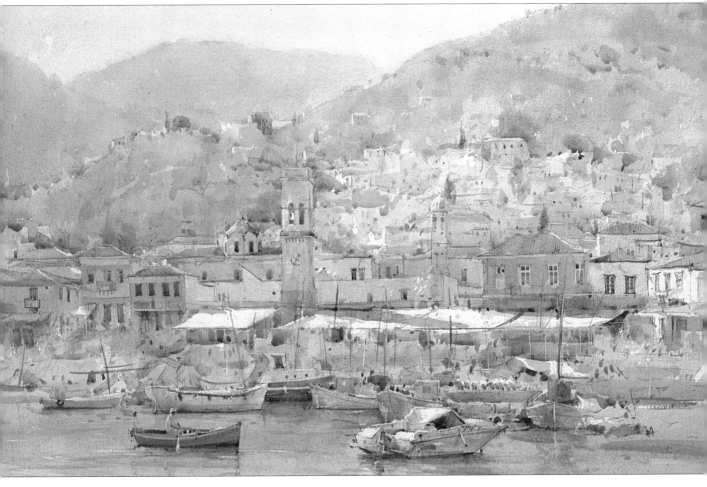

Still life and flowers

MAKING PICTURES

Still life is just as challenging as landscape or architecture, and provides a broad range of subject matter. More importantly, you have complete control of it, providing an excellent opportunity to improve your technical and compositional skills. When painting outdoor subjects you are tied more or less to what you see, but you can arrange an indoor setup as you choose, and take as long as you like.

CHOOSING THE SUBJECT

Not that still lifes have to be indoor subjects, of course. Although the term conjures up images of bowls of fruit, bottles, and vases of flowers on a table, outdoor groups offer equally exciting possibilities. Empty deck chairs on a beach, flowers on a patio, a piece of garden

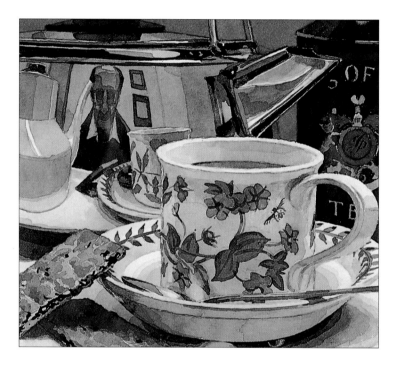

▲ **A Nice Cup of Tea**
Ronald Jesty

The artist extracted the maximum from a small selection of ordinary objects. He paid close attention to detail with the pattern on the cup, the currants in the cookies, and even his own reflection in the silver teapot, which brings a personal note into the painting.

▶ **Still Life in Cellar**
Terry Longhurst

In A Nice Cup of Tea, Jesty focused very closely on his group, so that there is virtually no background. Here the objects are presented in the context of the room. This kind of still life needs only a little rearrangement to make it perfect.

▲ **Still Life with Fruit – Shirley Felts**

This lovely painting exploits a more conventional subject; flowers and fruit, a favorite still-life theme. The colors are cleverly orchestrated: The deep purples, red-browns, and blues used for grapes and background contrast so strongly with the brilliant colors of the remaining fruit that it appears almost luminous.

statuary or even a group of garden tools could form the basis for a still-life painting.

However, to begin it is probably best to stick to the arranged indoor group. This still gives you a wide choice – you can paint anything you like, from an elaborate floral group to some pieces of fruit on a dish, or the remains of a meal on a dining table. Most still lifes have a theme, relating the objects to one another

137

through common purpose. A popular subject is the culinary still life, with fruit and vegetables and perhaps a kitchen knife and cutting board. But the theme can be purely visual. For example, if your subject was a vase of blue flowers, you might put a book with a blue cover beside it – a relationship of color.

Some still lifes tell a story, often about the artist. One of Van Gogh's early paintings, when he was working as a farm laborer and painting scenes of peasant life, consists of no more than a pair of worn and muddy boots. Later, when he was living in the South of France, he painted a pile of books on a table. He was a voracious reader, and the books, which can be identified, reflected his current interests.

COMPOSITION

With still life, most of the composing is done before you begin to paint – you do it when ▷

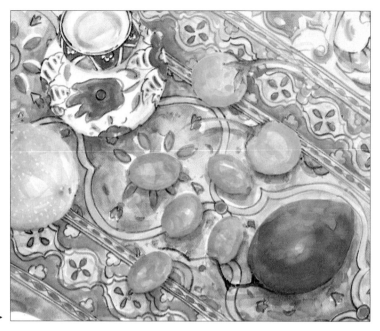

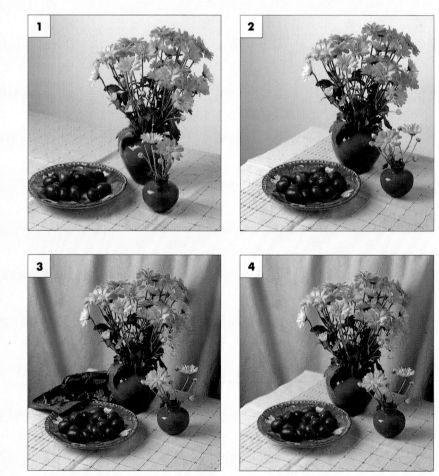

ARRANGING A FLORAL GROUP

1 *Because a vase of flowers makes a tall shape it often needs to be combined with other objects. However, you don't want too many colors and shapes. Here, the small blue pot and bowl of fruit harmonize with the pink and blue color scheme.*

2 *The long line of the back table edge is distracting; moving the group to the other end of the table provides a more interesting corner view. Moving the small pot away from the vase makes each shape distinct.*

3 *The background needs some color and "action," so a piece of blue fabric is pinned up and arranged in loose, diagonal folds to give a feeling of movement.*

4 *The napkin, although harmonizing with the other colors, complicates the composition. It is removed.*

◀ **Five Kumquats**
Rachel Gibson

If you're interested in pattern, try arranging a group below your eye level. This group might have looked dull at eye level, but viewed from above, the pattern of the fabric is clearly visible, and the fruit and background pot make a series of repeated circles and ovals. Never be afraid to crop your subject, letting one or two objects go out of the picture, as the pot and grapefruit do here; it often makes a better composition.

▶ **Still Life with Grapes**
Shirley Felts

For reasons not entirely understood, shapes have particular properties, and circles are natural eye-catchers. Many still lifes incorporate circles in some form: plates, fruit, the tops of bottles, or a circular table, as in this painting. But you'll need other shapes to balance circles. Here the upward-thrusting vase forms the perfect foil for the table top and teapot, while the bunch of grapes makes an irregular triangle.

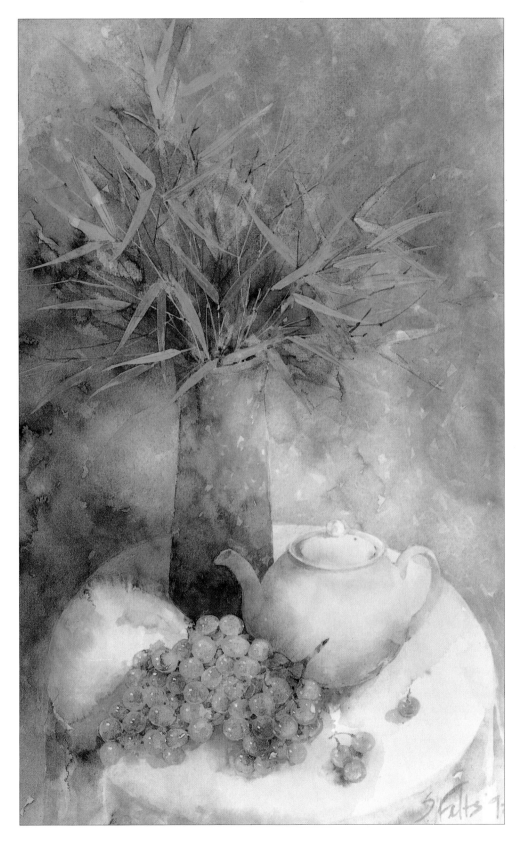

139

WRONG

RIGHT

DRAWING CIRCLES AND ELLIPSES

You'll find it much easier to draw circles and ellipses – which are circles seen in perspective – if you remember that they fit into squares (right). The illustration above shows the square seen at an angle.

ELLIPSES

Another frequent error is "pinching" the ends of an ellipse. When you are drawing an object, such as a vase or bottle,

avoid this by lightly marking in all of the ellipse even when you can't see it.

▶ **Copper Kettle and Blue Bowl**
Ronald Jesty

Again a circle was used, and the artist chose a fairly high viewpoint to give an open ellipse. This is a clever, well-planned composition. Although there are only two objects, a wide variety of shapes was introduced through the reflections in the metal and by way of the newspaper used as base and background.

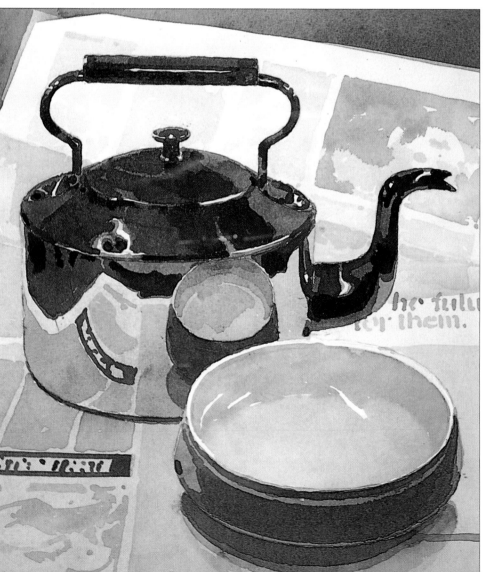

IDENTIFYING CIRCLES AND ELLIPSES

If you look at an object such as a vase or bottle from directly above you will see a true circle.

Seen from slightly above, the circles will become wide ellipses (near-circles).

Ellipses appear shallower the nearer they are to your eye level. The ellipse at the bottom will be deeper than the one at the top.

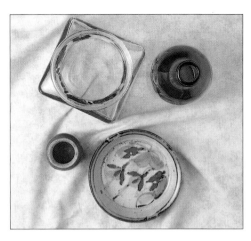

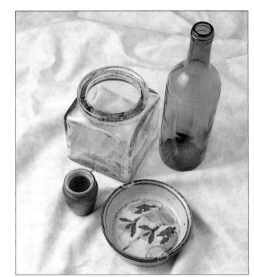

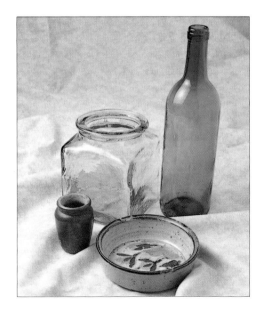

you're setting up the group, and it pays to take your time over this stage. Sometimes a still life can end up looking altogether too still, so try to choose a selection of objects that provide a good variety of shapes, and don't arrange them in a row with equal spaces between them. You'll often find that placing the table at an angle makes the composition more lively. This will provide diagonal lines, which lead the eye into the picture instead of horizontal ones, which have the opposite effect.

Place some objects nearer the front, and don't be afraid to let some of them overlap, as this establishes visual links. Take care how you do this, though; you don't want to obscure one object by putting another in front of it, nor create an awkward shape by taking a "bite" out of the background object. If your group includes a pitcher or similar item, make sure that it faces inward, toward the other objects and not out of the picture.

Take care over spaces between objects. Too small a space can look ugly and cramped, while too large a space will have the effect of forcing the objects apart. In this case you'll have to find a way of linking them, perhaps using a shadow as a positive compositional device.

Once you've set up a good group, use the viewfinder shown on page 99 to check it. You will quickly be able to see whether everything will fit comfortably within your picture area. You may find that you have to make some last-minute adjustments – perhaps a tall object goes out of the picture at the top, or there is too much empty space at the front of the picture. Still using the viewfinder, look at the group from different angles. Sometimes a group that doesn't look exciting from straight-on is improved by a side view or a higher viewpoint which can provide a stronger element of pattern.

PERSPECTIVE

Most still lifes are arranged on a table top or similar flat surface, so you'll need to get the right perspective for the front, back, and side edges (if these are part of the picture), or the entire painting will look tilted. There's no problem with this; perspective is just the same for tables as it is for buildings (see pp.118-121).

There is another thing you'll need to know for still lifes, however: how to cope with circles

and ellipses (circles seen in perspective). There are few still lifes that don't include an ellipse or two in the form of cups, dishes, pitchers, and bottles, or the bottom and top of a vase. Like a crooked table, a wrongly painted ellipse can make the object look bizarre and unrealistic.

Ellipses are a continuous problem for painters, but there is a simple rule to help with them. Circles fit into squares, so if you can draw a square it isn't too hard to draw a circle. Look at the drawings to see how this works. Knowing the rule doesn't guarantee success every time, because it isn't easy to draw squares in perspective, but it does help to understand the principle, and you can check a faulty ellipse by drawing a square over it.

Often you'll find the only thing wrong is that the sides are unequal. Making a faint line to indicate the center will prevent this fault. If the object is a tall one, such as a bottle or vase, take this line to the bottom to help you to get both sides of the body equal. Don't be afraid to take measurements if you're unsure.

SIMPLIFYING FLOWER SHAPES

Understanding ellipses will also help you with flowers, another hard-to-draw subject. Flowers look complex, sometimes bewilderingly so, but most can be simplified into basic shapes. Some are bell-shaped or almost tubular; some – such as daffodils – are a bell shape inside a circle; but the majority are rounded or flat circles, which become ellipses as they turn away from you.

When you're doing the preliminary drawing for a floral subject it's best to keep it simple, avoiding the complex details of petals and drawing the main shapes as a series of circles or ellipses. Pay careful attention also to the way the stem joins the flower head and to the way the stems "sit" in the vase. Stems will often be hidden from view behind other flowers or leaves, but it's important to give the impression of each bloom growing from its own stem, which is "rooted" in the vase.

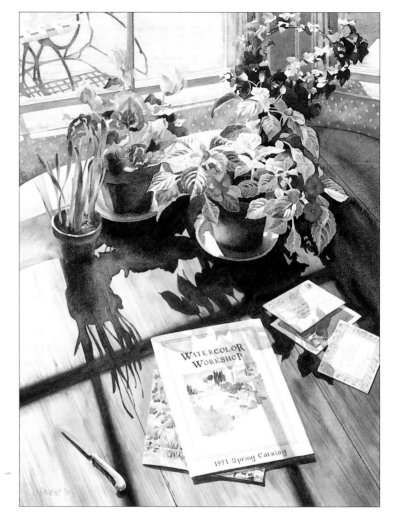

▲ **Waiting for Spring**
William C. Wright

This ambitious still life might have been set as an exercise in perspective. The artist relished the task of painting every ellipse, angle, and line with perfect accuracy. Yet it is also an exciting composition, full of movement and color. The shadows thrown by the pots and window bars not only create their own pattern but also make a series of links between the objects.

▶ **Sunflowers**
Rosalind Cuthbert

Although the petals, bending in different directions, are quite complex, the basic shape of the flowers is a circle, which becomes an ellipse as the flower heads turn down or away. A common mistake is to paint every flower from a straight-on view, but in a floral group many will be seen from the side.

FLOWER SHAPES

Many flowers, like these daisies, are based on a circle. Look for the main shapes when you're drawing and painting them. Leave the details of petals until you are sure you have the angles of the flower heads right, and their sizes in relation to the stems.

Stems are just as important as flower heads. Study them closely when you draw to convey the way they twist and bend, swelling slightly where they join the flower head

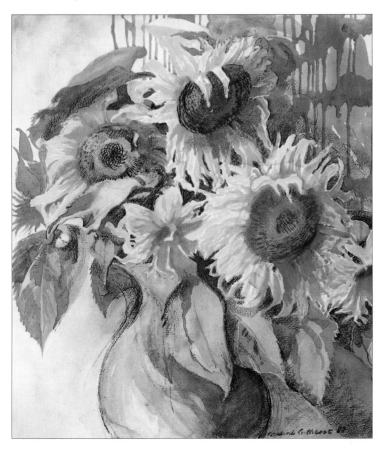

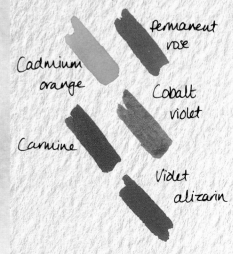

COLORS FOR FLOWERS

If you specialize in flower painting you will certainly need additional colors. Many secondary colors produced by mixing primaries are less bright than ready mixed secondaries. The purple/violets, for example, are almost impossible to mix satisfactorily, and cadmium orange is brighter than a mixture of cadmium red and cadmium yellow.

Cadmium orange

Permanent rose

Carmine

Cobalt violet

Violet alizarin

Glass, with its reflective surface providing bright highlights, and its transparency creating fascinating, distorted shapes, is rewarding to paint. And it isn't difficult provided you observe your subject carefully. On a curved glass surface such as these bottles, most of the light or shadow is concentrated at the edges, which can look very bright or fairly dark, while through the center the color

Painting transparent objects

Achieving color harmony

Building up colors

MAKING PICTURES

Painting glass

of the background is visible. It's usually best to choose a dark or vivid background rather than a pale one; this will stress the transparency and enable you to use strong colors in the glass itself.

You'll need to pay attention to the lighting when setting up the group, as glass looks best when some highlights can be seen. Here, the light is coming from a window on the left, providing a good balance of light and shadow. If you use artificial light, don't place it too close or it will throw hard shadows and may make the colors look garish.

PALETTE USED

From left to right the colors used in this demonstration are: Cadmium red deep, permanent rose, cadmium orange, cadmium yellow, phthalocyanine blue, cobalt blue, cobalt green.

1 *One of the advantages of a group like this is not having to look far for subject matter. Most homes contain glass bottles, bowls, jars and pieces of colored fabric.*

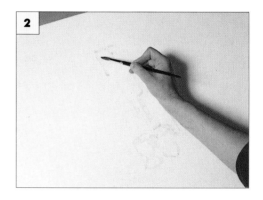

2 *The artist draws with a small brush, using well-thinned paint that she will be able to integrate into the subsequent layers of color. This is not, however, a practice recommended for beginners, as you can't erase any mistakes. It is much safer to make a pencil drawing and then add paint.*

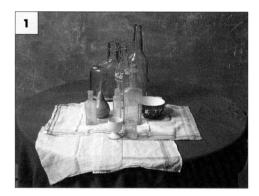

3 *The first color laid down was cobalt green, diluted, and applied with sweeping brushstrokes over the background and parts of the bottles and tablecloth. Repeating the same color from background to foreground creates visual links, ensuring a unified color scheme.*

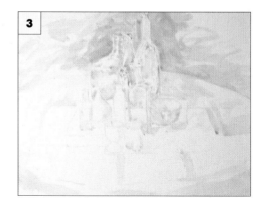

144

4 *Having laid in pale colors all over the painting and darkened the background behind the bottles, she now uses a small pointed brush to define the necks and rims.*

5 *To preserve the overall delicacy of the colors, the deep blue of the bowl is slightly "played down." Always try to give as much thought to your picture as to the objects in front of you, and change colors if they aren't right for the painting.*

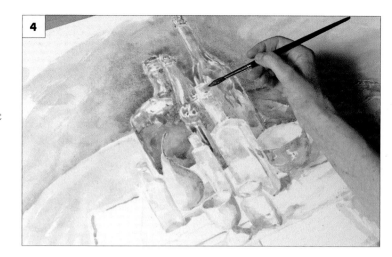

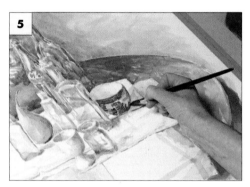

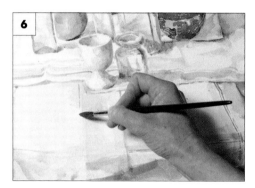

6 *Final touches are added to the handkerchiefs in the foreground. The artist is careful not to overwork, as this could spoil the freshness of the colors.*

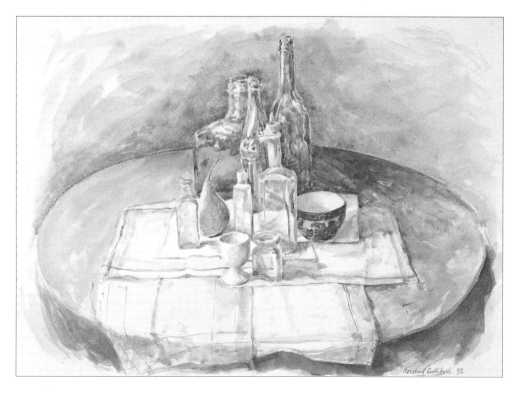

◄ Still Life on a Round Table
Rosalind Cuthbert

The bright but delicate colors were achieved by building a series of layers. The effect is particularly noticeable on the right-hand area of the tablecloth and on the bottles themselves, where you can see a wide range of yellows, pinks, blues, and greens, A palette of only seven colors was used, and no mixture contained more than two colors.

Flower groups are among the most popular still-life subjects, and it is easy to see why; flowers, beautiful and colorful, are one of nature's masterstrokes. For your first attempts, keep the group simple, choosing not more than two types of flower.

Make a careful preliminary drawing, but don't try to represent every petal; look for the main shapes of the flowers and their relation to

Floral still life

the vase. When you begin to paint, don't spend too much effort with a small brush; try to work freely and boldly. Flowers need a light touch, not layer upon layer of paint. If you have chosen white flowers, remember that you can use masking fluid to reserve the highlights; it will make your task much easier.

project

6

Arranging a flower group

"Painting" white

Cropping for better composition

1 The flowers were arranged with care: some higher in the vase than others, some facing away, and some small blooms overlapping the top of the vase. The artist then made a quick sketch to ensure that the composition was satisfactory.

2 The next step is to make a drawing on the working surface, apply masking fluid to some of the white flower petals, and lay light green and blue washes for the leaves and vase. Here a blue wash is being taken carefully around the edges of the petals in front of the vase, which have not been masked.

PALETTE USED

From left to right the colors used in this demonstration are: Violet alizarin, ultramarine, cobalt blue, cerulean blue, sap green, Hooker's green, oxide of chromium (green), cadmium yellow pale, Indian yellow, indigo.

146

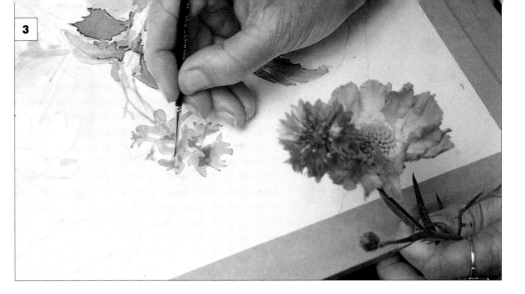

3 *The cornflowers are lightly blocked in, and the paint left to dry before the addition of darker detail. To make sure she fully understands the structure of the flower, the artist has removed two from the vase to study closely as she works.*

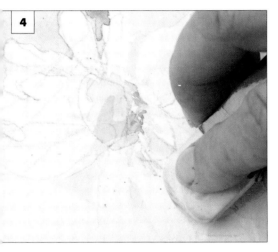

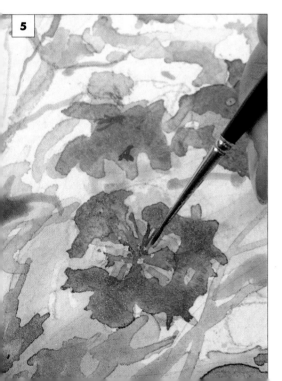

4 *This flower, on the left of the picture, was painted with masking fluid, which enabled the artist to lay the pale background wash freely and rapidly. When the wash dries, the fluid is rubbed off with an eraser, which also removes the pencil lines.*

5 *A tiny pointed brush is used to touch in the dark edges of the petals at the center of a cornflower. In a successful flower painting, it should be possible to recognize the species of flower, so it pays to be painstaking over details.*

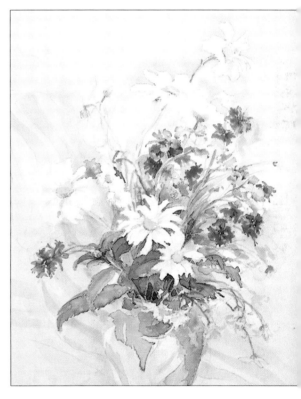

▲ **Daisies and Cornflowers – Elisabeth Harden**

The decision to crop the bottom of the vase allowed the artist to make more of the flowers. Although the overall color scheme is light, there are enough small dark areas to set off the whites and yellows, and the pale background is well chosen. A dark background would have provided stronger contrasts and a more dramatic effect, but lightness and delicacy are the themes here.

147

Lighting the group

When setting up a still life or floral group, lighting is almost as important as the objects themselves. Light coming from directly in front is seldom satisfactory, since it casts no shadows and therefore flattens the forms. Side lighting is the usual choice, because it provides clear shadows on one side of an object and highlights on the other. Backlighting can be effective if you want a silhouette effect.

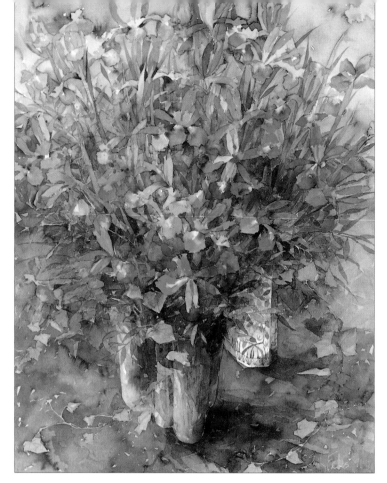

▶ **Blue Irises – Shirley Felts**

A gentle light from the left and slightly behind the group provided cast shadows and darkened the flowers on the right-hand side to give form and volume. The artist avoided hard edges in the shadows, which would have been at odds with the delicate treatment of the flowers.

◀ **Still Life on a Windowsill
John Lidzey**

The artist's primary concern was to convey a brilliantly lit group against the dark window. The light comes from a lamp in front but slightly to one side, so that the highlight in the mirror is not central. The highlights are an important feature of the painting, so the artist moved the lamp around until he found the best position.

▶ **William's Pears**
Ronald Jesty

As in the flower piece opposite, the light comes from the left, but here it is considerably stronger, because the artist wanted to stress the contrast of light and dark. The deep shadows on the sides of the pears, and the equally deep cast shadows on the plate and tablecloth, enhance the brilliant yellows of the fruit.

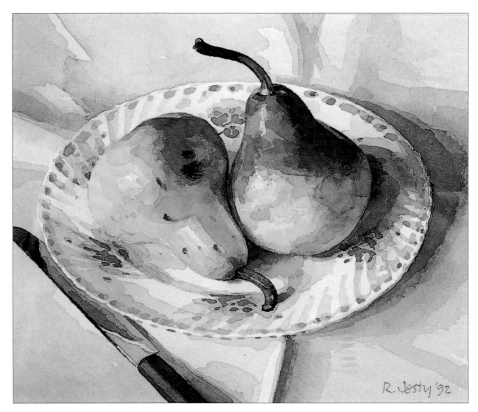

◀ **Jugs by Lamplight**
Elisabeth Harden

Here a lamp was used as a key feature in the composition as well as illuminating the group. Notice how effective a simple color scheme can be, with the repeated blues and yellows evoking a feeling of quiet harmony.

▶ **Tigerlilies II**
Rosalind Cuthbert

The light comes from the window, turning the window recess and table top into clear white shapes. The artist deliberately distorted the perspective to make the most of these shapes, playing off the curves of the pitcher and flowers against sharp diagonals.

Animals and birds

MAKING PICTURES

Because of its versatility, watercolor is a perfect medium for animal subjects. You can lay loose fluid washes to establish broad areas of color, work wet on wet (see p.64) for soft effects, "draw" with your brush to suggest a bird's feathers or the long hair of a cat or dog, and use a tiny brush to paint details such as eyes and whiskers. In the 19th century watercolor was the medium most often used for the colorful and detailed illustrations in botanical and zoological books, and many wildlife artists today still find it the most sympathetic means of expression for their work.

CHOOSING A SUBJECT

Professional wildlife artists often specialize in this branch of painting because they are fascinated by animals and birds rather than because they love painting. When not painting they will be out "in the field" observing, making notes, and collecting visual information in the form of photographs and sketches.

But you don't have to devote your life to it in order to paint good animal pictures. However, painting wild animals will involve working from photographs or painting at a zoo. If you are interested in wildlife subjects look through nature magazines and other likely sources to amass a reference file of ideas.

There are two important things to bear in mind. First, basing a painting too closely on a photograph seldom produces good results (see p.90), and second, there can be copyright problems. If you do a painting that is a recognizable copy of a photograph and try to sell it, you could find yourself in court.

▲ **Pandanus Party – Philip Farley**

At first sight it is hard to believe that this marvellous painting, with its rich colors and wealth of detail, is a watercolor. But long before watercolor was used in a loose, free manner it was valued by natural-history artists for its capacity to create precise detail. Farley works out his composition with tracings and sketches, moving the elements around until he is satisfied. Then he slowly builds up colors, mainly with dry brush over washes. He uses a little

► **Tabby Kitten – Gillian Carolan**

In Badgers Grubbing, *the artist was concerned with accurate rendering of detail. Here a broader, freer approach was used to emphasize movement and* *atmosphere. For a painting like this it is better to work from sketches than photographs, which tend to "freeze" movement.*

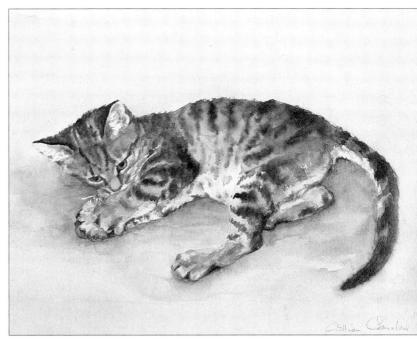

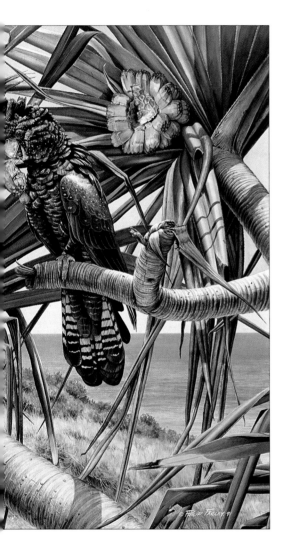

▼ **Badgers Grubbing**
Sally Michel

Shy creatures like these would be difficult to paint without the aid of photographs and museum exhibits. The setting is important, because it gives authenticity as well as making a lively and interesting composition.

gouache paint for small highlights, and sometimes covers areas with masking fluid so he can work freely on others.

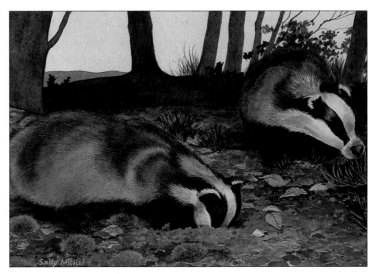

It is probably best to stick to domestic animals that you can observe, sketch or photograph first hand. If you live in the country you may have access to horses, cows, sheep, or goats, all of which make excellent subjects and will often obligingly stand still and graze quietly, allowing you to make sketches, or even complete a whole painting on the spot. For bird subjects you may be limited to ducks and geese on ponds and lakes, but don't dismiss them because they are so familiar – they are also highly paintable.

SPECIAL TECHNIQUES

One of the most atttractive aspects of bird and animal subjects is the texture of fur, hair, and feathers. If you're painting them at a distance,

as an incidental feature in a landscape, you won't want to emphasize texture. Instead, you'll want to concentrate on overall shapes. A close-up view of a creature that fails to give some indication of texture, however, is a missed opportunity, so you may need to bring some special techniques into play.

Many animal painters favor the dry-brush method shown on page 70. This is perfect for fur and hair; you can build realistic and quite complex effects by laying one layer of dry brush over another and varying the length and direction of the strokes. Practice this by working from a photograph or even a painting by another artist.

A related method is to paint in small separate brushstrokes, thickening the paint

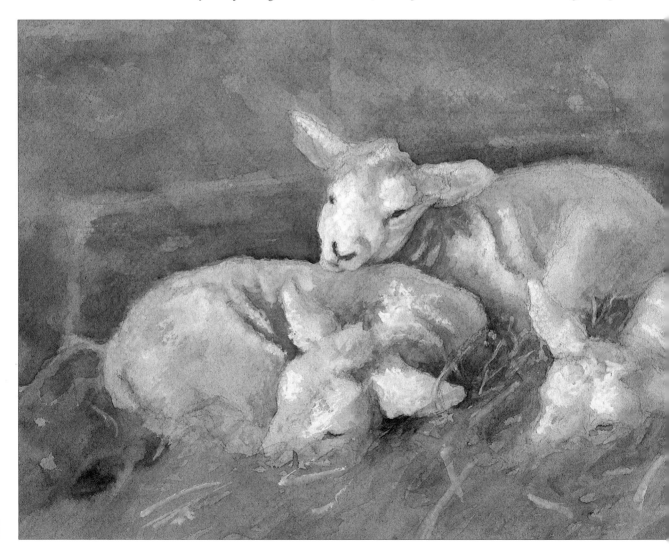

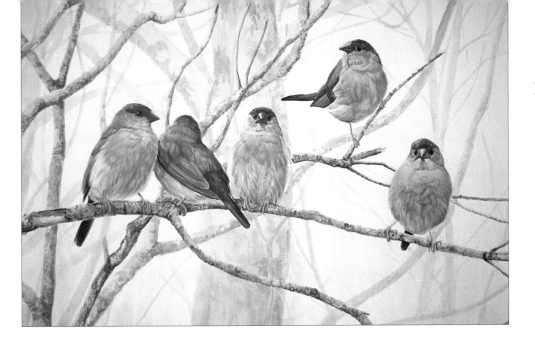

Opaque paint was also used in this painting, but more precisely. The plumage is built with a series of tiny strokes using a small brush. The misty background is beautifully captured, and provides the ideal setting for the birds.

◀ **Lambs Resting**
Gillian Carolan

For this beautifully observed study, the artist worked on a slightly tinted and textured paper, and mixed opaque white with the watercolor. She also used touches of soft pencil, most clearly visible around the ears of the lamb in the middle. The quiet color scheme and soft-edged quality suit the subject perfectly.

▲ **Young Himalayan**
Panda
Sally Michel

Pastel was laid over watercolor washes to build the dense texture of the animal's fur. The artist worked on tinted pastel paper, which has a finer grain than watercolor paper and does not break up the pastel strokes. Pastel and watercolor are often used together, especially where texture is an important feature.

153

► **Pelicans
Donald Pass**

This painting was done from life. A combination of soft pencil drawing and watercolor washes allowed the artist to rapidly record his impressions. When sketching wildlife on the spot, you won't have time to worry about techniques; the key is to get your impressions onto paper as fast as possible.

with a little white gouache or Chinese white (see p.19). Adding opaque paint is not always a good idea, as it tends to muddy the colors, but for animal subjects it's useful, because it gives the paint enough body to prevent the brush-strokes merging into one another. Another paint additive is gum arabic, which is the "binder" used in the manufacture of water-colors. A little of this added to the water makes the paint less runny, and unlike opaque white, makes colors brighter.

If you're still not happy with your animal paintings, why not branch out and try a mix-ture of mediums? The line and wash technique (p.82) can be just right for fur and feathers. Pastel and watercolor is a nice combination, and so is charcoal and watercolor. You can sug-gest texture very effectively with no more than a few strokes of pastel or charcoal over a water-color wash – in half the time it would take to do a dry-brush painting.

COMPOSING THE PICTURE

One of the things that can go wrong with paint-ings of animal subjects, particularly if you're working from photographs or sketches, is that you become so obsessed with rendering text-ures that you forget about the rest of the painting. If you treat one part of the picture in much more detail than the others it will not hang together. The most important rule of

composition is that all the elements in the painting play their part. Whether your subject is a cat asleep on the windowsill or a horse in a field, make sure you integrate the creature with the background and foreground.

The same applies to technique. If you use a careful dry-brush method for the animal and paint the background in loose, fluid washes, the effect will be disjointed, as if you'd stuck two separate paintings together. Whichever tech-nique you decide on, be sure to carry it through the whole painting.

► **In the Sunlight
Gillian Carolan**

The pool of sunshine where the dog lies is carried over the chair to unite separate elements of the picture. The style is loose and fluid, but the dog is described with amazing accuracy. Dark washes were made around the side of the head to depict its shape.

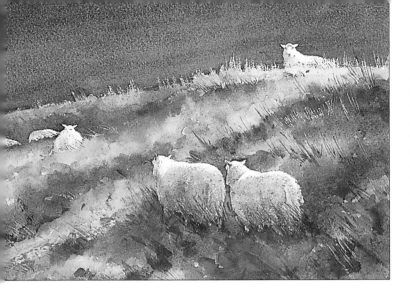

◄ Sheep, Wales
Terry Longhurst

In a simple but effective composition, the lines slanting across the field lead the eye from the two groups of sheep in the foreground to the one looking down from the top of the hill. The dark background focuses attention on the white animals and the rich colors of the grass.

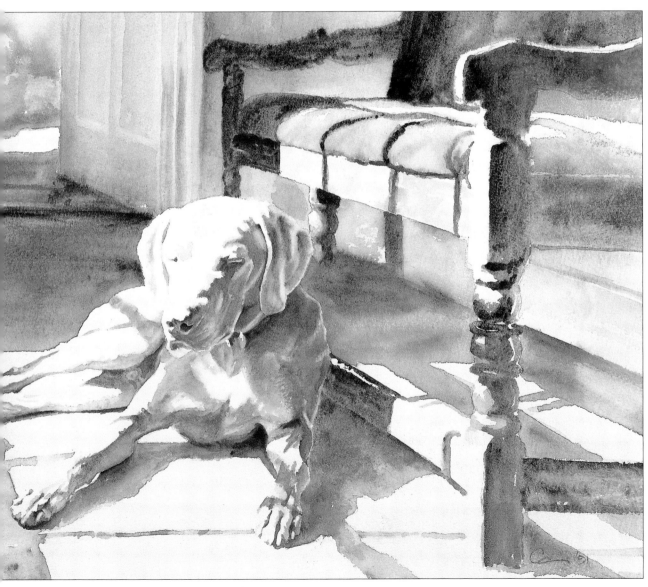

155

When painting a landscape or still life it is possible to hide an imperfect drawing if the colors are well chosen and the composition is good. It may not matter if a tree is slightly out of proportion or a bowl not quite round, but fudging with animal subjects is more difficult. It may help to brush up on your drawing and to make preparatory sketches. Back up your sketches with photographs; and get into

Improving your observational skills 🖌

"Drawing" with watercolor 🖌

Working rapidly 🖌

MAKING PICTURES

Making studies

the habit of carrying your camera as well as your sketchbook. It wasn't until the 19th-century photographer Eadweard Muybridge made his famous photographic studies of animals in motion that artists began to get the horse's gallop right – previously horses in motion were depicted with all four legs off the ground.

1

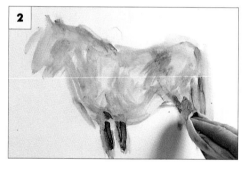

2

SHETLAND PONY

1 *When using watercolor as a sketching medium, think about the quickest way of doing it. Here it is wiped across the paper with a rag, in a similar way to drawing with charcoal or pastel.*

2 *The rag absorbs much of the paint, so it is immediately dry enough to add a further layer. The main shapes of the pony have been blocked in only a few minutes' work.*

3 *With the addition of rapid, free brushwork over the rag painting, the pony is complete.*

PALETTE USED

From left to right the colors used in this demonstration are: Venetian red, raw sienna, yellow ochre, sepia, cobalt blue, lamp black.

3

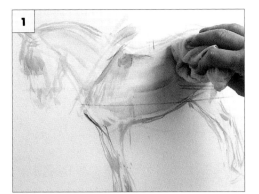

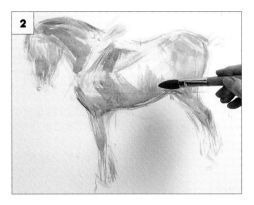

SHIRE HORSE

1 *The rag method is again used here, but this time preliminary light "drawing" was done with a brush.*

2 *The brush is now used to darken the paint in places and build the form of the animal.*

3 *The fine lines of the harness are touched in with the point of a brush. Because she likes to work standing up, the artist steadies her hand on a "mahlstick." This device, mainly used by oil painters, is a stick with one padded end which rests on the edge of the drawing board.*

4 *The harness is given close attention, because it helps to describe the various forms.*

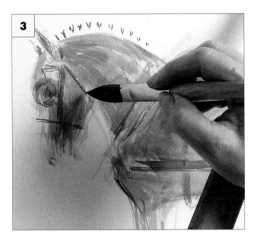

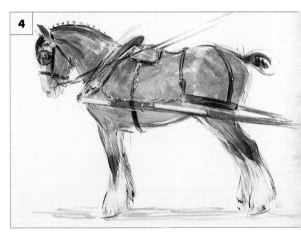

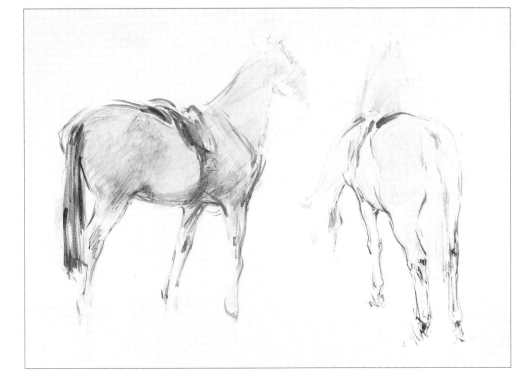

◀ **RIDING HORSES**

When sketching moving subjects choose a method that forces you to work fast. For this, brush drawing is ideal. Neither of these studies took more than 10 minutes. By keeping the colors light, you can paint over an incorrect line or change the position of the head or a limb while the animal moves, as the artist effectively did here.

157

Working from life

All the pictures on these pages show the artists' personal responses to subjects they have experienced firsthand. Although there is nothing wrong with working from photographs, you will probably make better paintings, and enjoy yourself more, if you paint directly from life.

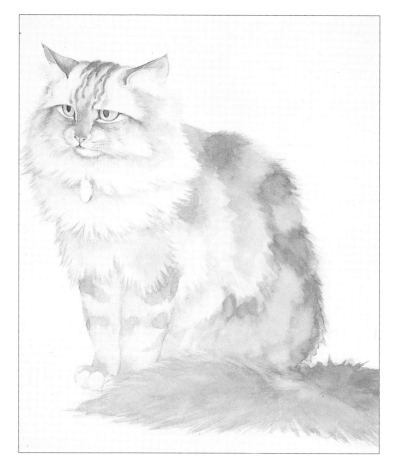

► **Catty Roberts – Sally Michel**

Cats are excellent models, since they often stay still for long periods, or repeatedly assume the same positions. You may need practice before you can *paint as convincing a feline portrait as this, but if you have a cat (or dog) you'd like to paint, begin by working from sketches and photographs.*

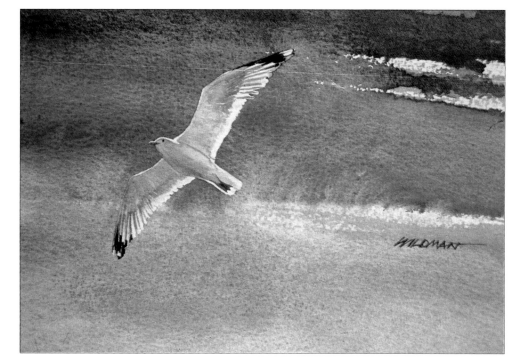

◄ **The Seagull**
Phil Wildman

Seagulls may move fast, but they don't fly high as they wheel above cliffs, beaches, and rivers. If you spend a day or so making quick sketches, you should gather enough material for a painting. This is a lovely evocation of flight, with the bird, just risen from the sea, outlined against the dark water.

► Michaelmas
Ronald Jesty

Geese are a popular subject; their heavy white bodies and long, twisting necks make beautiful shapes and patterns. A farmyard, which offers all sorts of fascinating subjects as well as animals, can be an excellent painting location, provided you have the farmer's permission.

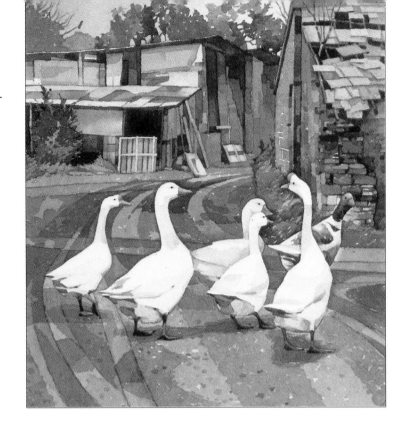

▼ Ewes and Lambs
Gillian Carolan

This painting is as much about light as about the animals. The misty sunlight is captured by working wet on wet over a lot of the picture. For a touch of crisp detail, masking fluid was used to reserve the small white shapes of the grass in front of the suckling lamb and its mother.

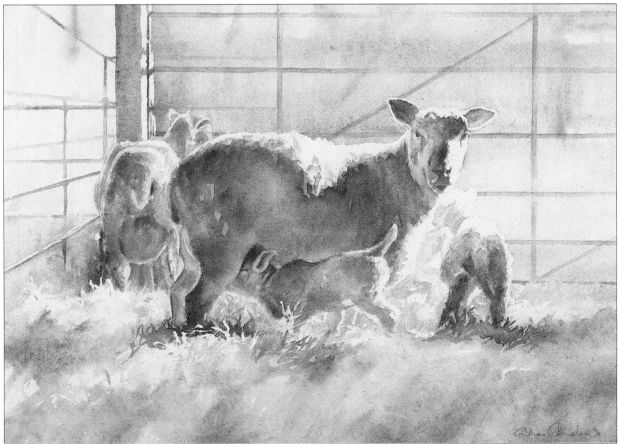

159

Figures and portraits

The human face and figure can seem an impossibly ambitious subject, and that's why it was saved for the end of the course. Ambitious it may be, but it is certainly not impossible, and by now you will have acquired enough skill in handling watercolors to tackle human subjects with a degree of confidence.

It's sometimes thought that watercolor is not the right medium for figures and portraits, and it may not be best suited to the kind of "studio" portrait worked over a long time, but its fluid qualities and glowing colors are perfect for quick impressions and informal portraits.

PEOPLE AND PLACES

You'll often want to include one or two figures in a landscape, and an urban scene would look odd without its complement of humanity, so begin by looking at outdoor subjects, where you can't ask people to pose but have to take them as you find them. The best way to get used to painting people, as with any other subjects, is by doing it. Start by making quick sketches (see p.94). You can sketch with a pencil or pen or "draw" with a brush and color, but you'll have to work quickly, since your subjects won't stay still for long. Try to record your overall impressions, and pay attention to people's characteristic shapes and gestures and the way they move – it is these individual differences that make a picture lively and convincing.

You may want to use your sketches as the basis for a finished painting done later at home, so try to make them as informative as possible by including some of the setting. For example, if you're sketching a group of people at a café table, don't draw them in isolation. Put ▷

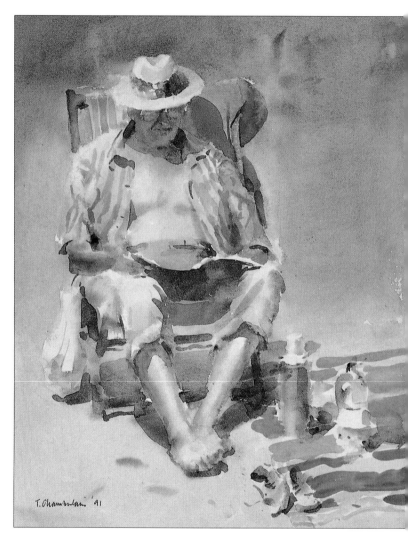

▲ **Granddad – Trevor Chamberlain**

Commissioned portraits are often done from a series of sketches, with the sitter present only for brief periods. However, an informal *portrait such as this can be completed in one session, and therefore benefits from a free, spontaneous approach.*

► **Market Stall**
John Lidzey

This is a quick sketchbook "note", of the kind that Lidzey often uses as a starting point. Unlike Longhurst, who enjoyed painting an "unofficial portrait," he is more interested in the effects of light, so he has defined only general shapes. With experience you will discover your own interests, and know what to include in a sketch.

▼ **A Café in Brussels**
Ray Evans

Evans sketches continually, sometimes with finished paintings in mind, but often simply because he loves to draw and paint. He finds line and wash a particularly sympathetic method, because it enables him to block in broad areas of color and to record details of features and clothes.

161

in a few lines for the tables and chairs, and perhaps a window or door in the background, which will provide a frame of reference. If you're not using color, make a note of the direction of the light – all you need do is put a small cross at the top of your piece of paper.

PAINTING A PORTRAIT

Making quick studies of this kind is excellent practice for portraiture, which is an extension of the same activity. If you've made some successful sketches, chances are that one or two of them are portraits.

The only criterion for portraiture is that the painting looks like the person. You don't have to pose someone carefully and paint every detail of their face to achieve a likeness – you can often depict a person very accurately without painting their face at all. When you see someone you know from too far away to pick out facial features, you will still recognize that person – you register the overall shape of the face and body, and perhaps a particular way of walking. These characteristics are just as important as eyes, noses, and mouths.

You need not necessarily paint indoors either. Portraits often make visual reference to some interest of the sitter, which backs up the physical likeness by explaining something about the person. For example, a portrait of a writer might include a pile of books or a manuscript, while an artist might be portrayed with one of his or her own paintings as a background. If you want to paint someone whose passion is gardening, it makes sense to paint that person in the yard.

COMPOSING A PORTRAIT

When you're painting a single figure, the main decisions you'll have to make are where to place the figure on the paper and how much of it to show. People in paintings automatically draw the eye and become the center of interest, simply because the viewer identifies with a fellow human. This means that your figure need not occupy a great deal of the picture space; in the garden-lover's portrait, for example, you could give equal space to the flowers, trees, and shrubs and still make a successful portrait study.

▲ **Skaters – Pat Berger**

People in movement of any kind make an exciting and challenging subject. But, it would be difficult to complete a painting like this on the spot. Photographs *would help here; if you took several shots of a scene like this you could make a composite of figures from different photos.*

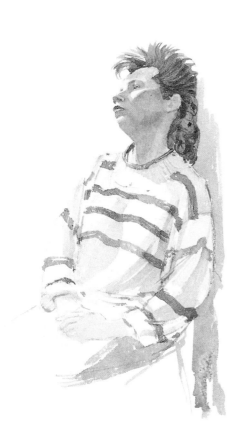

Portrait Sketches
Terry Longhurst

A portrait does not have to be highly finished, but to be successful it must convey a sense of the person portrayed. None of these studies has more than minimum background, and the treatment of the faces and figures is spontaneous. But, each gives a feeling of the sitter's character as well as describing features, hairstyle, and postures.

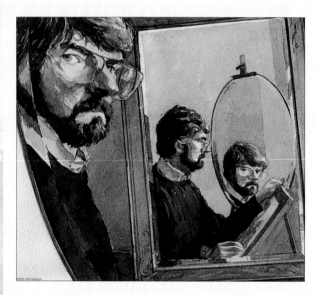

A good way of developing your skills in portraiture is to use yourself as a model. It isn't always easy to find people who will pose for long periods, but when you are your own model you can take as long as you like, and if you're not happy with the result you can quietly dispose of it and start again.

▲ Self-portrait in Three Mirrors
Terry Longhurst

This is an ambitious self-portrait, in which the artist shows three versions of himself in the same painting, playing with size and scale.

▲ Young Woman
Robert Wraith

In contrast to the sketchier portraits by Terry Longhurst on the previous page, the sitter here is shown in the context of a room, thoughtfully smoking, with the remains of a meal on the table in front of her. The painting is beautifully composed and full of atmosphere: The stillness of the girl is reflected by the dark but peaceful color scheme. The cigarette smoke (added with opaque white) is an intriguing touch, swirling upward to echo the patch of light on the wall and the vertical of the wine bottle.

▶ Seated Man
Jan Kunz

This painting is carefully composed. Including more of the legs might have stolen attention from the face, which is always the center of interest in a portrait. Similarly, the artist treated the hands in a sketchier way than the face, and only put in background details where she wanted a strong, dark color to contrast with the light side of the head.

SKIN TONES

LIGHT SKINS

The best approach to painting skin is to establish the overall color and make a suitable mixture. This can then be lightened for highlights by adding water, and darkened for shadows using touches of blue or green. There is no recipe for skin colors, as they vary so much, but for most light skins yellow-ochre and red will be among the colors used. Here are some suggestions for "basic skin colors." Payne's gray or raw umber can be used for shadows.

Yellow ochre Cobalt blue Cadnium red

Cadnium red Lemon yellow Yellow ochre

DARK SKINS

Again, look for the predominant color, which may be yellow-brown (as in this photograph), reddish brown, or even bluish brown. There are often considerable color variations between the highlights and the shadow areas, but these will always be related. If you mix the main color and add darker colors for the shadows, you won't go wrong. If you use too many different colors you may create a disjointed effect. The color combinations shown provide a starting point. Viridian or indigo can be used for shadows.

Payne's gray Alizarin crimson Raw umber

French ultramarine Sap green Cadnium red

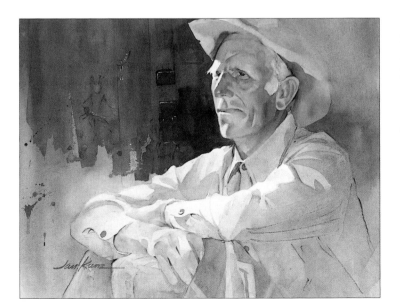

Often, however, you'll want to focus on a figure, particularly if a friend or member of the family has offered to pose for you. In this case, you might paint the face alone, or perhaps half of the figure down to the hands. If you're going to "crop," you'll need to do some planning, because cropping needs to be handled carefully. The head and neck form a unit, so for a head-and-shoulders portrait you could crop at the base of the neck or just below. In a three-quarter-length portrait you can usually crop below the hands, but don't let them slip out of the picture so that only the wrists are visible – this creates an awkward and ugly effect.

Don't allow too much space above the head either, because this will "push" the figure down, making it appear to slide out of the bottom of the picture. And whatever you do,

165

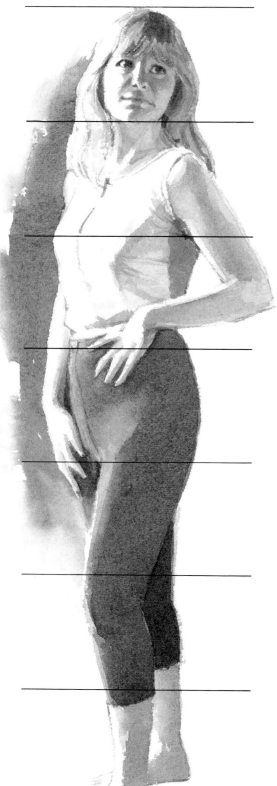

◀ PROPORTIONS OF THE BODY

The rule that the head fits into the body about seven times is a useful one, but no human body conforms absolutely to the norm, so use your observation along with your knowledge. The greatest variation is found in the hips and shoulders.

avoid placing the head bang in the middle and painting from directly in front, since this rarely makes an interesting composition. The majority of portraits (though by no means all) are three-quarter views, which show up the features and the shape of the head well and avoid a still and over-symmetrical look.

HUMAN PROPORTIONS

Poor drawing is the most common fault in figure painting and portraiture, but this is usually the result of lack of observation rather than insufficient skill. You will certainly improve with practice, but initially it will help you to memorize a few simple rules about the proportions of the face and body.

Artists use the head as a convenient unit of measurement when they are painting a complete figure. The body of an adult is approximately seven and a half heads high, and the foot is about one head in length. We tend to think of the waist as the mid-point of the body, but it is considerably higher, as the legs are relatively long.

Of course, few bodies conform to the "standard model." Heads can be smaller or larger, legs shorter or longer, shoulders wide or narrow, square or sloping. But you'll find that once you get into the habit of using the head as a measuring device you'll make fewer mistakes.

FORESHORTENING

These drawings show how dramatically foreshortening affects the shape of a limb. The thigh appears much shorter and thicker in the bottom drawing, because it is coming toward the viewer, with the leg bent at the knee. When drawing foreshortened limbs, forget about the rules of proportion and trust your eyes.

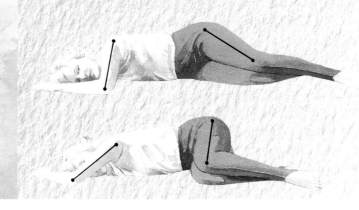

Try holding your pencil vertically at arm's length and moving your thumb up and down it to find the size of the head, and then see how many times this measurement fits into a leg, arm, or the width of the shoulders.

When drawing and painting the head, as in a head and shoulders portrait, it's important to remember that the features occupy a relatively small part of the head. The bottom of the eye socket is the mid-point. Beginners often make the features too large, with the eyes placed too high. Although faces vary widely (and the first step to successful portraiture is being able to pick out individual differences in proportions) you'll find it useful to remember the basic rules.

▲ PLACING THE FEATURES

A common mistake is to underestimate the size of the forehead and top of the head, and place the eyes too high up. It is helpful to remember that the mid-point of the head – allowing for individual differences – is the bottom of the eye sockets.

TILTING THE HEAD

When the head is tilted, the features are seen in perspective. To place the features correctly, see the head as an egg shape and draw some light guidelines around it, as shown here.

Artists who specialize in animal subjects often mix watercolors with white gouache or Chinese white. It is a method that can also help when building highlights on flesh or rendering the texture of hair, as in this portrait where the artist used Chinese white.

You could also try using pastel, charcoal or pencil on top of dry paint. A few drawn lines can provide crisp touches here and there, and

Achieving accurate flesh tones 🖌

Using Chinese white 🖌

Finger blending 🖌

MAKING PICTURES

Trying new methods

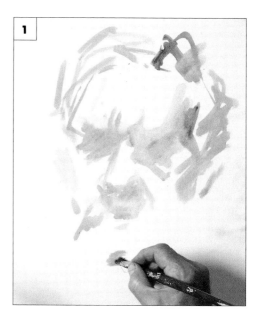

be a good way of firming up the details of noses, eyes and lips. Pencil lines in particular blend in very well with light watercolor washes.

There is a certain amount of snobbery in the world of watercolor painting. Some purists frown on opaque paint and combinations of drawing and painting as they do on the use of masking fluid or wax resist techniques. The important thing is to achieve the result you want by the most effective means available.

1 *A preliminary brush drawing is made with a light red-brown that will blend with the later layers of paint. Don't attempt a brush drawing unless you are confident of your draftsmanship; until then, stick to pencil.*

2 *At this stage the artist is still working with transparent watercolor. But instead of laying wet washes he uses it fairly drily, scrubbing it over the paper. He doesn't mix the paint on a palette but on a piece of watercolor paper, which absorbs some of the water to give him the consistency he likes.*

PALETTE USED

From left to right the colors used in this demonstration are: Alizarin crimson, Indian red, yellow ochre, Prussian blue, lamp black, Chinese white.

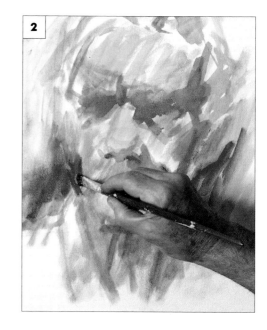

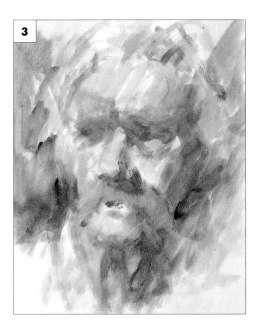

3 *The main structure of the face and the pattern of light and dark colors are now established. A very small range of colors was used, but it includes black, which mixes with other colors to provide rich dark tones.*

4 *Yellow ochre is the predominant color used for the face, with mixtures of Indian red, alizarin crimson, and ultramarine for the shadows. Here the artist uses his finger to blend the dark and light colors.*

5 *Some Chinese white, mixed with a little black, is introduced for the hair and mustache. The deep shadow beneath the nose is again finger-blended to avoid a hard line between the dark and light areas.*

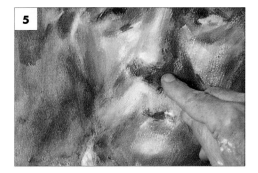

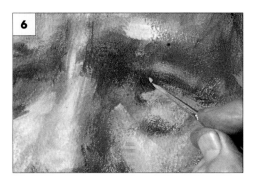

6 *The highlights in eyes are critical; if they are even a little misplaced, the shapes of the eyes will appear distorted. Pure Chinese white is touched in lightly with a small pointed brush.*

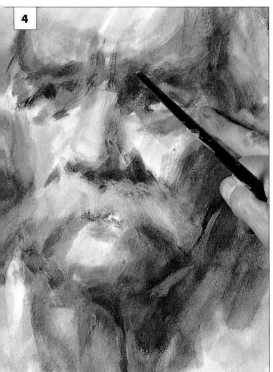

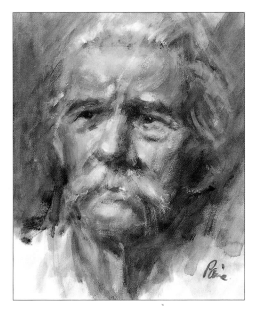

◀ **Portrait of a Mustached Man Ken Paine**

Opaque paint was used sparingly, mainly for the hair and mustache and to build the highlights on forehead, nose, and cheekbones. Like watercolor, it was put on almost dry, by dragging the brush over the paper so that the paint adheres only to the raised grain.

Different approaches

The way you treat faces and figures will depend upon the idea behind your painting. An incidental figure in a landscape can be treated quite broadly, but if you want to paint a likeness of a person or group, you'll need to observe and paint carefully. This doesn't mean adopting a fussy, tight style; you can work freely as long as you decide what you want to do before you begin.

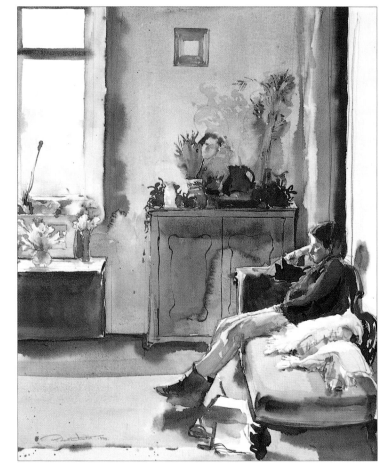

▶ **Interior – Robert Wraith**

This painting is more about the room than the girl. She was pushed to one side so that, although necessary to the composition, she does not dominate it. A figure used primarily to balance other shapes must nevertheless look convincing. The relaxed pose and the patches of light describing the forms were skillfully conveyed with the minimum of detail.

◀ **Young Girl Jan Kunz**

There is plenty of detail in this striking portrait, but nowhere was the paint overworked. The bright light allowed the artist to leave large areas of the face and body almost pure white. The shadows and details of the features were touched in with a sure hand, and the thick, waving hair was simplified into a series of clumps.

Gallery

170

▶ Sir John Best-Shaw
Terry Longhurst

This was a commissioned portrait, so the artist had to ensure a good likeness as well as a pleasing composition. A feeling of quiet strength is conveyed by the black background, which provides strong contrasts of tone, and by the upward-thrusting angle of the head.

▼ Fred and Edna
David Curtis

This delightful study, although not a portrait in the usual sense of the word, is a likeness. We can see only a tiny part of the man's face, and none of the woman's, but the shapes of the bodies and the way the couple are sitting are peculiar to them, and so are their clothes. If you find yourself on the beach with time to spare, make some sketches; beachgoers will often obligingly sleep or lie reading for long periods without moving.

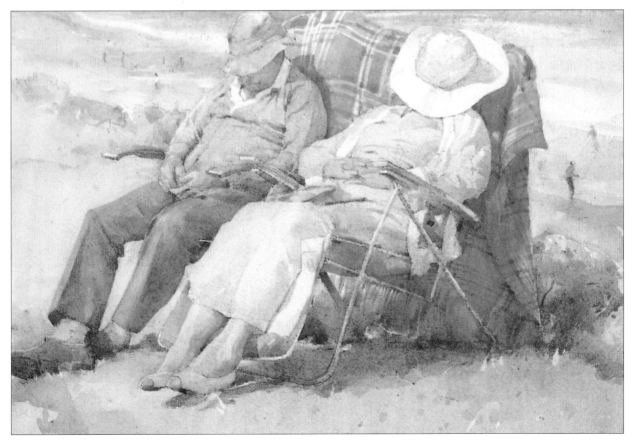

One of the best ways to improve your painting is to learn from your own mistakes. So even if you're not satisfied with your first attempts, resist the temptation to tear them up. Put them away, with a sheet of tissue or tracing paper between each one, and take them out after a couple of months. You may see virtues in work you abandoned, but more important, you'll be able to identify faults, and

► *Watercolors must be protected from both sunlight and damp, and should be covered with acid-free tissue paper, specially made for this purpose. A portfolio is useful if you have no suitably sized drawers in which to keep your work.*

When you have finished

this will help you in subsequent paintings. You can often use a less than successful picture as the basis for another of the same subject.

DISPLAYING YOUR WORK

When you've painted a picture you're pleased with, you may want to hang it. You'll need to mount and frame, or at least glaze it, as any painting on paper should be protected by glass. Most building supply centers will cut glass to size for you, and the mat you need for mounting can be cut at home.

The mats normally used for watercolors are "window" mats – a shape is cut out of board and the picture "sits" behind it. Mat boards come in a wide variety of colors, but in general the light creams, off-whites, and beiges are the most suitable. It's a good idea to take the painting with you when you buy the board so that you can make the best choice.

You can cut window mats using an ordinary craft knife and a steel ruler, but beveled edges, which look nicer than straight ones, are hard to achieve. If you intend to mount a lot of pictures, consider buying a matcutter. These work by means of a blade, fixed at an angle of 45 degrees, which slides along a metal ruler.

The proportion of mat to picture area is important: too wide and the picture will be swamped; too narrow and it will look cramped. If you are unsure, put the picture on the board and move it around until the margin looks right. Then make light pencil marks before

MAT CUTTING

In this demonstration, a ready made clip frame is used. These come complete with glass, and all you need do is cut the mat.

1 *Measure the picture, deciding whether you want the mat to cover any of the edges.*
2 *Cut the board to fit the glass of the frame, and then mark the measurements for the window.*
3 *Like most matcutters, this one is designed to cut on the back of the board. Cut carefully, exerting an even pressure.*

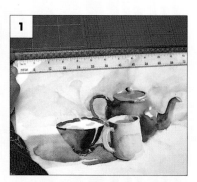

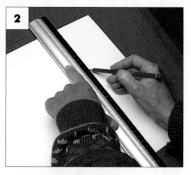

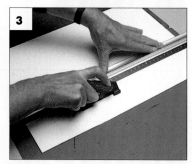

taking precise measurements for cutting. You'll need a wider margin at the bottom, or the picture won't look central when it is hung.

Unless you're handy at woodwork, framing is best done by professionals. If you don't want the expense of a frame, have a piece of glass and a piece of hardboard cut to the size of the mat, and use the metal clips shown here to sandwich mat, picture and hardboard mount together. The advantage of this method is that you can easily remove the picture and exchange it for another. Alternatively, you can buy picture frame moldings cut to length – often advertised in artists' magazines – and all you need do is glue and nail them.

4 When all the edges and corners have been cut cleanly, lift the board by the edges and let the unwanted piece slip out.
5 Position the mat, then fix the picture to it with a piece of masking tape attached to the back. Don't put tape around the edges, or the picture will buckle.
6 Place the picture and mat on the backing board.
7 Put the glass on top, making sure it is clean. Finally, use the picture clips to secure board, picture, mat, and glass together.

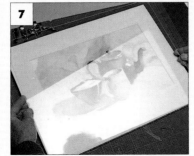

▲ Clip frames don't give as much protection as actual frames, as dampness can creep in at the edges. For a painting you're really proud of it's worth considering a more costly alternative.

Index

Page references in
italics refer to pictures.

Acknowledgments

The publishers would like to thank all the artists who carried out demonstrations for the book, but whose names do not appear in the captions: Jean Canter, Rosalind Cuthbert, Kay Gallwey, Elizabeth Harden, John Lidzey, Terry Longhurst, Debra Manifold, Ken Paine, Hazel Soan, Mark Topham, and Phil Wildman. In addition, the publishers would like to thank Peter Thaime (p.164 left) and Mr. Thomson (p.160) for kindly loaning their paintings for photography, David Kemp for diagrams, Sally Launder for color swatches, and Connie Tyler for the index.